FILM ASSEMBLY
AND PLATEMAKING

BY
A. L. GATEHOUSE
K. N. ROPER

GRAPHIC ARTS TECHNICAL FOUNDATION
4615 FORBES AVENUE
PITTSBURGH, PENNSYLVANIA 15213

Printed in the United States of America

CONTENTS

Preface

The aim of this book is to simplify the tasks within the specialties of film planning/assembly and platemaking and to present practical methods, techniques, and processes now available in the trade. Each technique is viewed with a two-fold approach:

- Considerations of the technique, and
- Methods of using the technique.

Where necessary each area of consideration is concluded with relevant information regarding its future use.

The book should be useful to those entering the trade, to established workers, to those engaged in printing administration, and to the retrainee who may possess a high degree of printing skill outside of these specialties.

The authors of this book wish to thank the technical editor, Ian Faux, for exercising a high degree of skill in blending our material into common reading. We are also grateful to him for the suggestions and objective advice so freely given, the hours of research undertaken, and the checking of statistics, calculations, and formulas.

We also wish to extend our thanks to the suppliers of information and illustrations used in this book, and for the talented skills of our very cooperative illustrators, Jo and John Mosen.

Publisher's Foreword

The Graphic Arts Technical Foundation is a center of practical graphic arts technological knowledge—its generation, collection, evaluation at the bench in both laboratory and industrial settings, and dissemination in workshops, seminars, and educational publications for schools and industry—not only with respect to the United States of America but internationally as well. Authors of our publications have free access to GATF materials and staff assistance.

This book was written by one of the foremost teams of graphic arts educators in England. We wish to express our appreciation to Gordon Birtles, director of the Selection & Industrial Training Administration Limited of London, for his initiative and cooperation in the production of the book.

Graphic Arts Technical Foundation

Editor's Foreword

During the last twenty-five years lithographers all over the world have been involved in the phenomenal growth of lithography. In that time this comparatively minor printing process has become the most significant process in the twentieth century. Vast sums of money are being spent on its development. Almost every week a new process or technique is announced to further the use of lithographic printing. International companies are exploiting modern technology in new products and processes; therefore it is essential that current technical information be maintained so that the lithographer is not left with highly sophisticated techniques without a corresponding knowledge of how to use them to the best advantage. Happily we have seen an increase in the number of technical publications on lithography in the past few years.

This book is set out as a reference source and is intended to be exhaustive in its review of processes and techniques. Ken Roper and Tony Gatehouse have long experience with the modern developments in lithography and have here made a very significant contribution to this important area.

Ian Faux

Section I

INTRODUCTION

SECTION ONE

Introduction

In the past few decades lithography has become more commercially important for a wide range of work, with the result that modern planning techniques are becoming more complex. In this relatively short period of time lithographers all over the world have been developing individual techniques and methods of film planning and platemaking. These methods vary in processing speed, accuracy, cost and use of sophisticated equipment. It is not unusual for neighbouring printers who produce work of similar quality to use completely different approaches to film planning. Modern developments in equipment and planning materials, however, are producing a high level of standardisation within the Trade.

Lithographic Production

Let us now look at the way in which a job travels through the lithographic production department and see how the various stages overlap (*see fig. 1*).

 (i) The original artwork or transparency is photographed to produce a negative or positive element for platemaking. Film elements for lithography are classified as "wrong reading" when viewed from the emulsion side. This produces a "right reading" image on the lithographic plate as the emulsion side of the film is placed in contact with the plate coating when printed down.

 (ii) The majority of planning work involves the assembly of film elements on a supporting sheet (known as a substrate) with the film emulsion uppermost. The sheet is subsequently turned over (or laterally reversed) on to the litho plate to bring the film emulsion into contact with the light sensitive plate coating.

(iii) The right reading image produced on the lithographic plate surface is finally printed by the "offset" principle on the press to produce a right reading print.

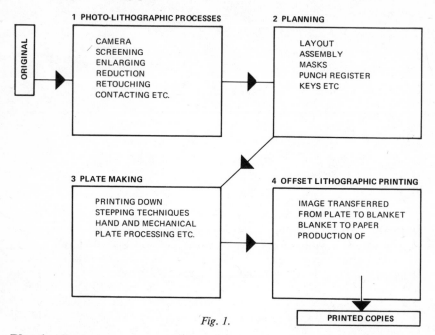

Fig. 1.

Planning Layouts

Every method of planning requires the production of a drawn layout. For mechanical step and repeat machines it will be a set of figures.

The layout is a scale size technical drawing of the proposed imposition, a plan of the job which will show the image areas, margins, spacing, bleeds, trims and all other relevant information.

The choice of layout material will be made according to the planning and printing down techniques used, which are dealt with later in detail. It is very important that the layout is prepared with care because errors produced at this stage will be passed on and may remain concealed until the job is on the press, or worse, until print finishing is attempted.

High standards are necessary throughout all operations of planning and platemaking. In the production of plates there are several aims:

• The press-ready plate must bear the image correctly positioned to enable rapid make-ready on the press. The work is usually centred across the plate width and placed at a distance from the leading edge according to the clamp allowance requirement of the press. The image must also be positioned to facilitate print finishing operations.

- Where multi-colour printing is carried out, accuracy is necessary to permit the respective colours to superimpose precisely to "fit" the previous colour.
- It is a priority aim to faithfully reproduce the film image on to the plate without image "gain" or "loss" occurring.
- A high degree of consistency is required throughout plate production. The platemaker must produce identical quality standards continually and this will only be achieved by eliminating as many variables as possible.
- Finally the plate must be press-ready, possessing suitable lithographic characteristics. It must be prepared, exposed and processed in strict accordance with the manufacturer's recommendations if optimum press performance is to be obtained from the plate.

Image and Non-image Area of the Plate

The lithographic plate is classified as a "planographic" printing surface. The plate falls mid-way between letterpress and gravure printing surfaces which are classified as "relief" and "intaglio" respectively (*see fig. 2*).

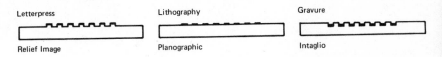

Letterpress Lithography Gravure

Relief Image Planographic Intaglio

Fig. 2. The surface characteristics of the three major printing processes.

The image and non-image areas of the lithographic plate have virtually the same surface level, with only a few microns separating them in height. When the press inking rollers come into contact with the plate, the non-image areas repel the ink because the surface is slightly damped immediately before the ink is applied. The non-image areas of the plate will carry moisture and reject greasy litho ink. The image, due to its oleophilic (greasy) nature will carry the ink but repel the moisture. The principle of lithography is therefore explained by this basic antipathy, "grease and water mutually repel each other".

Lithography is a comparatively young process, it being well under 200 years since those famous Senefelder discoveries occurred. As a result, lithography has developed alongside established printing processes from which some of its terminology has been inherited.

In 1968 the British Standards Institute published a "Glossary of Terms Used in Offset Lithographic Printing" (B.S. 4277). We have adopted these terms where applicable in this book, and a number of definitions related to planning and platemaking are included in Appendix I at the end of this book.

Section II

PLANNING CONSIDERATIONS

(a) *The Importance of the Planner.*
(b) *Environment and Working Conditions.*
(c) *The Layout and Planning Information.*
(d) *Planning for Rapid Press Make-ready.*
(e) *Preparing the Layout.*
(f) *Planning Imposition Schemes.*
(g) *Methods of Printing Bookwork.*
(h) *Materials Used for Planning.*
(i) *Tools Required by the Planner.*
(j) *Planning Room Equipment.*

SECTION TWO

PLANNING CONSIDERATIONS

(2a) THE IMPORTANCE OF THE PLANNER

Planning has always been an important stage in the lithographic process which has in the past received little attention. With the increasing range of platemaking processes, automatic platemaking machines, high material and labour costs, the planning stage has become an important contribution to the production programme.

Many planners may be restricted to the simple planning techniques which are related to the class of work or type of equipment available. The importance of establishing high standards in planning is seen in the speed of the later stages of production.

The class of work may vary tremendously from simple bookwork assembly to close register multi-colour work. Planning therefore not only demands considerable skills of hand and eye, but perceptual skills in knowing how the job should be approached. This will require decisions concerning the correct techniques to be employed and the selection of materials.

Planning also demands an attitude of conscientious responsibility and high standards of cleanliness and accuracy. An appreciation of typographic design and page layout should be a necessary attribute of the planner.

(2b) ENVIRONMENT AND WORKING CONDITIONS

In many lithographic establishments the location of the planning section appears to have been decided as an after-thought, without consideration to the particular requirements of this stage of production. We will here consider the ideal situation for planning production and show the necessity of careful consideration of the working environment.

Temperature and humidity control. Planning materials (cartridge paper, manilla, goldenrod, etc.) on which the layout drawing is made must retain its dimensions for satisfactory use. These materials, however, may be affected by rapid changes in temperature and humidity as is normal under an English climate. An air-conditioned environment in which temperature and humidity are maintained at a constant level is therefore ideal for planning. If the level of control is also extended to the film make-up and platemaking rooms, unacceptable dimensional changes in the layout will be avoided.

The need for control of the factory environment and its stabilising effect on product quality is well known in the lithographic trade. It is surprising to find that few companies make any considered attempt to install a system of control.

Although the ideal is a complete air-conditioning system (involving expensive plant and structural alterations to the building), some degree of control can be achieved by the use of small inexpensive de-humidifiers/humidifiers. With careful monitoring of the room temperature and humidity, extreme variations can be prevented.

For ideal conditions, the atmosphere should be regulated to maintain a relative humidity of 55 per cent at a temperature of 20°C (68°F).

Room lighting. Lighting research has shown that even for simple manual tasks, work performance improves with increased illumination up to a level of 1000 Lux. Work in the planning room involves the performance of many different visual tasks and lighting has an important part to play in creating an efficient working environment in which work can be performed accurately without eye strain.

Important considerations are directional control of lighting and reflected glare. Lamps vary in light output so choice of lamps is important. General lighting with "Northlight" fluorescent tubes is satisfactory but good results will not be obtained unless the quantity of light is sufficient. Since all lamps lose their brilliance with age it is necessary to replace tubes regularly with new ones if only minimum levels of illumination are to be maintained.

In addition to overhead general lighting there is a need for local lighting to give a directional property to the light and avoid glare on the planning table. Recommended fluorescent lighting is Graphica 47 tubes with special individual lamps over the planning areas which possess adjustment for height and angle.

In situations where planning and film assembly is carried out in the same room the general illumination should be in balance with the internal illumination of the light tables.

Windows should be sealed and fitted with venetian blinds to control extraneous light.

Ceilings and walls. As a further aid to light distribution in the room, the ceilings and walls should be clean and regularly painted in a light colour, preferably with a matt finish. Acoustic tiles on the ceiling will further improve the room conditions.

Floors. These should be wooden with easily cleaned, cushioned plastic covering. This is less tiring to the feet of the planner who will be standing for most of the day. If concrete flooring forms the base of the planning room, then plastic tiles should be fitted and regularly sealed to minimise the risk of dust and grit.

(2c) THE LAYOUT AND PLANNING INFORMATION

The layout. This is the working basis of all subsequent planning operations. It is a full size technical drawing which indicates the various image positions as they will finally appear upon the printed sheet. It will also

include "aids" such as register, collating, fold and trim marks, star targets, signal strips and colour control blocks. These will assist the specialists engaged in subsequent operations such as the printing, folding, collating, trimming and punching operations.

The number and kind of aids included in a layout will depend upon the type of product to be printed, and the number of colours required (*see fig. 3*).

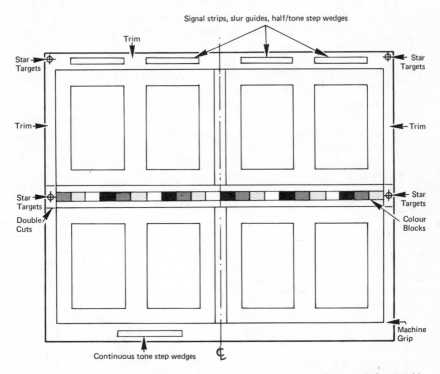

Fig. 3. Layout for an eight page section of a multi-colour periodical, including 'Aids'.

The aims of an accurately produced layout will be to facilitate the positioning of various images, the register of multi-colour work, ease of production in the later stages, economy in the use of materials and machinery at all stages. In order to fulfil these aims the necessary information must be readily accessible. Good liaison should therefore exist between the planning, production, camera, pressroom and finishing departments.

Some or all of the following factors will be required by the planner before preparation of the layout can commence:

12

Factors related to the paper on which the job will be printed

Sheet size. Economic planning will make the maximum use of the sheet area and ensure that the work can be positioned within the printable area of the sheet. The planner will need to know the maximum size of the sheet after it has been cut ready for the press.

The following information is required to calculate the number of copies which can be obtained from each sheet:

 (i) It is advisable to show all trim lines on the layout. These lines not only indicate the finished trimmed area of the images but also show waste areas of the sheet in which quality control aids may be located.

 (ii) "Single" and "Double cuts". These terms refer to the trimming allowances for each job, and must be known to the planner who must show them on the layout.

(iii) Allowance and position for folds are determined by consultation with the finishing department, and should be shown on the layout. In the case of web-offset installations consultation will be with the press operator. With the recent introduction of press-finishing

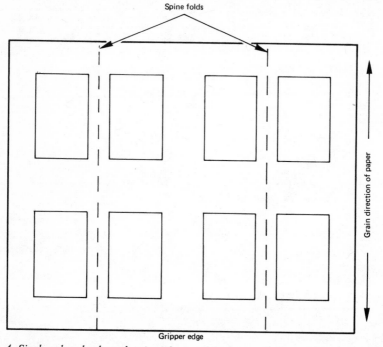

Fig. 4. Single colour book work using 'short-grain' paper with the grain direction running parallel with spine folds.

equipment such as the Harris-Intertype "Multi-binder", a greater variety of folding techniques are now in use with which the planner may not be familiar.

Sheet grain direction. When work has to be folded, it is necessary for the paper fibres (grain) to run in the same direction as the folds (*see fig. 4*). This is essential when thicker papers are used to enable a clean fold to be made without cracking the paper.

In the case of monochrome bookwork it is beneficial for the paper grain to run in the same direction as the spine. However, when planning multi-colour bookwork, the dimensional stability of the sheet will be of greater importance than the folding properties of the paper, and therefore "long-grain" paper must be used (*see fig. 5*).

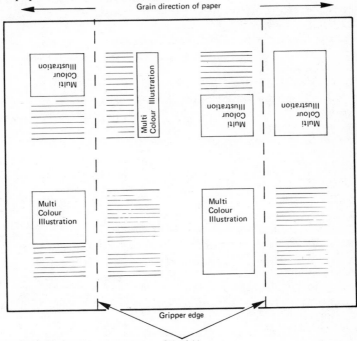

Fig. 5. Multi-colour work, using 'long-grain' paper with the grain running at right angles to the spine folds.

Factors related to the printing press

The type of plate used. In most cases the type of plate used for the job will be determined by the number of copies required and the quality of reproduction demanded. For example: deep etch plates are selected for their long run and quality characteristics. Process colour work on these

plates will require a stable layout such as manilla and this will be prepared to plan up positives on stable sheet plastic. Presensitised plates for monochrome bookwork, however, will require a simple planning base like goldenrod paper on to which film negatives will be assembled.

The size of plate used. The planner should trim the layout material to the same size as the press plate; this will enable the planning of images in the positions which they will appear on the plate. This will avoid the placing of images in wrong positions relative to the gripper and side-lay edges of the plate. This also has the advantage of making it easier to align the layout flat to the plate for printing down.

When planning for negative working plates, the assembly on goldenrod paper will not require other masking material because the goldenrod will completely cover the non-image areas of the plate.

Plate clamp allowance. This is the distance from the leading edge of the plate to the leading edge of the press sheet which must be allowed for when planning. It is an area of the plate which fits into the leading clamp on the press cylinder.

It is important that the plate image is correctly positioned and the distance from the leading edge of the plate to the leading edge of the press sheet correctly ascertained in order to facilitate rapid press make-ready.

Paper-grip allowance. Sometimes referred to as the "gripper margin", this allowance must be considered as a forbidden area on the press sheet where no image can fall. It can, however, accommodate trim allowances.

The paper-grip allowance is that distance on the leading edge of the press sheet which is securely held by the impression cylinder grippers at the moment of printing. This allowance will vary between 4 and 12 mm depending on the type and size of press.

The arrangement of individual images of varying sizes. A customer may require a range of labels or images of varying sizes to be printed in the same colour on the same stock. If all of these varying size images are planned on a single layout considerable savings may be made in planning and platemaking. Information regarding the final total will be required to calculate the number of images of each size which can be included in the layout relative to the press sheet size (*see fig. 6*).

Areas of critical register. The planner must consider the manner in which images register when on the press. Discussion with the pressroom manager will reveal problems which may be overcome by sensible planning. One such problem as "critical register" where image distortion increases towards the back edge of the press sheet at the moment of printing. It may be advantageous to plan images of critical register as near to the leading edge of the press sheet as other factors will allow.

Ink distribution over the sheet. Many printing problems may arise from lack of planning consideration to the areas of ink distribution on the press sheet. For example; a job is planned with a band of solid colour

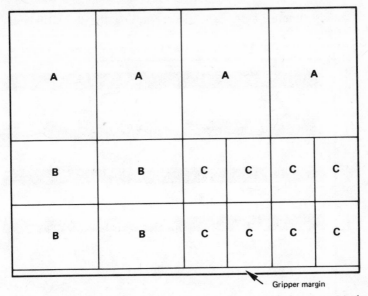

Fig. 6. *A combination layout of various image sizes. Images with the most critical register are planned nearest to the gripper margin.*

running parallel to the back-edge of the press sheet (*see fig. 7*). As the sheet is printed the solid area may still be in contact with the blanket as the leading edge of the sheet is being transferred from impression grippers to delivery grippers. The tension on the sheet at this point in the printing cycle can lead to mis-register and, in serious cases, to the sheet being pulled out of the grippers entirely.

Solid images near the back-edge of the sheet will also encourage "tail-end-hook", making it difficult to jog sheets in the delivery and increasing the danger of set-off.

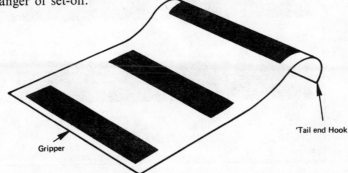

Fig. 7. *Solids positioned on the back edge of the sheet, producing 'Tail end hook'.*

16

Often solids running across the sheet forming the head of labels if planned as shown in *fig. 9* will give problems on the press. The adhesion between solid area and blanket at the moment of printing can cause

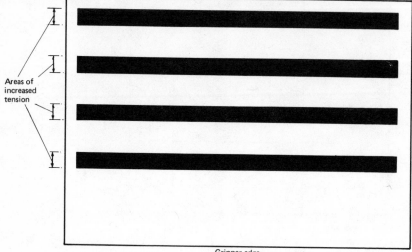

Areas of increased tension

Gripper edge

Fig. 8. Labels in single rows, head to foot, showing areas of tension.

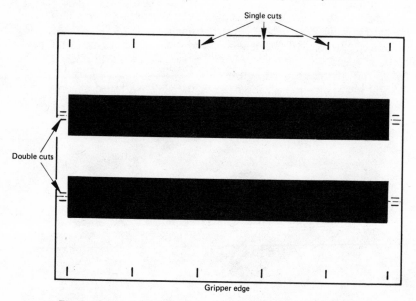

Single cuts

Double cuts

Gripper edge

Fig. 9. Sheet tension reduced by planning labels head to head.

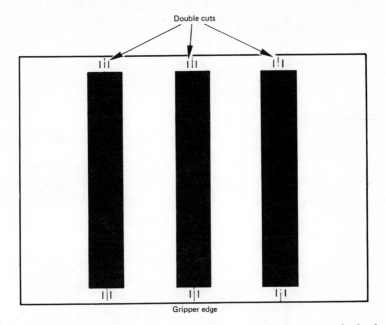

Fig. 10. Labels planned head to head, with solids running from gripper to back-edge.

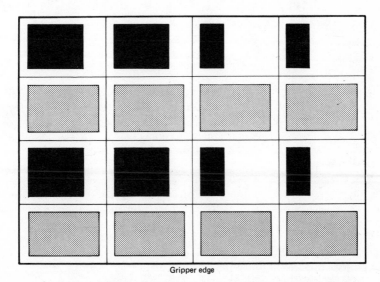

Fig. 11. Solids with half-tone images, producing ink duct setting difficulties.

extensive dimensional changes to affect register and cause sheets to be pulled out of the grippers. By reversing alternate rows of labels head-to-head (*see fig. 8*) the number of tension areas can be reduced and therefore reduce press problems.

Problems of this nature can be further reduced if solid areas can be planned to run from the leading edge to back edge of the press sheet (*see fig. 10*).

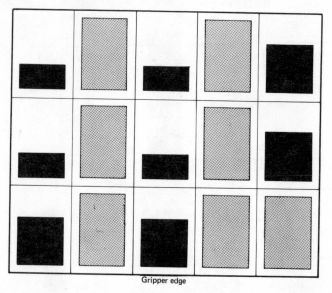

Fig. 12. Solids and half-tones re-planned to assist ink duct setting.

When half-tone images are positioned with solid areas in front or behind them (*see fig. 11*) the weight of colour carried by the press rollers for the solids may cause the half-tones to fill in, print too heavily or cause ghosting in the solid. Re-arranging the layout (*see fig. 12*) will enable the pressman to set the ink duct to suit the different weights of ink required for both solid and half-tone areas. In certain circumstances it may be possible to plan and print two colours from the same plate. For example; a 16 page sheet work section of a periodical with text printed in black and two illustrations, one in red and black and the other in blue and black. It may be possible to plan the red and blue images at the extreme edges of the sheet as shown in *fig. 13*.

The pressman would use a split ink duct technique, running two colours at opposite ends of the ink duct. A film of tinting medium in the centre helps to keep the two colours apart as well as lubricating the centre of the rollers (*see fig. 14*). Roller oscillation would also need to be reduced.

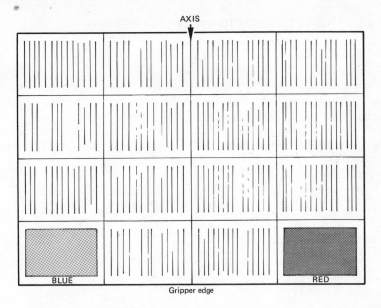

Fig. 13. *16 pp work and turn section showing the red printed on page 2 and the blue printed on page 1 using the same plate.*

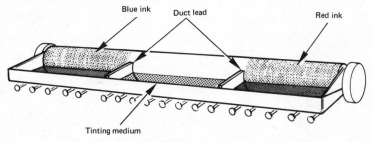

Fig. 14. *Dividing the press ink duct to print two colours.*

Note. When possible work should be planned to appear the right way up when viewed from the leading edge of the plate. This not only enables the leading edge of the plate to be identified, but also enables the pressman to see the work the right way up when the printed sheets fall into the delivery pile on the press. Consultation with the managers of the pressroom and print finishing department is always recommended before implementing any new method of planning. The planner will thus demonstrate that he is aware of problems which might arise due to layout of the work. This will not only pave the way to the elimination of problems, but also increase the co-operation between the various sections of the Printing Works.

(2d) PLANNING FOR RAPID PRESS MAKEREADY

The lithographic pressman does not have the same facility as his colleague in letterpress printing for the movement of individual images to obtain register. The lithographic plate must be positioned into register as a whole. It is therefore necessary when planning the layout to ensure that all images, when printed down to a plate, will accurately register into position relative to the plate cylinder guide marks.

Plate cylinder guide marks. These marks are found in the cylinder gullies close to the leading edge of the plate cylinder (*see fig. 15*), on the centre of the plate cylinder leading edge, and the centre of the leading edge plate clamp.

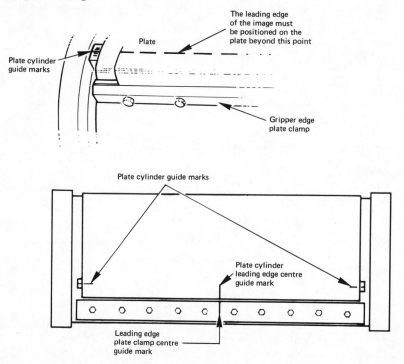

Fig. 15. The position of the plate cylinder guide marks.

Problems of "standard distance". Many "Trade Platemakers" and company platemaking departments work to a "standard distance" when calculating the edge of work to edge of plate. They use this irrespective of the paper size or size of press the plate is to be used on (*see fig. 16*). For the planner to appreciate the absurdity of this practice it is necessary to look at the leading edges of both plate and blanket press cylinders

when they come into contact, and observe the position of the plate image (*see fig. 17*).

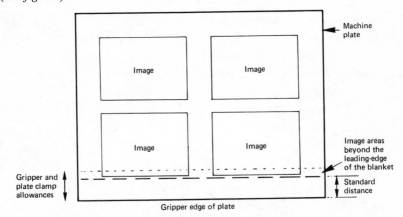

Fig. 16. Images incorrectly planned using 'Standard Distance'.

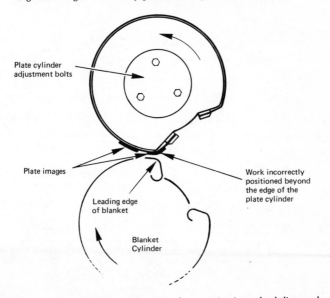

Fig. 17. Image in the wrong position due to using 'standard distance'.

The leading edge of the plate image shown in *fig. 17* is beyond the leading edge of the blanket cylinder and will not transfer to the blanket to print on to the paper. To overcome this problem the pressman will swing the plate cylinder back (away from the leading edge) by use of the

plate cylinder adjusting bolts. Or he may draw the plate back by slackening the leading edge plate clamp and tensioning the rear edge plate clamp until the image is in a correct position to transfer to the blanket (*see fig. 18*). Drawing the plate back like this may cause the leading edge bend to pick up ink while printing and form a build-up of ink on the leading edge of the blanket.

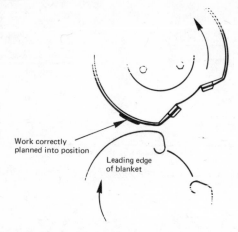

Work correctly
planned into position

Leading edge
of blanket

Fig. 18a. Images in the correct position by using press clamp allowances.

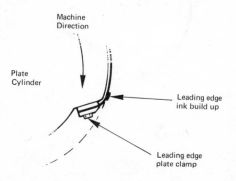

Machine
Direction

Plate
Cylinder

Leading edge
ink build up

Leading edge
plate clamp

Fig. 18b. Ink build up on the leading edge bend of the plate.

If the image is positioned too far from the leading edge of the plate, the pressman will either swing the cylinder forward or draw the plate forward by using the plate tensioning bolts.

These unnecessary press alterations increase makeready time, frustrate the pressman and disrupt production schedules in both pressroom and finishing department.

Fitting the plate to the press. When the correct allowances have been used the pressman is able to fit the plate to the press cylinder in such a position that will require a minimum of further adjustment.

Plate positioning is obtained by the use of the two datum lines ("base" and "centre line") which are drawn or scribed on the extreme edges of the plate. When fitted to the cylinder the datum lines are lined-up with the corresponding marks on the plate cylinder (*see fig. 19*).

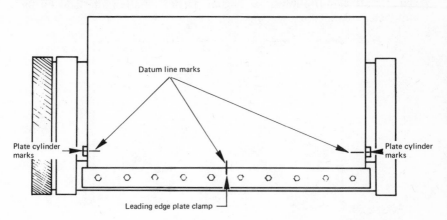

Fig. 19. Plate positioning using datum lines on the plate cylinder.

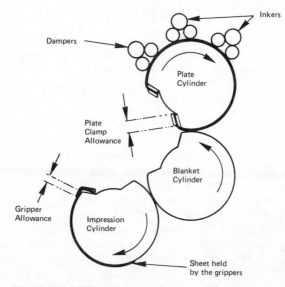

Fig. 20. Press 'Plate Clamp' and gripper allowances.

When producing layouts and plates for web-offset presses the squareness and accuracy of the image position is of great importance due to the limited movement of the plate clamping devices and the absence of front lays on these presses.

Gripper and plate clamp allowances. The "gripper allowance" is that portion of the sheet which is held by the grippers and is an area on which no work can be printed. It is sometimes called the "gripper margin".

The "plate clamp allowance" is that portion of the plate held by the leading edge plate clamp (*see fig. 20*).

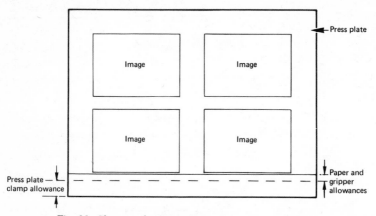

Fig. 21. Clamp and gripper allowance on the press plate.

These two allowances will produce the measurement for "edge of plate to edge of work" distance (*see fig. 21*). This is the minimum distance from the leading edge of the plate that an image can be positioned to ensure good transfer to the press blanket. These allowances vary considerably with individual presses and are obtained from press handbooks.

(2e) PREPARING THE LAYOUT

When preparing the layout it is important to remember that when film elements are assembled to the layout they will be positioned with the film emulsion uppermost (wrong reading). This requires that the layout is drawn laterally reversed so that when viewed on the planning table the right hand page of a two page imposition will appear on the left.

An alternative is to draw the layout as it will be seen on the plate (correct reading) and then turn the sheet over (or laterally reverse it) for assembly of the film elements. This method will require strong light table illumination if the lines are to be viewed through the layout paper.

The layout sheet. A stout, dimensionally stable sheet of layout material such as manilla, cut to the same size as the plate is used.

Place the sheet on the ruling-up table and ensure that the gripper edge is parallel to the edge of the table and secure the sheet to the glass top (*see fig. 22*). Identifying numbers or customer's name is written in an area of the layout which is well clear of the area required for the press sheet size.

Fig. 22. Securing the layout sheet.

Base and centre reference lines. It is essential that all lines on the layout are square and at right angles to the leading edge of the layout sheet. This will not only assist the pressman but also the accuracy of guillotine cutting and other finishing operations. To achieve this commence the layout with two major reference lines.

These are the "base line" and "centre line" which form the basis of all other measurements on the layout, and reduces the element of error which could result from normal point to point measuring.

The position of these two lines is plotted as follows:
 (i) Measure from the leading edge of the layout sheet the plate clamp allowance and draw a line parallel to the edge—this is the base line.
 (ii) Calculate the centre of the layout sheet across its longest edge and draw a line vertically at 90° to the base line—this is the centre line. This line is often marked on the layout with the symbol ℥ which is written in a position close to the leading edge (*see fig. 23*).

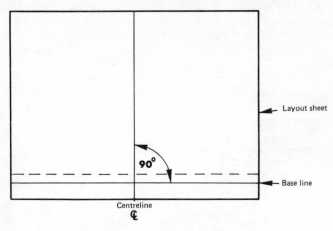

Fig. 23. Base and centre reference lines.

Ruling in the press sheet size. As the layout is drawn up, it is useful to have a visual indication that all the work is contained within the printable area of the press sheet size. The next step, therefore, is to indicate this area on the layout as follows: (*see fig. 24*)

 (i) Measure the width of the press sheet and plot this distance from the base line and draw a heavy line parallel to the base line.
 (ii) Measure the length of the press sheet and plot on the layout with an equal distance either side of the centre line and draw in two lines at 90° to the base line.
 (iii) Determine the "gripper allowance" and draw a line parallel to and above the base line.

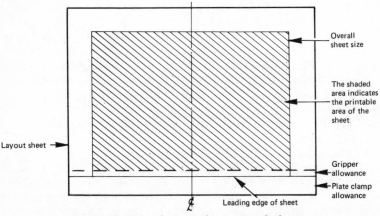

Fig. 24. The press sheet size drawn on to the layout.

Positioning the images on the layout. The next step is the positioning of images on to this layout, and for the purpose of this example, it will be assumed that there are to be an even number of images spaced across the sheet.

The first measurement required is the centre of the image width and the centre of the image length. Most film elements are produced with centre marks which are used for the accurate positioning of each film element. The layout will therefore require guidelines corresponding with these centre marks for each image. If centre marks are not provided on the film element the trim marks on the element will be used to calculate layout positioning lines.

Centre lines parallel to the base line for each image are now drawn on to the layout as follows: (*see fig. 25*)

(i) Calculate half the width of the image, add the "gripper allowance" and rule a line parallel to the base line (*measurement (a) on fig. 25*).

(ii) Add half the image width and draw a line to indicate the upper limit of the first image (*measurement (a) + (b)*).

(iii) At this point the allowance for trims or double cuts is introduced. A single trim is shown as line (*y*) this will allow a margin (*x*) to the image.

(iv) The line showing the commencement of the next image is now drawn (*measurements (a) + (b) + (x) + (x)*).

(v) The second image centre-line can now be drawn (*measurements (a) + (b) + (x) + (x) + (d)*).

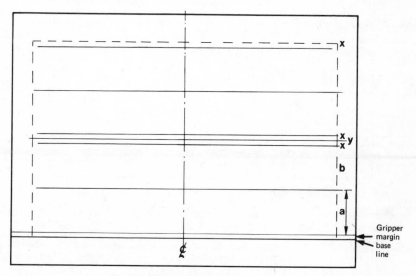

Fig. 25. Plotting horizontal layout lines.

(vi) The upper limit of the second image is now marked in (*measurements (a) + (b) + (x) + (x) + (d) + (c)*).

(vii) The trim on the upper image is now marked in (*measurements (a) + (b) + (x) + (x) + (d) + (c) + (x)*).

Note. Successive images may be located in the same manner by adding the measurements and plotting from the base line.

Centre lines at 90° to the base line are drawn in as follows: (*see fig. 26*).

When determining the image centres which run at right angles to the base line the "centre-line" is the point from which all measurements are made.

Working to the right of the centre-line, measure and draw in the trim (x) to the right of the centre-line. This will indicate the left hand limit of the image. Continue to work to the right, marking and drawing the lines in the following positions from the centre-line:

(i) (x): *trim.*

(ii) (x) + (c): trim, plus image centre.

(iii) (x) + (c) + (d): trim, plus total image width.

(iv) (x) + (c) + (d) + (x): trim, plus total image, plus trim.

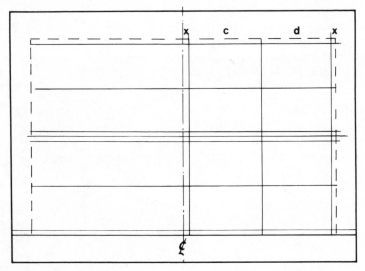

Fig. 26. Plotting vertical layout lines, to the right of centre.

Working to the left of the centre-line, draw in the lines in the same manner: (*see fig. 27*)

(i) (x): trim.

(ii) (x) + (d): trim, plus image centre.

(iii) (x) + (d) + (c): trim, plus total image.

(iv) (x) + (d) + (c) + (x): trim, plus total image, plus trim.

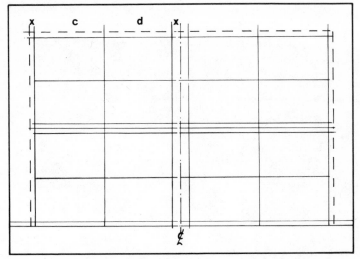

Fig. 27. Plotting vertical layout lines, to the left of centre.

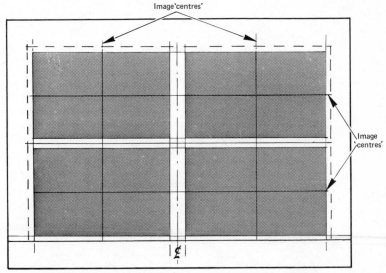

Fig. 28. The shaded areas indicate areas occupied by images.

Note. When the layout has to accommodate an odd number of images across the sheet, the centre image will straddle the centre-line (*fig. 29*). In this case, when working to right or left of the centre-line the first measurement to be shown will be the edge of the image (*measurements* (*d*) + (*c*)). All other measurements then follow as previously described.

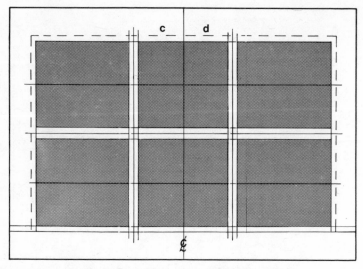

Fig. 29. Layout with image straddling the centre line.

Placing "Aids" within the layout. The position of quality control aids (register marks, colour blocks, star targets, etc.) may now be plotted. Such aids are usually placed in waste areas of the press sheet. The position of trim or fold marks may be drawn in slightly heavier (*see fig. 30*) or circled as a reminder to the planner.

Fig. 30. Trim 2nd fold marks on layout.

On completion of the layout, all dimensions should be thoroughly checked with reference to the original specification.

Complicated layouts. When planning images of varying shapes and sizes the layout assumes a more complex structure. The planner must ensure that the final press sheet can be cut, folded, etc. (*see fig. 31*).

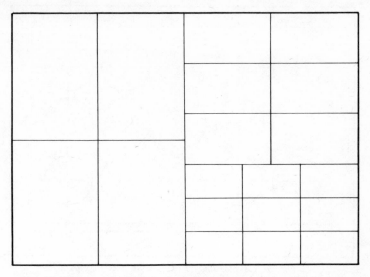

Fig. 31. Different sized labels planned to permit straight guillotine cuts.

Straight-cut, die-cut and punched finishing. When planning for irregular shaped or circular images two factors must be considered:
 (i) The economic use of the press sheet size (*see fig. 32*).
 (ii) The method of finishing (guillotine, punching, die-cutting).

Fig. 32. Cartons planned for the most economical use of the sheet.

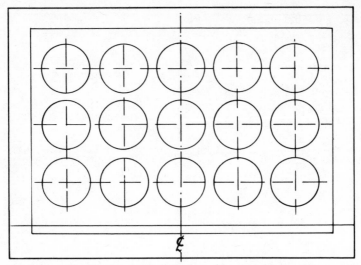

Fig. 33. Circular images planned for straight cuts.

If straight cuts are to be used at any stage in the production the layout must make allowance for such, as in the production of circular labels (*see fig. 33*). Interlocking labels cannot be guillotined but must be die-cut or punched (*see fig. 34*). When planning a layout to obtain the maximum number of images from the press sheet, information regarding the finishing

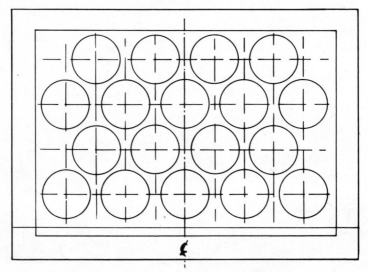

Fig. 34. Interlocking circular labels for die-cutting.

process will indicate the maximum and minimum distances to be used between punched labels to prevent splitting of the paper or movement of the punch cutter through the sheets when punched.

Die-cut dummies should be obtained to aid the planning of complicated layouts.

Customer's and work's specifications. The positioning of images in the layout will conform to the customer's specification or the work's specification. Which of these is used will depend upon the type of work involved.

In the production of periodicals, the position of images on the layout will be supplied by the customer who may have direct liaison with the planner. Circular labels or interlocking shapes, however, will be positioned to a work's specification which will take into account the most economic use of the press sheet.

Specifications take the form of a dummy layout of the job and includes all the dimensional data.

(2f) PLANNING IMPOSITION SCHEMES

We will now look at the planning of work which when printed is folded.

The imposition. This term is normally used to denote the positioning of book pages which when printed, folded and trimmed, will follow in the correct sequence. Imposition in this sense is often assumed to apply only to bookwork, but it is equally applicable to any folded work.

Imposition terms. The terminology used in connection with imposition is as follows: (*see figs. 35 and 36*)

Heads. This refers to the white space at the head of the book page and the space between pages placed head to head on the layout.

Foot. This refers to the base of the page.

Fore-edge. This is the white space on the outer edge of the book page.

Backs. This is the white space between pairs of pages which when folded becomes the back of the book.

Gutters. This refers to the space between pages with their fore-edges together within the imposition layout.

Tails. This is the space between pages with their feet together within the imposition layout.

Folio. This term is used when referring to the page number.

Perfecting. Also called "backing-up", this refers to the printing of both sides of the paper in one pass through the press, and loosely applied to the printing of sheets on one side which will be perfected by passing through the press a second time.

Imposition rules. All imposition layouts for lithographic printing are prepared as they will appear on the printed sheet. The layout must be laterally reversed for film assembly and the "planning flat" (the completed assembly) is laterally reversed on to the plate for printing down.

● The folio is drawn in at the foot of the page and underlined.

34

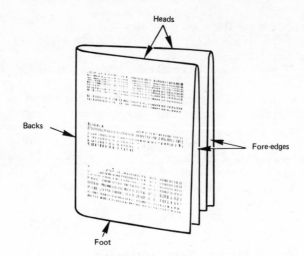

Fig. 35. An eight-page (portrait) folded section.

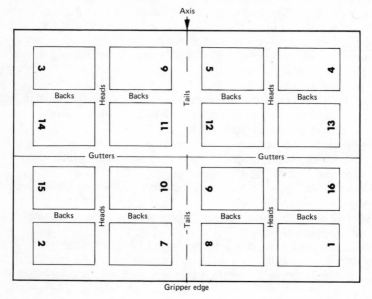

Fig. 36. A laterally-reversed sixteen page portrait bookwork scheme to be printed 'Work and turn'.

- The folio should be drawn the right way up on each page.
- All schemes should indicate margins, axis of backing-up, cuts and trims.

- Collating marks and signature notation will appear on the "outer" (*see fig. 37*).
- The imposition for sheet work is the same as for work and turn. To produce the sheet work outer and inner schemes simply part the work and turn imposition on its axis line.
- *Signatures.* When bookwork involves two or more sections, each section is called a "signature", and is identified by an alphabetical letter or number placed at the foot of the first page of each section (*see fig. 38*).
- *Collating marks.* To facilitate the collating of each signature into its correct sequence within the book, a collating mark (or "Black step") is printed on the spine of each section between the first and last pages. The collating marks are progressively stepped to enable a quick visual check to be made when the sections are gathered together (*see fig. 39*).
- *Inner and outer pages.* Imposition schemes produce inside and outside pages of various sections. In a four page scheme pages one and four are called the "outer" and pages two and three the "inner" (*see fig. 40*). When additional four page sections are gathered together for sewing, side-stitching or stabbing the page numbers will continue as shown in *fig. 41.*

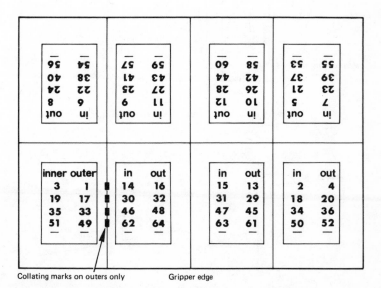

Fig. 37. Inner and outer pages for 16, 32 and 64 pages printed in 16 page sections, sheet work.

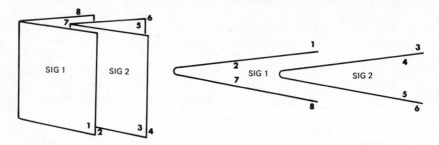

Fig. 38. Two four-page sections or signatures inserted.

Fig. 39. Gathered sections with 'Black strip' collating marks.

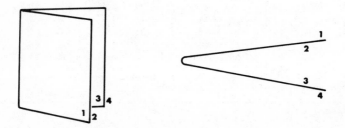

Fig. 40. Folded four-page sections.

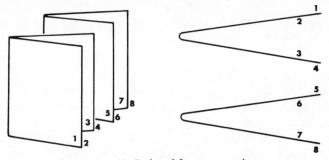

Fig. 41. Gathered four-page sections.

When two four page sections are inset for sewing or saddle stitching the page numbers will fall as shown in *fig. 38.*

To obtain accuracy during planning and for checking the final imposition the following rules are applied for *eight page work and turn printing:* (*see fig. 42*)

(i) Page one will appear in the bottom right-hand corner of the sheet with the foot of the page nearest the leading edge.

(ii) Page two will be in line with page one, across the short cross axis of the sheet.

(iii) Pages three and four occupy the remaining corners of the sheet following a clockwise direction.

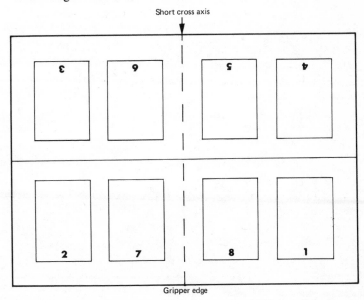

Fig. 42. Eight page portrait imposition printed 'Work and turn'.

38

(iv) The second half of the sheet follows the first half in an anti-clockwise direction.
(v) The first and last pages of the section always make a pair, appearing side by side.
(vi) The sum of each pair of pages will be equal to the sum of the first and last pages in the section.
(vii) The centre pair of pages will appear head to head with the first and last pages of the section.

For larger imposition schemes additional rules are applied. The following example shows the rules for *16 page work and turn printing:* (*see fig. 43*)

(i) Page one will appear in the bottom left hand corner with the fore-edge of the page nearest the leading edge.
(ii) Page two will appear in line with page one across the short cross axis of the sheet.
(iii) Pages three and four will follow in an anti-clockwise direction.
(iv) The second quarter beginning with page five follows the first quarter clockwise, head to head.
(v) The second half beginning with page nine follows the first half anti-clockwise, side by side.
(vi) The fourth quarter beginning with page 13 follows the first quarter clockwise, side by side.

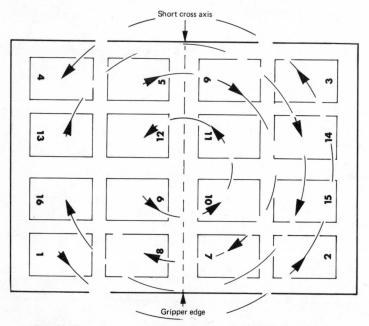

Fig. 43. Sixteen page portrait imposition printed 'Work and turn'.

Numbering the pages of the dummy. To enable the pages of the dummy folded section to be numbered in the correct sequence, a "V" shape is cut with a sharp knife through all the pages (*see fig. 44*). The "V" slips can be easily numbered and the point of the "V" will indicate the foot of each page when the dummy is opened flat.

Fig. 44. A 'V' cut into a folded section to enable easier page numbering.

Folding the dummy. The ultimate position of pages in the book will be determined by the method of folding employed by press folding unit or finishing department. The correct sequence of folds is fundamental to planning a correct imposition scheme. There are a number of methods used, some of which may appear confusing; here is outlined a simple method for standard folds:

Four Page Portrait

Hold the sheet in a landscape position with the longest edge towards you.
Mark page one in the bottom right-hand corner.
Hold the sheet with the right-hand thumb covering page one (*see fig. 45*).
Fold the longest edge in half away from you.
Number pages one to four.
Imposition for sheet work will appear as *fig. 46*, using two plates.

Eight Page Portrait (*see fig. 47*)

Hold the sheet in the portrait position with the shortest edge towards you.
Mark page one in the bottom right-hand corner.
Holding the sheet with the right-hand thumb covering page one, fold the
 longest edge away from you.
Fold the longest edge away from you in half.
Number pages one to eight.
Imposition for sheet work will appear as *fig. 48*, using two plates.

40

Fig. 45. Method of holding the sheet for folding.

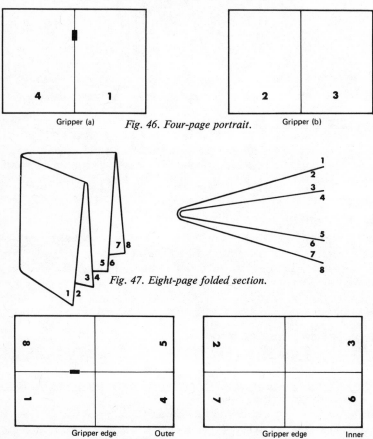

Fig. 46. Four-page portrait.

Gripper (a) Gripper (b)

Fig. 47. Eight-page folded section.

Fig. 48. Eight page portrait imposition.

Gripper edge Outer Gripper edge Inner

Eight Page Landscape

Hold the sheet in the landscape position with the longest edge towards you.
Mark page one in the bottom right-hand corner.
Holding the sheet with the right-hand thumb covering page one, fold the
 shortest edge in half away from you.
Fold the longest edge in half away from you.
Number pages one to eight.
Imposition for sheet work will appear as *fig. 49*, using two plates.

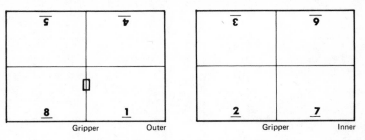

Fig. 49. Eight page landscape imposition.

Sixteen Page Landscape

Hold the sheet in the portrait position with the shortest edge towards you.
Mark page one in the bottom right-hand corner.
Holding the sheet with the right-hand thumb covering page one, fold the
 longest edge in half away from you.
Fold a parallel fold to the last on the shortest edge in half away from you.
Fold the longest edge away from you.
Cut a "V" through the dummy and number one to 16.
Imposition for sheet work will appear as *fig. 50*, using two plates.

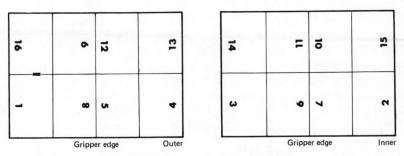

Fig. 50. Sixteen page landscape imposition.

42

Sixteen Page Portrait

Hold the sheet in the landscape position with the longest edge towards you.
Mark page one in the bottom right-hand corner.
Holding the sheet with the right-hand thumb covering page one, fold the longest edge in half away from you.
Fold the longest edge in half away from you.
Fold the longest edge in half away from you.
Cut a "V" through the dummy and number one to 16.
Imposition for sheet work will appear as *fig. 51*, using two plates.

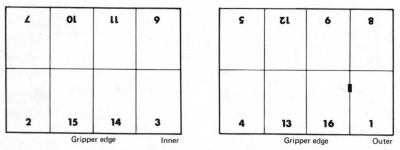

Fig. 51. Sixteen page portrait imposition.

Thirty-two Page Landscape

Hold the sheet in the landscape position with the longest edge towards you.
Mark page one in the bottom right-hand corner.
Holding the sheet with the right-hand thumb covering page one, fold the longest edge in half away from you.
Fold the longest edge in half away from you.
Make a parallel fold to the last on the shortest edge in half away from you.
Fold the longest edge in half away from you.
Cut a "V" through the dummy and number one to 32.
Imposition for sheet work will appear as *fig. 52*, using two plates.

Thirty-two Page Portrait

Hold the sheet in the portrait position with the shortest edge towards you.
Mark page one in the bottom right-hand corner.
Holding the sheet with the right-hand thumb covering page one, fold the sheet in half away from you.
Fold the longest edge in half away from you.
Fold the longest edge in half away from you.
Fold the longest edge in half away from you.
Cut a "V" through the dummy and number one to 32.
Imposition for sheet work will appear as *fig. 53*, using two plates.

3	30	27	6
14	19	22	11
15	18	23	10
2	31	26	7

Inner

5	28	29	4
12	21	20	13
6	24	17	16
8	25	32	1

Outer

Fig. 52. Thirty-two page landscape imposition.

Twelve Page "Concertina"

Hold the sheet in the portrait position with the shortest edge towards you.

Mark page one in the bottom right-hand corner.

Holding the sheet with the right-hand thumb covering page one, fold one third of the longest edge at the top towards you.

Make a parallel fold to the last of one third of the same edge away from you.

Fold the longest edge in half away from you.

Cut a "V" through the dummy and number one to 12.

Imposition for sheet work will appear as *fig. 54*, using two plates.

44

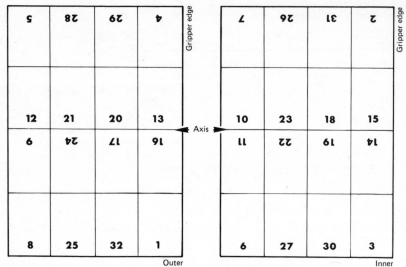

Fig. 53. Thirty-two page portrait imposition.

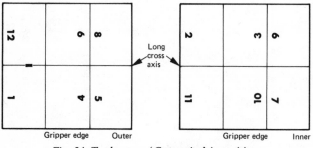

Fig. 54. Twelve page 'Concertina' imposition.

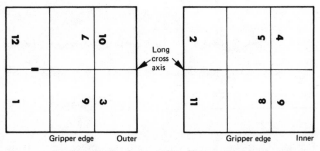

Fig. 55. Twelve page 'Tuck' imposition.

Twelve Page "Tuck"

Hold the sheet in the portrait position with the shortest edge towards you.
Mark page one in the bottom right-hand corner.
Holding the sheet with the right-hand thumb covering page one, fold one-
third of the longest edge away from you.
Make a second parallel fold to the last on the same edge, one-third away
from you.
Fold the longest edge in half away from you.
Cut a "V" through the dummy and number one to 12.
Imposition for sheet work will appear as *fig. 55*, using two plates.

B.P.I.F. booklet of imposition schemes. It is not possible to deal with
all the imposition schemes in use in this volume. Only a few of the standard
schemes have been dealt with. For those specialising in publishing and
bookwork, the British Printing Industries Federation of Bedford Square,
London, have published a booklet of imposition schemes which may be
purchased on application to their office.

(2g) METHODS OF PRINTING BOOKWORK

Sheet work. When printing bookwork by the sheet work method, two
press plates are used, one carrying all the outside pages and one carrying
all the inside pages of the imposition. These two plates are called the
"outer" and the "inner" plates. The outer plate (*see fig. 56*) is recognised

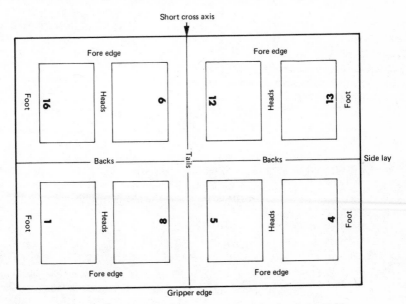

Fig. 56. The 'outer plate' for a sixteen page landscape imposition.

easily because it carries the first and last pages of the section. It is important to plan the plates for inner and outer schemes with the same gripper edge.

To ascertain the correct printing down position for the two plates, the folded dummy should be laid open flat with the outer side uppermost. Page one will be placed in the bottom left-hand corner against the gripper edge of the plate (*see fig. 56*).

The dummy is now turned over on the short cross axis with the gripper edge toward the gripper edge of the plate. The inner plate imposition will now appear as *fig. 57*.

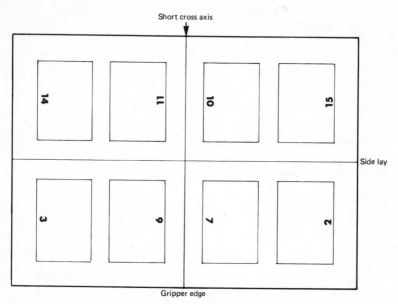

Fig. 57. The 'inner plate' for a sixteen page landscape imposition.

When printed, the side-lay mechanism used on the right-hand edge of the press sheet for the outer pages must be changed to the left-hand side of the press when printing the inner pages of the section. This will maintain accurate register between the two sides of the sheet.

This change of side-lay when printing bookwork requires careful centering of the bookwork image on each plate.

Work and turn. When printing bookwork by the work and turn (half sheet work) method all the pages of the imposition for a section will appear on the same plate. This plate is used to print both sides of the sheet which when perfected is cut in half to yield two copies of the section (*see fig. 58*).

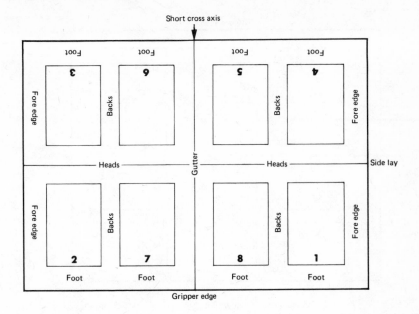

Fig. 58. Eight page portrait imposition printed 'Work and turn'.

After printing one side of the press sheet it is turned over on the short cross axis, at the same time using the same gripper edge. The press side lay is changed over in order to ensure that the sheet is moved into position on the same edge as the first working, thus maintaining good register.

When work and turn is used on a perfector press, two identical plates are used.

Work and tumble. When the imposition scheme (as in 12 page schemes) will not allow the sheet to be printed by the work and turn method, the sheet will be backed-up by the work and tumble method.

After the first side of the press sheet has been printed it is turned (or tumbled) on its long cross axis for the back-up printing operation. Both of the longest edges of the sheet are used as gripper edges using the same side lay (*see fig. 59*). This method requires that press sheets are carefully cut on both gripper and side lay edges to ensure good register of both sides of the sheet.

The imposition scheme shown in *fig. 59* will produce two copies of the section when cut in half along the long cross axis.

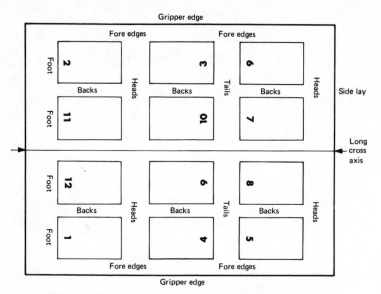

Fig. 59. Twelve page 'Concertina', printed 'Work and tumble'.

Back Margin Allowances

When planning imposition schemes the planner should be conversant with the various kinds of binding and know if they will influence the visible margin in the back of the book.

Sewing and saddle-stitching. When several signatures are inserted one inside the other for sewing or saddle-stitching, the entire back margin will show after the book is finished. However, due to the wrap-round, each folded signature will be slightly pushed forward (this varies with stock thickness) to reduce the visible fore-edge margin after the book is trimmed (*see fig. 60*).

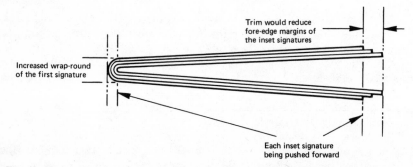

Fig. 60. Showing increased wrap-round on the spine and the loss of fore-edge margins.

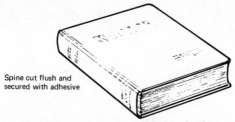

Spine cut flush and
secured with adhesive

Fig. 61. Perfect binding (Adhesive binding).

Fig. 62. Side stitching.

Fig. 63. Slide-on plastic fastening.

Fig. 64. Spiral-wire binding.

Fig. 65. Plastic comb binding.

Fig. 66. Ring binder.

An allowance for this is made by reducing the back margin and adding the reduction to the fore-edge margins of the inset signatures.

Perfect binding (adhesive binding) (*see fig. 61*). Modern book finishing techniques seldom use stitching as a method of attaching pages of books. One of these modern methods is perfect binding. This involves trimming the spine fold off gathered pages which are then roughened and glued together. When the book is opened the back margin is fully visible and because the signatures are normally gathered rather than inset, no extra allowances are required in either the back or fore-edge margins.

Side-stitching, plastic sprung or slide fastening. These methods secure the book pages in a manner which prevents the book being opened fully to expose the entire back margin. An allowance for this must therefore be made at the planning stage according to the particular binding method used (*see figs. 62 and 63*).

Spiral-wire, plastic comb and ring binders. These methods allow the book to open flat with the entire back margin being exposed. The sheets are not secured to each other and therefore require a trim to be taken off the back margin (*see figs. 64, 65 and 66*).

New finishing techniques. New folding, collating and insetting techniques are now employed by finishing equipment such as the Harris-Intertype Multi-binder (*see fig. 67*).

In this method, four page sections only are used on the folding machine. This allows imposition schemes based on four page sections to be planned for any size sheet. Four page sections with difficult register or colour weight can be positioned on the sheet where least distortion takes place during printing.

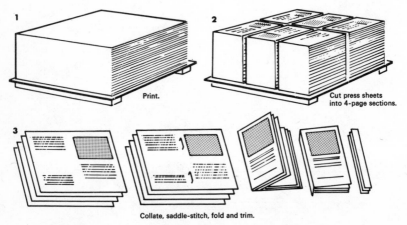

Print.

Cut press sheets into 4-page sections.

Collate, saddle-stitch, fold and trim.

Fig. 67. The operations of the Harris Intertype Multi-binder.

Bookwork Margins

Unfortunately the training of lithographers has in the past paid little attention to printing or bookwork design. This omission may mean that the planner may not be able to arrange the position of text and illustrations if the necessary instructions are not available.

The standards for margin allowance in good quality bookwork provide for the visual balance of work on the single page, and present double-page spreads as a single visual unit. This balance is dependent upon the width of the margins. There are several methods for calculating these margins, which the planner should be conversant with; three of which are here described.

(i) *The thirds method.* First obtain a dummy of a portrait imposition which has been folded and trimmed to the finished size of the job.

Measure the width of the text on the page and deduct this measurement from the page width. Divide the result by three and allow one-third in the back margin and two-thirds in the fore-edge margin. Now repeat the calculation for the page height, allowing one-third of the difference between the height of the text and the page at the head and two-thirds at the foot (*see fig. 68*).

(ii) *The geometrical method.* Open the folded and trimmed dummy to the centre spread (two centre pages), and draw two diagonal lines from the top of the centre fold to each of the opposite corners (*see fig. 69*).

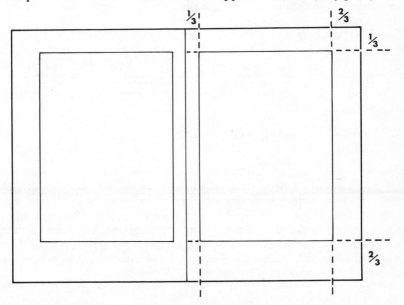

Fig. 68. The thirds method.

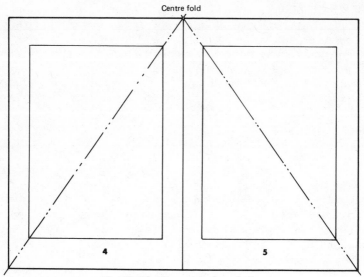

Centre fold

Fig. 69. The Geometrical method.

Using a diazo page proof or film element of the text, place in position so that the diagonal lines run through the corners of the text area, ignoring short headlines or folios.

(iii) *The sevenths and fifths method.* This method is calculated by dividing the sum of the back and fore-edge margins by seven and distributing three-sevenths in the back margins and two-sevenths in each of the fore-edges. The sum of the head and foot margins is divided by five and is distributed with two-fifths in the head margin and three-fifths in the foot (*see fig. 70*).

(2h) MATERIALS USED FOR PLANNING

Layout Sheets

Dimensional stability is the most important requirement of any material used as the layout substrate. It should also be translucent, allowing enough light transmission to enable layout lines to be easily seen during film assembly. On receipt of the layout paper material it should be unwrapped and guillotined to the various press plate sizes required. The sheets should then be stored flat or hung for some time in the planning room atmosphere before use. This will enable the sheets to come into equilibrium with the planning room and ensure constant stability of the sheets.

All paper layout materials must be guillotined to produce long-grain sheets; i.e. with the paper fibres running parallel to the gripper edge (*see fig. 71*). This will ensure that any dimensional change in the layout sheet

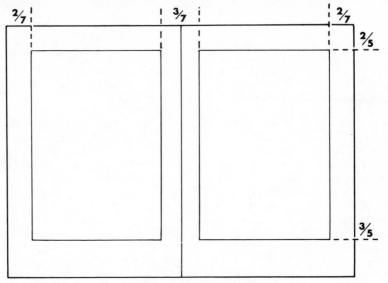

Fig. 70. The sevenths and fifths method.

will occur from gripper to back-edge. The grain direction is normally indicated on the wrapper in which it is received from the supplier.

Fig. 72. The dimensional stability of layout materials.

Manilla paper. This has the advantage of very good dimensional stability because the length of the fibre is long and strong. The paper is produced with a hard smooth finish which absorbs moisture from the atmosphere less readily than other papers.

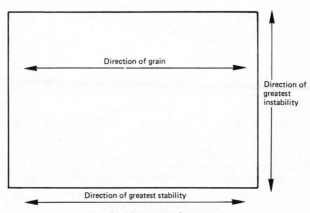

Fig. 71. 'Long-grain' paper.

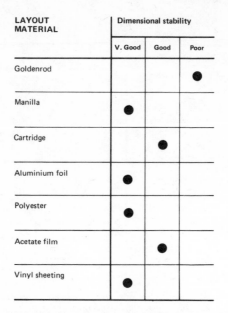

LAYOUT MATERIAL	Dimensional stability		
	V. Good	Good	Poor
Goldenrod			●
Manilla	●		
Cartridge		●	
Aluminium foil	●		
Polyester	●		
Acetate film		●	
Vinyl sheeting	●		

Fig. 72. The dimensional stability of layout materials.

It has the disadvantage of being buff in colour and less translucent than other layout papers. This makes it difficult to see layout lines when used on the planning light table; however, increasing the illumination of the light table will help to overcome this problem.

Manilla layouts are recommended when accuracy is required, or when the layout is to be stored for reapeat orders and use in photo-template methods of planning.

Cartridge paper. A good quality smooth cartridge paper of no less than 118 gsm is suitable for planning layouts. Cartridge which contains esparto grass has good dimensional stability.

Cartridge paper has the advantage of being less expensive than manilla, and because of its white colour layout lines are easily seen on the light table. It can be used for a wide range of work and is particularly useful when film positives are assembled. For high accuracy polyester layout sheets should be used.

Goldenrod paper. This is a layout paper of approximately 90 gsm which is manufactured in a variety of shades from light yellow to orange. It is basically a general purpose paper which has been tinted with special dyes to prevent the transmission of actinic light and calendered to a smooth finish.

Although goldenrod has inferior dimensional stability and is not recommended for precise register work, it remains the most popular layout sheet material for single colour and bookwork negative planning.

Goldenrod has two main advantages:

- The paper functions as the layout substrate and serves as the support upon which the negatives are assembled to produce the planning flat.
- It has excellent masking qualities. The darker shades should be selected for use with high intensity lamps. All shades have good translucency.

Goldenrod for register work. The dimensional instability of goldenrod paper is shown in the following example:

With a 10 per cent increase in relative humidity the paper will stretch 0.2 mm (0.008″) for every 254 mm (10″) with the grain, and 0.37 mm (0.014″) across the grain.

On large layouts the amount of distortion can be considerable and prove a serious problem if planning register work. Nevertheless this problem can be overcome by conditioning the guillotined long-grained sheets in a simply constructed conditioning cabinet (*see fig. 73*) in which small batches of goldenrod paper are suspended from bull-dog clips. Air is allowed to circulate over the entire sheet area which should be fanned apart when first hung in the cabinet.

Holes drilled in the sides and door of the cabinet allow air to circulate, and a simple method can be devised for raising the humidity inside the cabinet to a higher point than the rest of the room. The longer the sheets hang in the cabinet the greater their dimensional stability. This is because every time the paper passes through the cycle of absorbing moisture and then desorbing it, the sheet becomes less affected dimensionally. During conditioning the paper fibres take up moisture and increase in size, the whole sheet stretching, particularly across the grain. As the sheet dries

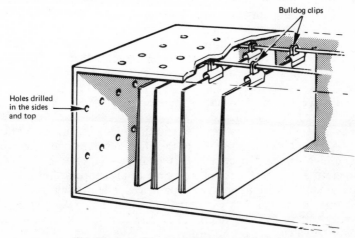

Fig. 73. A conditioning cabinet for goldenrod paper.

it will shrink but not to its original size, the fibres dry and become thin allowing air to enter the sheet and surround each fibre. The fibres can now change dimension within the sheet with less dimensional change in the sheet itself.

Plastic sheet. Clear or grained plastic sheeting is used mainly for the preparation of layouts on which positives are assembled to become a planning flat. It is also used for negative assembly when dimensional stability is required for good register, and also for the production of blue and red keys, burn-out masks and overlays.

Plastic layout sheets are particularly useful for jobs that are repeated and for standard bookwork impositions. "Key layouts" may be drawn on plastic sheet, which because it is hard wearing and stable, can be used repeatedly. Keys should not be produced on plastic sheet with a caliper less than 0.15 mm (0.005") as the dimensional stability of the sheet decreases with a reduction in the material thickness.

Several types of plastic sheet are available with acetate, vinyl (PVC), or polyester bases. They are produced in a range of thicknesses from 0.05 mm (0.002") to 0.6 mm (0.020") in roll or cut sheet form.

The grained surface of plastic sheet is produced by coating the surface or producing a matt finish integral with the base film. Integral matt surfaces are unaffected by normal use and are recommended for lithographic planning because erasures and corrections can be made without damage to the surface.

Acetate based sheet. These are inexpensive, but are not of high dimensional stability, being affected by changes in humidity.

Vinyl (PVC) based sheet. This is a popular, dimensionally stable material unaffected by changes in humidity but slightly affected by temperature changes. In an air-conditioned environment no problems will arise, although slight change in sheet dimension may occur if used on a light table in which the glass working top is allowed to overheat.

Flexible under normal conditions, this material may crack or split if stored for long periods at low temperature. It should therefore be stored flat within the planning section and used within a few months of the purchase date.

Vinyl will accept dyes easily and is therefore popular for "key layouts" and blue and red key production.

Polyester sheet. This is very flexible, and the most dimensionally stable of all the types of plastic sheet. It is therefore recommended for work requiring a high degree of accuracy. It is virtually unaffected by humidity and temperature changes, it remains flexible at all temperatures and will not crack or split. Difficulty may be experienced when trying to use dyes or liquid opaque paint on this material. "Pelican TT" ink can be used for opaque painting and line ruling. There are also special pencils which are recommended for use on polyester.

Drawing on grained plastic sheet. Care should be taken to ensure that the surface of the plastic sheet is perfectly clean. Difficulties may be experienced if layout drawing is attempted on plastic sheet which is not chemically clean.

Pencils. The recommended pencils for polyester are:
Stabilo 8000 Micro-grades F.H. and 2H.
Mars-Lumigraph H.B., F. and H. grades.
Eagle Turquoise H.B., F. and H. grades.
A normal rubber eraser, slightly moistened, will remove pencil lines without leaving a ghost image. Particularly good are the new plastics erasers introduced by Faber-Castell and Staedtler.

Ball-point pens. The majority of good quality ball-point pens using an acetate based blue ink will draw easily on grained or matt plastic sheet. Use of a light blue non-reproducing ink will enable positives to be assembled accurately and the blue ink will not interfere with the printing down exposure because the light will pass through it.

Drawing inks. Many drawing inks will flake off or refuse to dry when used on polyester. Gunther Wagner of Bavaria have produced an ink for polyester which is marketed under the name "Pelican TT". It requires considerable time for drying and hardening.

Trade names of plastic sheet. A representative selection of plastic sheeting suitable for planning is as follows:

Kodatrace. Kodak Ltd.
Astrafoil. D.E.P. Ltd.
Melinex. Imperial Chemical Industries.
Agralon. Agaprinta-Griffin Ltd.

Laminated masking strip film. Laminated plastic sheet of the "Rubilith" and "Polypeel" type are welcome additional aids to the lithographic planner. The clear plastic sheet carries a red or orange plastic membrane on one side. This membrane is easily cut with light pressure of a scalpel and can then be removed by peeling away (*see Section 3* "Negative Assembly on Peelable Membrane Substrates"). The red and orange membrane laminated to the plastic sheet has excellent masking properties and is popular for masks of every description used in lithographic planning (*see figs. 74 and 75*).

Pre-printed grids on layout sheets. Layout sheets can be purchased with grid lines printed on them. The range covering small-offset presses also contain information for press clamp allowance, paper gripper allowance, centre and base lines. The sheets are usually of strong cartridge tinted yellow or red with actinic-light-proof dyes. They can therefore be used in the same manner as goldenrod paper.

Metal masking foil. This is used for masking large areas of photographic film. It is very thin, 0.025 mm (0.001") and is used for masking close to image areas without loss of contact. It is widely used for masking step

Fig. 74. Cutting the laminated masking strip film.

Fig. 75. Peeling away the masking strip film.

and repeat film carriers. The foil can be obtained in rolls approximately 152 mm (6″) wide.

Petroleum jelly. This is used as an adhesive to secure metal masking foil to film or glass. Due to its non-drying characteristics the metal foil can be moved without damaging the film.

Aluminium foil. This is a thin 0.1 mm (0.004″) highly stable sheet material which is used for metal keys and is usually employed when a high degree of accuracy is required. The foil is normally supplied in rolls; the width should correspond to the width of the largest plate used to allow it to be cut into sheet size suitable for the layout.

Small-offset planners sometimes use reject aluminium plates for the preparation of metal keys (*see Section 3* "Metal Keys").

Red masking tape. Transparent red, pressure sensitive polyester based masking tape of the type recommended by P.I.R.A. are used for securing negative film elements together on the planning flat.

Red tape can be purchased in various widths, the most popular being 12 mm (½″) and 24 mm (1″). Produced on an extra thin polyester base,

the red dye is incorporated in the base and will not bleed or form pin holes. The tape has many uses:

- The production of burn-out masks.
- Masking unwanted work or blemishes on film elements.
- Masking work on line negatives from which two plates can be made to produce two colours from one original negative.
- To strengthen areas of goldenrod paper where trim and fold marks are cut through.
- For cropping half-tone negative illustrations. The tape ensures a sharp edge to the illustration.
- For cropping irregular areas of a half-tone negative. This is faster and gives a sharper outline than opaque painting methods.

Red masking tape is easily removed from photographic film without damaging the surface and will not allow the transmission of ultra-violet light.

Clear transparent tape. Pressure sensitive tape of this type is used for securing positive film elements and plastic substrates at the film assembly stage. Care should be taken to avoid the adhesive picking up dirt or dust which may later produce blemishes on the plate.

Classification of Substrates. The "substrate" is a term given to the material on which film elements are fixed at film assembly to become a planning flat. Substrate materials vary considerably in dimensional stability, opacity and cost. The method or technique employed at the planning, film assembly and platemaking stages of production will determine the choice of substrate. These materials are classified according to their particular characteristics in the following tables: (*fig. 76*)

(2i) TOOLS REQUIRED BY THE PLANNER

Where planning of precision layouts is undertaken, personal attitudes of care and pride in the condition and use of tools is essential. Planning is the foundation to many following operations, and errors can become serious when repeated in subsequent platemaking and printing operations. The following tools should be part of the planner's personal tool kit:

Pencils and ball-point pens. All layout drawing should produce easily discernible lines which are uniformly thin for greater accuracy at the film assembly stage. Hard lead drawing pencils of the 4H range are recommended and should be sharpened to a chisel edge rather than to a point which will give a variation of line thickness as it wears. "Thin-lead" propelling pencils which produce a consistent thin line from a small diameter lead are popular because they remove the necessity of constant re-sharpening.

The ball-point pen is popular for planning layouts. It produces a line of consistent thickness and density for viewing on the light table. Good quality pens with smooth ball action and even ink flow should be used.

DIMENSIONAL CHARACTERISTICS OF SUBSTRATES USED FOR PLANNING FLATS

SUBSTRATE MATERIAL	Dimensional stability			Resistance to Actinic light		Transparency		Used for negative working methods	Used for positive working methods
	V. Good	Good	Poor	Good	Poor	Good	Poor		
Goldenrod			●	●			●	●	●
Laminated masking foils		●			●		●	●	● when used as burn-out mask
Clear or grained polyester	●					●	●	●	●
Pre printed grid layout sheets (s/o)		●			●		●	●	●
Acetate film		●				●	●	●	●
Vinyl sheeting	●	·				●	●	●	●

Substrate	Approximate expansion (1)	Approximate expansion (2)
Golden rod	0·152mm ·006" (3)	0.038mm .0015"
Golden rod	0·508mm ·020" (4)	
Acetate film	0·18mm ·007"	0.0889mm .0035"
Vinyl sheeting	0·025mm ·001"	0.0965mm .0038"
Polyester	0·025mm ·001"	0.038mm .0015"
Plate glass	Nil	0.0127mm .0005"

(1) In 254mm (10") For a 10% increase in RH

(2) In 254mm (10") For a 5.5°C (10°F) increase in temperature

(3) With grain

(4) Across grain

Fig. 76. The dimensional characteristics of substrates used for planning flats.

Many modern ruling-up tables are fitted with spring-loaded ball-point pen carriers which present the pen to the layout sheet in a fixed vertical position to produce a consistent line thickness.

Ruled grids on plastic sheet. These grids can be obtained in black, red, blue or green on clear or matt plastic sheet (*see fig. 77*). They are manu-factured in sheet sizes up to 1780 mm × 1270 mm (70″ × 50″) with metric or imperial divisions. Ruled grids are used for preparing and checking of layouts, for film assembly, for checking image position and squareness on the plate and on the printed sheet.

Dimensional stability and flexibility are the most important features to be considered when selecting a grid. Polyester sheet is the most suitable material for accurate grids. The planner should be aware that dimensional changes can occur to the plastic grid and the layout material whilst on the layout table. If two different materials are used for grid and layout, then the dimensional changes may be different. This can be minimised by standardising the materials, e.g. polyester grids should be used with polyester layout sheets and polyester based photographic film elements.

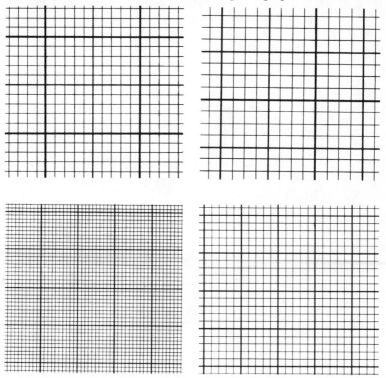

Fig. 77. Ruled grids available on plastic sheet.

Ruled grids on glass. Precision ruled grids are etched into the glass top of some ruling-up tables. Glass grids allow film and mask cutting to be performed on the grid which is not possible on plastic grids because of possible damage. Glass grids are of course dimensionally stable, but they cannot be removed from the layout table like the plastic grid when not required.

Liquid opaque. This is a water soluble paint which contains an opaque pigment in red or black. When applied to certain areas of a negative it will prevent the transmission of light. It is used to cover pin holes and making good any broken areas of negative or positive film, and for cropping negative images.

Erasers. Soft or putty rubbers and plastics erasers are best for removing fine layout lines with little damage to the surface or stability of the sheet. Plastics erasers are recommended for use on plastic layout sheets.

Compass. The draughtman's compass is a useful planning aid. It can be used as a compass when fitted with pencil lead or pen, or used as a divider when fitted with a steel point (*see fig. 78*).

The compass is used for drawing circular lines, dividing lines and angles and the repeating of small measurements. It can also be used for opaquing and scribing circular lines on film.

The pencil should be sharpened to a chisel point and adjusted to be slightly below the needle point when closed.

The beam compass. Where larger circular lines or measurements are required the beam compass should be used (*see fig. 79*). It is most valuable for drawing angles and squares, the checking of angled measurements and measurements which are too large for the use of dividers.

Dividers. Recommended dividers are those fitted with a screw adjustment and locking device (*see fig. 80*). They are used for the accurate transfer of small measurements to the layout and film elements from the straight-edge scale. They are also used in film assembly for the accurate alignment of images before taping down.

Steel and plastic set squares. A variety of squares are available in stainless steel or plastic, with angles ranging from 30° to 60° (*see fig. 81*).

Fig. 78. Spring-bow compass.

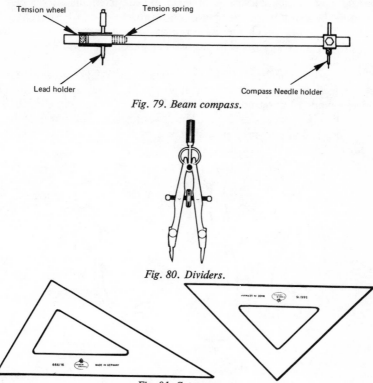

Fig. 79. Beam compass.

Fig. 80. Dividers.

Fig. 81. Set squares.

An adjustable square incorporating a protractor scale for intermediate angles is also available in plastic.

A steel square should always be used when a high degree of accuracy is required.

Straight edges. These are manufactured in stainless steel and possess accurate machine ground edges. Measurement divisions are finely etched into the metal and it is preferable if these are sited on a bevel edge, for greater accuracy. The straight edge is used for drawing and scribing straight lines. They are produced in metric sizes of 500 mm and 1 m; and Imperial sizes of 18, 24 and 36 inches.

Steel or plastic rules. These are used for measurement and the drawing of short lines. Plastic rules vary considerably in quality and may be subject to distortion; they should therefore be carefully selected when any degree of accuracy is required.

Good quality steel rules have finely engraved divisions which are better than the thicker lines normally found on plastic rules. When using scalpel-type cutting knives or scribers, the steel rule only should be used.

Irregular or French curves. A range of plastic irregular curves (*see fig. 82*) should be available in the planning room. They can be purchased in a variety of shapes which facilitate the drawing and opaquing of curved lines and irregular shapes. The adjustable, flexible curve (*see fig. 83*) is also useful.

"T" squares. The use of the long, traditional "T" square requires careful selection and use if a high degree of accuracy is required. They should be made of good quality steel with a machine ground straight edge which is firmly fixed to its head. The layout table itself should contain metal edges ground to give precision use of the "T" square on at least two edges of the table (*see fig. 84*).

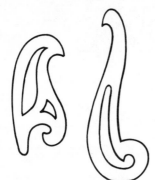

Fig. 82. Irregular or French curves. Fig. 83. Flexible curve.

Fig. 84. T Square.

Rubber hand roller. A 150 mm (6″) photographic rubber roller may be used to roll down metal masking foil using petroleum jelly as the adhesive. The roller will ensure that the foil is smoothed down without damage to give firm contact with film or glass.

Scalpels and cutting tools. This is probably the most important tool used by the planner. Sharp, un-burred edges are required when cutting film, masking strip film, and layout materials. The Swan-Morten surgical scalpel with 10A blade is recommended. Its blades are easily replaced

and are available in a variety of shapes (*see fig. 85*). Open blade cutting tools of this kind must be handled with great care and the following safety rules should be observed when using them:

- The scalpel should not be used against the bevelled edge of a rule when cutting. The scalpel may ride over the edge and across the fingers of the hand holding the rule in position.
- Scalpels used with plastic rules and set-squares will quickly damage the edge and give uneven cutting lines.
- It is advisable to keep an open tray container for scalpels. When not in use they should not be left lying on the bench where they may cause severe cutting to an unsuspecting persons hands. A scalpel knocked off a bench is quite sharp enough to penetrate the leather of a shoe.

Fig. 85. Swan Morton scalpel.

Other types of cutting tool are available, some of which have a blade which can be retracted into the handle for safety. Cutting tools of this type may employ a cutting blade which can be broken off when the edge becomes dull to provide a fresh blade. These are suitable for making straight cuts only.

Swivel-head cutting tools of the "Ulano" type (*see fig. 86*) have been designed for the cutting of irregular shapes on laminated masking strip film materials.

Rotary trimmer. A small rotary trimmer of the "Rotatrim" or "Protocol" type is a useful aid for accurate trimming of film elements and masking materials. The trimmer is safe to use and are available for cutting materials up to 1370 mm (54″) wide.

Brushes. Opaque painting on negatives or positives will require good quality brushes of various sizes. Sable hair brushes are the best, but they are relatively expensive. The tapered shape of the brush produce a fine working point. For fine work No. 0, 2, 3 and 5 are recommended.

Squirrel hair brushes are less expensive, and for sizes above No. 5 are quite adequate for most general painting jobs. No. 8, a 12 mm ($\frac{1}{2}$″) and 24 mm (1″) flat hair brush are recommended.

Scalpel with
light-table attachment

Hand-held scalpel

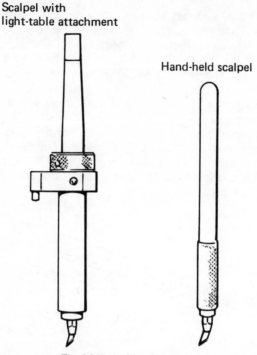

Fig. 86. Swivel-head scalpels.

Scribers. The quality of the scriber will depend upon the type of scribing technique to be used. The scriber may be a small steel tip needle embedded in a wooden holder. This is the general type used by planners although a variety of scribing points (*see figs. 87 and 89*) may be used.

Special scribing is performed with a sapphire which has been cut and polished to a specific size and shape. Sapphires can be cut to an accuracy of 0.003 mm (0.0001″) and will not require re-sharpening. They are set

Fig. 87. Scriber.

Fig. 88. Swivel scriber with
magnifying glass
attachment.

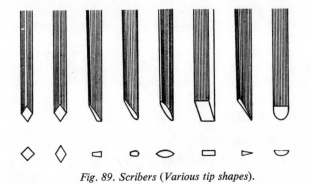

Fig. 89. Scribers (Various tip shapes).

in a special pen-type holder and are usually used for specialist work such as cartography where irregular shapes and consistent line thickness are required (*see fig. 88*).

Ruling pens. The spring bow ruling pen (*see fig. 90*) is used for drawing lines on positives or art work and for cropping negatives with opaque. Ruling pens must be kept clean and the tips carefully sharpened on a fine oil stone when dull or difficult to use.

Technical pens (*see fig. 91*) are the modern answer to the spring bow pen which requires considerable skill in use. The performance of the technical pen is determined by the quality of the point which should provide a steady, non-clogging ink flow. The range of line widths produced by these pens is from 0.1 mm to 2.0 mm.

Fig. 90. Spring-bow ruling pen. *Fig. 91. Technical pen.*

The chrome vanadium, plated steel point will provide long and smooth wear on most paper surfaces. Tungsten carbide points are recommended for drawing lines on grained or matt plastic sheet.

Checking tools for accuracy. It is important to check drawing tools for accuracy periodically. The straight edge can be tested by drawing a straight line on a sheet of cartridge over the full length of the edge. The sheet is then turned through 180° and a second line drawn superimposed upon the first. Any irregularity in the straight edge can now be seen. A fine point 4H pencil should be used.

The set square is tested by first drawing a straight line on cartridge paper with a straight edge which has been verified as accurate. The set square is placed on the line against the straight edge and a line drawn at 90°. The

set square is now turned over and placed against the straight edge and a second line at 90° superimposed over the first. Any error in the square will now be seen.

The "T" square is tested in the same manner as the straight edge.

A further check can be made by placing the straight edge, set square or "T" square over a glass engraved grid. Grids on plastic sheet may not give reliable results.

(2j) PLANNING ROOM EQUIPMENT

The Planning or Rule-up Table

When selecting a table for planning and ruling-up no expense should be spared to obtain the best equipment. Layout accuracy in lithographic planning is essential at this point in the production cycle since little can be done at later stages to put bad planning right.

The planner should select a table which is versatile in use and of solid construction for accuracy. Its uses will include the drawing of impositions and layouts, the checking of press sheets and assembled flats, and aid the assembly of film. It may also have provision for the scribing of negative film or cutting of masking materials, preparation of ruled and continuous forms and ruling-up with indian ink.

The best tables are relatively inexpensive in comparison to the high cost

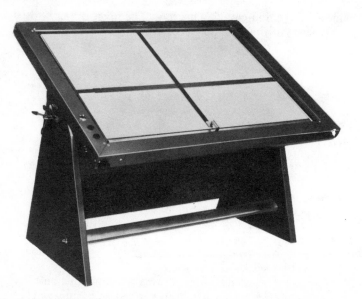

Fig. 92. Free standing, adjustable 'Lithotex 160'. Pictoral Machinery Ltd.

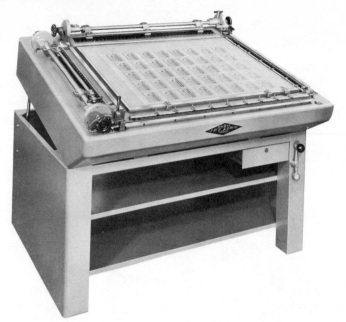

Fig. 93. nuArc Model RR41F Line-up table.

of equipment in other production departments. The choice of a table should take into account the following factors:

- Bench-top models are normally manufactured to small offset planning requirements, 584 mm × 787 mm (23″ × 31″).
- Free-standing models are for larger sizes (*see fig. 93*).
- The majority of tables are of the horizontal type, some of which may include a mechanical ruling unit (*see fig. 96*).
- Adjustable tables (*see fig. 92*) allow for varying working postures and are particularly suitable for planners of small stature.
- The glass working top should be large enough to comfortably accommodate a layout sheet for the largest production plate.

Table construction. Irrespective of the size, the table should be of strong and rigid construction with absolute freedom from warp or distortion. Many tables are fitted with spirit levels and adjustable feet, and it is essential that these tables are placed level in order to prevent inaccuracies occurring due to the distortion of the ruling arms.

Parallel squareness. The method employed to obtain parallel squareness of the straight edges is probably the most important factor to be considered. There are four principle methods in use:

(i) *Precision gear track.* The two straight edges work independently of each other on separate rack and pinion gearing, which may be protected

against accidental damage by solenoid safety stops (*see fig. 94*). The simplicity of the gear action utilises a minimum of moving parts, with less wear and possible inaccuracies.

Some of the more expensive gear track models incorporate a vernier scale with adjustments to 0.06 mm (0.002″). These also carry an automatic spacing device within the vernier mechanism which is useful for ruling up work with repeated even spacing and ruled forms.

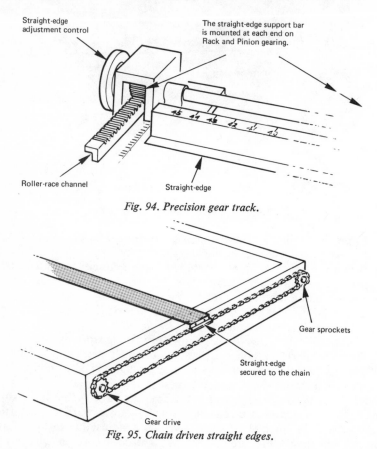

Fig. 94. Precision gear track.

Fig. 95. Chain driven straight edges.

(ii) *Chain drive.* Each of the two chain driven straight edges on this model are adjustable by a shaft which has sprockets at each end engaged in chains to which the straight edge is attached. By turning the adjusting wheel connected to each of the shafts, the straight edges are moved parallel across the table (*see fig. 95*). Chain driven straight edges have the disadvantage that slackness occurring in the chains will result in a loss

of accuracy. Tension control devices are incorporated on the chains to overcome this problem and on good quality tables a micrometer adjustment device can be used to correct loss of squareness.

(iii) *Ball race runners.* This method maintains parallel squareness of the straight edges by placing them on balanced beams which locate with a machine ground track on ball race runners (*see fig. 96*). This gives very smooth movement of the beams and allows the use of various attachments such as ball-point pen, scriber and technical pens, with no-glare magnification of the beam calibration for accurate setting. A perspex viewer may be used on the beam for film assembly, and some models incorporate a punch register pin bar for assembly of register work.

This type of table requires careful levelling and regular cleaning for smooth operation of the beams.

(iv) *Tape or wire guides.* This method is used on inexpensive tables. They are accurate enough for simple layout drawing but are not recommended for precision drawing (*see fig. 97*).

Table components

The straight edges. These should be of stainless steel with finely engraved scales. It should be possible to lock the straight edge in a fixed position. Some models incorporate a raise and lock-down action on the straight

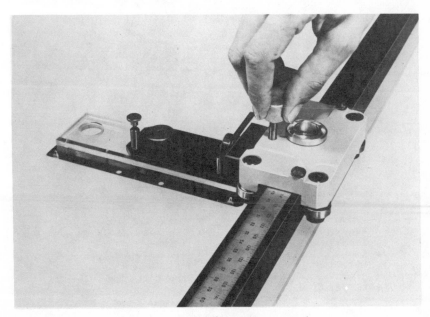

Fig. 96. Ball-race runners (Cornerstone).

72

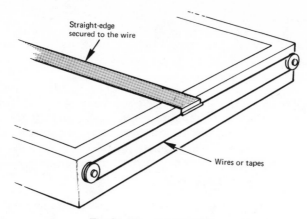

Straight-edge
secured to the wire

Wires or tapes

Fig. 97. Tape or wire guides.

BUILT-IN FEATURES FOR ACCURACY

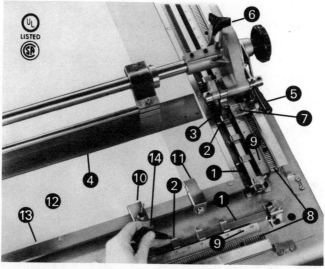

1. Register and Repeat Bar
2. Adjustable Stops
3. Stop-Engaging Finger
4. Stainless Steel Moving Straight Edge, Calibrated in 32nds
5. Straight Edge Lift Lever
6. Straight Edge Lock
7. Double Hair Line Position Indicator

8. Precision Gear Track
9. Front and Side Scales Calibrated in 32nds
10. Paper Hold Downs (Two)
11. Paper Side Guide
12. Fluorescent Lighting
13. Work Guide Bar
14. Adjustment Wrench

Fig. 98. Built-in features for accuracy.

edges; when raised the straight edge can be moved freely into position, when locked-down the straight edge holds the sheet firmly whilst the line is drawn (*see fig. 98*). A large hand wheel drive will aid the accurate adjustment of chain and gear driven straight edge models.

Side scales. Graduated side scales should be fitted on the left-hand side and the gripper edge of the table frame. They should be finely divided and may be fitted with a magnifying lens to assist accurate reading of the scale. Correct reading of the side scales is important. To avoid parallax error the planner should view the reading from a position vertically over the scale.

Layout grippers. It is essential that the layout is held firmly in position during the layout preparation. Most tables are fitted with strong, adjustable grippers (*see fig. 99*) which may be foot or hand operated. Large layout sheets will also require additional securing with tape on sides and back-edge.

The front lays, two of them, are adjustable on the front-lay bar, and can be set to coincide with press grippers. The paper tension lever guarantees accurate locking of sheet. The lever can be locked in open position.

Fig. 99. Front lay paper grippers.

Table illumination. Two 30 watt fluorescent light tubes, the same length as the table are normally fitted. They should be positioned to give even illumination over the entire surface of the glass top. The table design may mean that the illuminant is placed close to the glass top. In this case a diffusion sheet of plastic or glass is usually placed between the light and the glass top. This aids light distribution and prevents the glass top from overheating. Overheating will not occur with lamps placed more than 500 mm (*20″*) from the glass top. Some tables overcome overheating with an air blower unit.

Scribing unit. This is used for scribing lines direct on to film or masking materials (*see fig. 100*). Hardened steel scribing points in various thicknesses are available.

Micro-set vernier scale. This permits fine settings to 0.06 mm (0.002″) and may be used in conjunction with the scribing unit or standard pen unit (*see fig. 101*).

Repeater unit. This mechanism consists of a series of adjustable stops fitted to a special bar or to the beam of the ball race type table. The stops may be set to measurements which will be repeated on further layouts, thereby making it unnecessary to constantly refer to the scales when drawing up identical layouts. The unit is particularly useful for bookwork impositions (*see fig. 102*).

Protractor unit. This is used to aid film assembly and for checking the position of images which are set on an angle (*see fig. 103*).

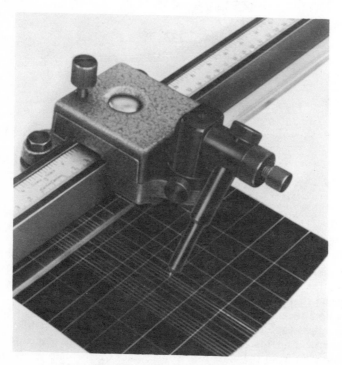

Fig. 100. Scribing unit (Bacher).

The micro-set unit can be mounted either on the beam or on the lateral bearer. When unit is to be shifted over a larger measure, a geared hand-wheel makes this possible with great speed. As the line interval is fixed by the lead of the threaded spindle, there are no tolerances, even when adding a large number of small intervals together.

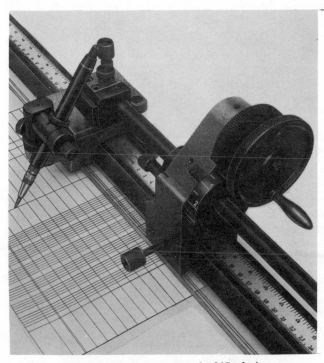

Fig. 101. Micro-set vernier wheel (Bacher).

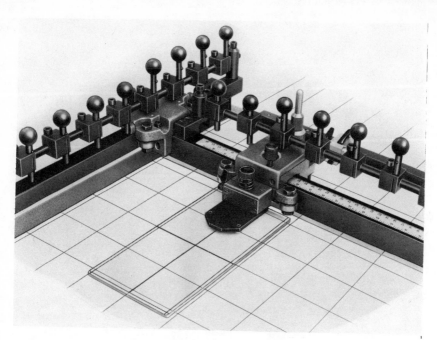

Fig. 102. Repeater unit (Bacher).

Storage Drawers

Shallow drawers for the storage of planning flats, film and layout sheets are necessary in the planning room. Some ruling-up tables incorporate drawer space of this kind. Most commercial drawer chests also provide a working top although a properly designed planning room will provide continuous working-top surfaces over benches and chests. Special consideration should be given to providing planning bench tops suitable for the largest layout sheet, which will not allow pieces of film etc., to fall behind or between benches. This is also important at the floor level where a skirting board fitted to the base of chests and benches will prevent pieces of film being kicked accidentally under them.

Diazo Proofing

In order to avoid mistakes proceeding beyond the planning stage an inexpensive proof can be obtained from a diazo printer unit. Proofs can be produced for the customer, reader or print finishing department in a

short space of time in one colour, or with the use of diazo transparencies, a superimposed full colour proof may be made.

Modern dry, odourless, processors of the "pressure diazo" type (*see fig. 104*) are replacing the earlier types which produced unpleasant fumes and required a warm up period before they could be used.

Fig. 103. Protractor unit (Bacher).

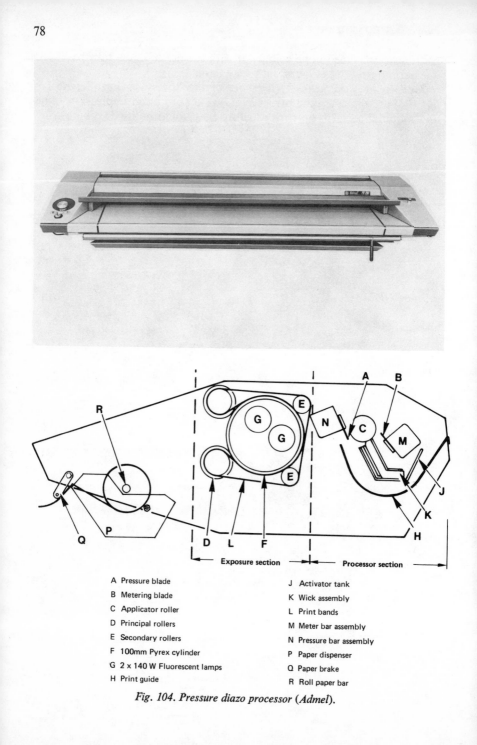

A Pressure blade
B Metering blade
C Applicator roller
D Principal rollers
E Secondary rollers
F 100mm Pyrex cylinder
G 2 x 140 W Fluorescent lamps
H Print guide

J Activator tank
K Wick assembly
L Print bands
M Meter bar assembly
N Pressure bar assembly
P Paper dispenser
Q Paper brake
R Roll paper bar

Fig. 104. Pressure diazo processor (Admel).

Section III

METHODS OF FILM PLANNING

(a) *Direct Ruling to the Plate.*
(b) *Manilla and Paper Templates with Projected Lines.*
(c) *Metal Keys.*
(d) *Negative Assembly to Goldenrod.*
(e) *Negative Assembly to Goldenrod with Plastic Interleave.*
(f) *Negative Assembly on Peelable Membrane Substrates.*
(g) *Conventional Positive Assembly.*
(h) *Hinged Printing Down Flats.*
(i) *Burn-out Masks.*
(j) *Non-reproducing Keys, Photo Blue.*
(k) *Blue and Red Keys on Film.*
(l) *Adhesive and Transfer Systems of Assembly.*
(m) *Punch Register Systems.*
(n) *Step and Repeat Systems.*

SECTION THREE

METHODS OF FILM PLANNING

(3a) DIRECT RULING TO THE PLATE

THE methods described here are commonly used for producing small size plates and monochrome work in which precise accuracy is not the prime consideration. The techniques may be used with either negatives or positives.

Considerations

When scribing or drawing on the plate surface with a pencil or ball-point pen there is the possibility of these marks reproducing and printing up on the finished plate. Unfortunately this is likely to occur with the lightest pressure applied.

Disadvantages of this technique are as follows:

(i) The ruling is carried out on the sensitised coating.

(ii) The coating may become fogged by prolonged exposure to room

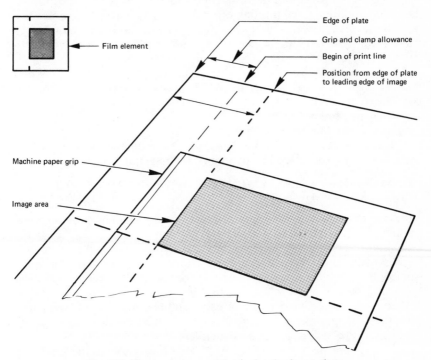

Fig. 105. Plotting image position by hand ruling technique.

lighting or extraneous daylight while marking up.

(iii) The coating may be soiled with extra handling during ruling operation.

(iv) Moisture from hand perspiration may soften water-soluble coatings.

With practice a precision ruling-up table (*see diagrams Section 2, Planning Equipment*) incorporating an integral pen may be used for ruling in register positions on the plate.

When ruling by hand, the following method is common:

The coated plate is laid on a dry bench and marks which correlate with the film register marks are lightly drawn on to the plate surface. This will take into account the image position, the size of paper to be printed on, the paper grip and the press clamp allowance (*see fig. 105*).

Short register lines are drawn on to the plate taking care to correlate them with the register and trim marks on the film and that they are placed outside of the finished size of the job.

This technique is not recommended for work which requires more than three exposures, or where accuracy of register is essential.

The coated plate bearing the register positions is now ready for exposure. The plate is placed in the printing-down frame and the negative or positive positioned to the register marks and taped down. Care must be taken to mask areas reserved for further exposures and the technique varied to suit the type of plate in use (negative or positive working).

After vacuum has been obtained and the exposure completed, the film element is moved to its next position. The masking technique is repeated accordingly until all exposures are completed (*see fig. 106*).

Two or more film elements can be printed down simultaneously in this manner, or one film element "stepped" several times.

This is a rapid method of preparation and printing down single colour work where precise image positioning is not essential.

(3b) MANILLA/PAPER TEMPLATES WITH PROJECTED LINES
Considerations

Here is another simple and rapid method of predetermining printing down positions. These methods are slightly more time consuming, certainly safer, and result in a higher degree of accuracy. They are not really suited to jobs where close register or process colour work is handled, but quite suitable for simple low-key two colour work containing overdrawn solids, line work, etc.

Due to the hygroscopic nature of paper and board, these frail templates do tend to change dimension quite dramatically with changing atmospheric conditions. Producing the first colour plate of a four-up two colour job on one day and the second plate from the same template the following day might result in alarming register discrepancies.

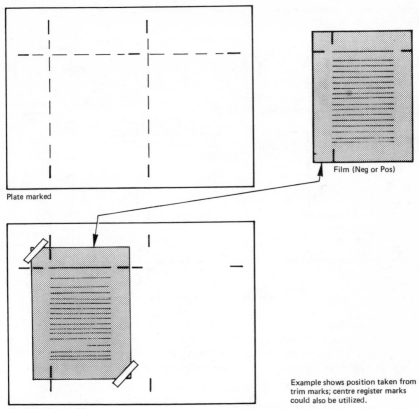

Film (Neg or Pos)

Plate marked

Example shows position taken from trim marks; centre register marks could also be utilized.

Film taped into position

Fig. 106. Stepping two images by hand.

Method

The sheet of manilla (or other stout, stable card) is cut slightly larger than the plate size to be used. Draw the layout on to the manilla sheet using a ruling-up table or a straight edge and pencil. The information on the layout is common for the majority of layouts, although with experience, one will find that a suitable layout can be prepared with a minimum of information on it. This will include the paper size, image and finished job sizes, single or double cuts, corner trims and register marks (*see fig. 107*).

The next stage must be executed with great care. The film element to be printed down must be related to the manilla layout and marks made on the lines which correlate with the position of the film register marks. When three register points for each image have been plotted, a sharp blade and steel rule are used to cut away small windows from the layout in the areas of the register marks. The windows should be approximately

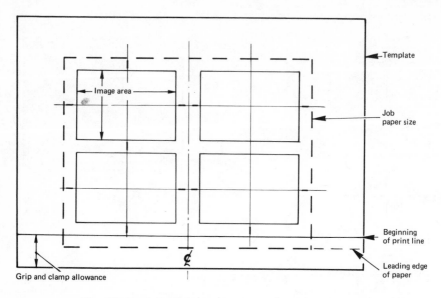

Template

Image area

Job
paper size

Beginning
of print line

Leading edge
of paper

Grip and clamp allowance

Fig. 107. Example of four up job with centre register marks.

3 mm wide and 10 mm long, the space between and around the images often determining the length of the line (*see fig. 108*). The sensitised plate is now laid on a dry bench and the manilla template placed over it and taped in position. The grip edges must align and the centre of the template and plate coincide (*see fig. 109*).

Window

Register line

Fig. 108. Enlarged example of a 3 mm x 10 mm window cut away from the register line.

When taped in position a straight edge and blue ball-point pen is used to mark through the windows on to the coated plate (*see fig. 110*). Lines drawn should be fine and produced with the minimum of pressure.

The manilla template is now removed and the film elements are attached to the plate by registering them to the prepared marks. If a multi-image plate is required, the single film element can be stepped from one position to another. Templates may be used with negative or positive film elements.

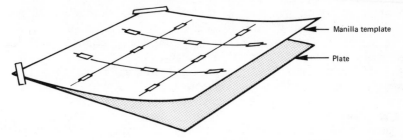

Fig. 109. The manilla layout being positioned and secured on to the sensitised plate.

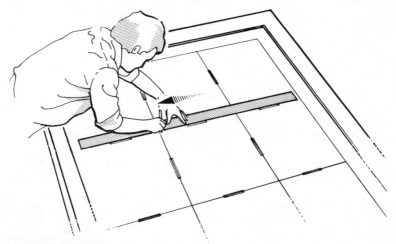

Fig. 110. Aligning the straight edge with the ruled lines and marking through the windows on to the plate.

(3c) METAL KEYS

Considerations

This is a relatively slow method of organising the printing down of film elements. The technique can be used with either negatives or positives. The metal key is produced for a certain class and type of work. The method is used for its high accuracy but also requires a high degree of

skill to perfect the production technique. Many planners consider that the variety of modern alternatives have made the metal key obsolete, but those who still use the technique rightly claim that it affords just about as stable a planning material as it is practicable to use. Once a key has been made it will not deteriorate like other planning substrates which curl, shrink, expand, fade and tear.

Metal keys are suited to printers who produce a great deal of standard size, similar jobs such as periodicals and labels. Where short run periodicals are being produced, the work of the planner may be eliminated. The prepared key is selected by the platemaker ready for printing down. All he requires is the page number and imposition instructions as the film elements arrive from the camera department.

Suitable aluminium foil that is flexible and stable can be purchased from lithographic suppliers for producing metal keys. Many printers economise by using plates which have been damaged prior to use on the press. The thinner plates of less than 0.254 mm (0.010″) are most suitable.

Colour work of close register can be comfortably handled by this method, but process colour work is not best suited to the metal key technique.

Method

The layout is specially prepared on the metal key material. The same information and general approach described earlier is applied, but here a sharp pointed needle or stylus is used to lightly scratch the layout lines into the surface. It is worth spending a little extra time and care when preparing a metal key, which, if looked after, may be used again and again over a long period.

There are two methods of producing exposure apertures in the metal key:

(*a*) Determine exactly where exposure marks are required to appear and mark them on the layout lines on the key. Place a straight edge along the line, and with a sharp blade cut through the metal producing a slit in every register, cut or trim position required (*see fig. 111*). It is important that clean, regular cuts are made and that burrs from both sides of the key are removed. Apart from the risk of sharp particles getting into the hands, the raised burr may prevent close contact between plate and template, and the surface of the plate may be scratched during use. The aluminium swarf can be picked off with a knife blade and fine grade abrasive paper used to produce a smooth finish.

(*b*) The alternative method is to prepare the key layout in the same manner, but instead of cutting slits, a window is cut away in the areas where register and trim marks are required. Photographically produced register marks are then mounted over the windows. (Either

negative or positive marks may be used, depending on the type of
plates being used) (*see fig. 112*). The emulsion side of the film
should be uppermost (away from the metal key) to permit good
contact between emulsion and plate coating during exposure. The
key is laterally reversed on to the plate for exposure.

Fig. 111. Using a sharp blade and a straight edge to cut clean slits through the metal key.

*Fig. 112. Register marks in positive and negative film positioned over windows of key
material.*

The use of register marks in positive or negative form is determined
by the work. In most cases these marks are only used as printing down
guide lines and not required further. It does not necessarily follow that
positive register marks will be used with a positive-working plate. The
same may be said about negative register marks and negative-working
plates.

The key is used to produce a series of register marks on the plate. It must be thought of as a giant master positive or negative. The key can be used in various ways with a variety of different plates. It is a very versatile method. A factor which restricts the use of the metal key is that it is only suitable with sensitised coatings which produce a visible image after exposure.

Metal keys are used in the following ways:

(i) A key is exposed to an Albumen coating (an almost obsolete process now that there are so many superior presensitised coatings). Negatives are then positioned to the darkened register marks produced by the key exposure.

(ii) The key is exposed to a rough Albumen coating which is then processed in the normal manner, recoated with Deep Etch coating, leaving the black register marks clearly visible. This makes the positioning of film positives much easier than to register marks produced by the key on Deep Etch coating (*see iii*) which shows little colour change after exposure.

(iii) As suggested above, the metal key is used with the Deep Etch process. The plate is coated with Deep Etch coating and the key exposed to it. The key is removed and the positives positioned by aligning their register marks to the darkened key marks on the coating.

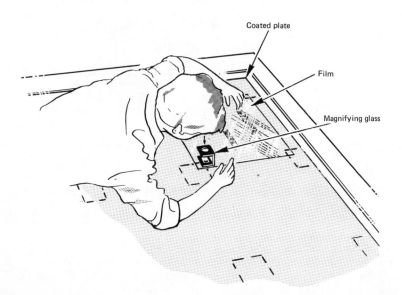

Fig. 113. The platemaker viewing register marks from a vertical position above the key.

(iv) Presensitised plates may be used with metal keys providing the coating produces a visible image after exposure. The method is the same as for (iii) above (*see fig. 113*).

Multi-metal plates and Wipe-On coatings also work well with these metal key techniques.

Goldenrod Key

A simple, less stable method based on the scheme above is the use of goldenrod masking paper in place of aluminium foil. The layout is drawn on the goldenrod in the normal manner. Before register slits are cut, the paper is strengthened in those areas by applying masking tape to both sides of the sheet. This will prevent ragged slits and reduce the possibility of tearing.

(3d) NEGATIVE ASSEMBLY TO GOLDENROD

Considerations

This method is widely used to assemble negative bookwork impositions and multi-image work, where duplicate negatives are supplied. Whilst no high degree of accuracy is obtainable due to the dimensional instability of goldenrod paper, it is an economic method of handling this type of work.

The substrate of the assembly is goldenrod paper (previously discussed). It is more than just a yellow coloured paper. Goldenrod is made to specific requirements, preventing the transmission of short wave actinic light and thus preventing this light from striking the light sensitive coating in unwanted areas. The substance and uniformity of gauge are important in the manufacture of goldenrod paper. Thin patches within the sheet may allow transmission of light. While considering this factor it is well to point out that once a piece of adhesive tape has been fixed and lifted from goldenrod it will probably remove many paper fibres with it. This will result in the paper being less opaque than is acceptable. A simple repair technique is to place a piece of masking tape over the damaged area but on the reverse side of the sheet where it will not prevent good contact during use.

For the small offset market suppliers have produced special printing down sheets. These are simply conveniently sized sheets of goldenrod paper containing printing down instructions (printed in a tinted colour on one side of the sheet). The information may show the beginning of the print line, maximum and minimum handling requirements, paper grip allowance and perhaps two or three "A" sizes. The remainder of the paper is covered with a grid pattern to aid the square assembly of negatives.

Planners involved in a great deal of negative assembly work (of low register requirements) may find it helpful to originate and arrange the printing of pre-printed goldenrod sheets which carry specific information related to standard jobs.

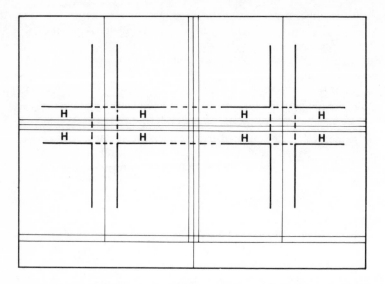

Fig. 114. Example layout showing lines for positioning heads and backs of bookwork pages.

Fig. 115. Negatives positioned with the emulsion side uppermost.

Method

If a pre-printed goldenrod sheet is not available, a sheet of goldenrod, larger than plate size is ruled out with the layout imposition. This has been previously described and an example given in *fig. 114*.

For correct assembly the layout must be drawn laterally reversed, or if a correct layout is drawn, the sheet must be turned over laterally on the light table. The negatives are assembled and fixed with the emulsion side of the elements uppermost, away from the goldenrod (*see fig. 115*). The completed assembly is turned over and placed with the emulsion side of the negatives in contact with the plate coating prior to exposure.

When the negatives are in position together with register marks, trim marks etc., the assembly is turned over on the light table (film now beneath the goldenrod). The planner must now cut away window sections in the goldenrod layout in the image areas of the negatives. Cut the window as close to the work as possible to gain the maximum masking effect. Care must also be taken to remove all goldenrod from the work areas (*see fig. 116*). Avoid cutting too deep, although it will not matter if the film surface is marked. Take care not to cut right through the film.

Areas cut away to reveal images

Fig. 116. The planner, cutting windows around the image area, freehand, using a sharp knife with light pressure.

(3e) NEGATIVE ASSEMBLY TO GOLDENROD WITH PLASTIC INTERLEAVE

Considerations

This method involves identical preparation as above with only a few more minutes added to the production time. As the title implies, a clear sheet

of plastic is used as the actual assembly substrate. This gives added dimensional stability (although foil stability does vary, as previously discussed) depending on the grade and quality of the foil selected. This extra expenditure must of course be justified as necessary.

There are two main reasons for interleaving a sheet of plastic between negatives and goldenrod paper:

 (i) A high degree of dimensional stability is obtained. Tight register and colour work can be handled with good registration results.
 (ii) A goldenrod assembly becomes quite fragile when large windows are cut from it. This makes handling and storage of the assembly difficult with the risk of the goldenrod paper tearing. By fixing the paper to a more permanent base material such problems are eliminated.

Method

The goldenrod layout is ruled out on a light box or ruling-up table. For the assembly stage the ruled sheet is positioned on a light table, remembering the procedure for lateral reversal.

The clear plastic sheet is attached to the goldenrod layout, the grip edges butting together. The sheet should be large enough to support all the film elements, register and trim marks etc., which need to be assembled. When the two are secured together, the negatives are fixed in position on the plastic sheet with tape or adhesive by sighting the register marks

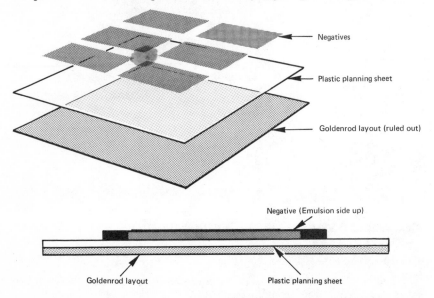

Fig. 117. Arrangement of plastic sheet with goldenrod layout.

through the plastic to the layout lines beneath. The various layers form a sandwich (*see fig. 117*).

At this stage we offer a warning to those who attempt "dot for dot" register by this method. Unless the eye of the planner is directly above the register lines of both negative and layout, misalignment may occur and result in close fitting work. This is because the layout is viewed through a layer of plastic in addition to the thickness of the negative film

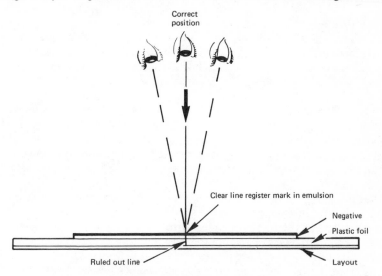

Fig. 118. To avoid parallax error, viewing of register marks must be at 90° to the layout.

Fig. 119. Collimating magnifier.

and may result in a phenomenon known as *parallax* (*see fig. 118*). A planning aid such as a register tube magnifier (Collimator) will overcome this possibility. The magnifier is a simple tube mounted on a base which incorporates a low power lens. The viewing aperture is at the top of the tube so placed to avoid parallax viewing (*see fig. 119*).

(3f) NEGATIVE ASSEMBLY ON PEELABLE MEMBRANE SUBSTRATES

Considerations

The planning materials we will consider here are clear plastic sheet materials which are supplied with a coloured transparent membrane formed on one side. They are marketed under trade names such as "Amberlith", "Rubylith", "Polypeel", "Automask", "Amber" and "Ruby".

The suitability of these materials have already been discussed for stability, range and efficient masking. There are many trade suppliers of this type of masking material which may be purchased in either sheets or on roll. Each supplier produces a variety of qualities to meet different trade requirements and potential buyers should investigate the wide choice available.

The material is usually a stable, clear, polyester base plastic, with a thin amber or ruby coloured membrane which may be peeled away from the base. Under the section dealing with "Classification of materials" we noted that the ruby red membrane has the advantage of being a more functional filter of short wave light but has the disadvantage of being less transparent than amber materials. As the amber masking is sufficient to withstand normal platemaking exposures it is more commonly used for lithographic planning. Ruby coloured materials are better suited for camera work, photographic masks, etc.

The materials are exceptionally convenient, permanent and durable, but practice is required to produce acceptable standards of "cutting and peeling". They are used widely for producing accurate, uniform gauge masks for use with all positive-working plates. These materials are also used for cutting lines, borders and solid blocks (for negative or positive use) and are popular because they can with care, produce straight clean edges. Some materials cut cleaner and peel more freely than others.

The peelable membrane substrates should be stored as directed by the manufacturer. Although these materials are most suitably employed in conjunction with negative assembly, many printers would consider it too costly and reserve them for masks with positive-working plates only.

Method

The layout must first be prepared by ruling out on a stable material such as manilla. The use of a pen which produces a strong fine line (special

fine pencils and pens may be obtained from trade suppliers). This is important because the layout lines will be viewed through the coloured masking substrate. Observe the rule for lateral reversal when preparing the layout.

The next stage is to position and secure the masking substrate to the layout with the membrane side in contact with layout. If difficulty is found in locating the membrane side, test a corner with a sharp knife.

The negatives, register marks and any other items are now assembled on the non-membrane side of the masking substrate. Negatives are placed with the emulsion side uppermost. Align negative marks with layout lines by sighting through the amber substrate (*see fig. 120*), using a magnifying glass. Note the position of the planner in *fig. 120*. He is directly over the area of work sighting register marks in such a way as to avoid parallax.

Fig. 120. The planner assembling negatives on to the non-membrane side of the masking substrate.

When the assembly is complete and has been checked, the layout is removed and placed to one side. The assembly is now turned over to bring the membrane side uppermost. As with the use of goldenrod, the membrane masking must be removed from the image areas and in places where register, trim and fold marks are to be printed down. The technique is simple. Using a sharp blade, with pressure light enough just to cut through the membrane, cut close to the work keeping within the area of the negative. With some practice you will find that a corner of the membrane can be lifted up with a blade and the section pulled away by gripping between thumb and forefinger. Take care when removing the membrane that it is not lifted in areas outside the cut lines (*see fig. 121*). The assembly is now ready for printing down to the plate.

The technique is similar to the goldenrod/clear plastic sheet method which utilises the layout (drawn on goldenrod) as the masking material.

Use of the peeling membrane substrate requires a separate layout which may be an advantage if the job is to be repeated later, or is a regular layout, common for more than one job.

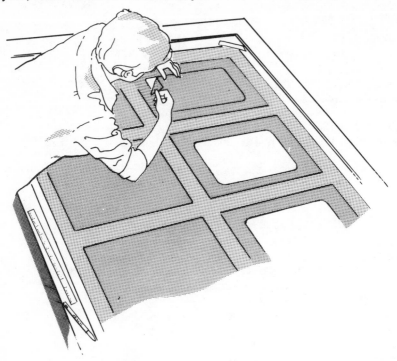

Fig. 121. After cutting around the area to be removed, the membrane is carefully removed.

(3g) CONVENTIONAL POSITIVE ASSEMBLY

Considerations

This is a rapid hand method of arranging positives into an assembly. The substrate consists of a sheet of clear plastic, although lightly grained plastic sheet can be used to reduce the reproduction of film edges when printing down from positives. Positives are easier to position and assemble than negatives, and a high degree of accuracy is possible especially with small impositions. Although the system is used for large impositions, we suggest that it is not practical for tightly fitting work.

The range of work, degree of accuracy, etc., will be determined by the grade, stability and quality of the layout and assembly materials used. The technique is usually reserved for simple monochrome planning for positive-working plates used in printing periodicals, magazines, leaflets, etc.

There are many variations of this basic method of positive assembly, and additional techniques may be combined with it, e.g. burn-out masks.

Method

The layout is prepared in the same way as for the method discussed earlier under the heading "Negative assembly to goldenrod with plastic interleave". The main differences being:

(a) The layout is used only for aiding the position of the film elements and is then dispensed with.

(b) Positive film elements are used. Most planners prefer the use of positives because they are easier to see through to the layout.

The layout is ruled out, preferable on a ruling-up table. A suitable material such as manilla is used for the layout which, when complete, is taped to the top of a light table. Observe the rule for lateral reversal. A sheet of clear plastic is now secured over the layout.

The positive film elements, register, trim and fold marks are assembled on the clear plastic with the emulsion side uppermost. These are positioned by sighting through the plastic sheet to the information drawn on the layout beneath, and fixed with tape or adhesive to the sheet. When complete, separate the layout from the assembly (which is now referred to as a "planning flat"). The flat is now ready for exposure to any type of positive-working plate.

Before or after the flat is exposed to the plate, a "burn-out mask" may be used to minimise the correction of unwanted work (tape and film edges), or to reduce the image size (cropping). The subject of masks is dealt with later.

(3h) HINGED PRINTING DOWN FLATS

Considerations

This is a method of "stepping" multiple negative or positive film elements over a plate. The method is simple and suits a particular class of work. It does simplify planning of butting images and work in which register marks are too close together to be included on the finished plate.

One limiting factor with this method is the risk of the film carrier moving slightly on the tape hinge. The risk is increased if narrow width tape is used. We suggest the use of tape at least 25 mm (1″) wide, but even with this tape, precise accuracy cannot be guaranteed. Process colour work may be handled quite successfully with this method, but we do not recommend it as a system for stepping tight register work.

Method

A layout is prepared in the usual manner (*see fig. 122*), and fixed to a surface which gives room for the plate to be laid beside the layout.

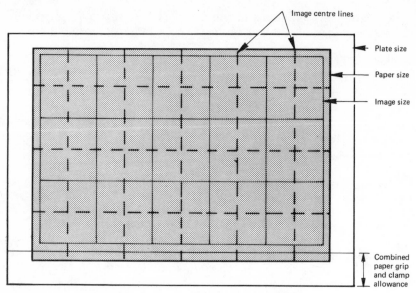

Fig. 122. Example of fifteen up butting imposition.

A sheet of clear plastic is taped to one edge of the coated plate, the sheet opened (away from the plate) and positioned in edge to edge relationship with the layout (*see fig. 123*). Register marks are then fixed to the sheet to relate precisely with the layout. The film element is then fixed to the sheet, emulsion side up. The assembly is now turned over on the hinge to its plate position and the first exposure made with suitable masking. After exposure the assembly is hinged back to the layout and repositioned to the register marks. The film element is moved to its next position, the assembly hinged back to the plate and the second exposure made. This is repeated until all the exposures have been completed. A useful technique is to place a cross upon the layout in the image position as each exposure is completed.

An alternative to repeated positioning of the assembly sheet to register marks on the layout is to use a register punch and pin-bar (e.g. the Kodak register punch system). The layout and the assembly sheet are located together and punched. The pin-bar is inserted through the holes of the layout sheet from underneath. When the assembly sheet is relocated on the layout it is a simple operation to place the punched holes on to the pin-bar (*see fig. 124*).

Extreme care must be exercised if images actually butt on the layout and are separated from the adjacent image by single cuts at the guillotine. This difficulty is common on hand and mechanical step and repeat work (negative or positive), and requires skilful masking to produce a true butt.

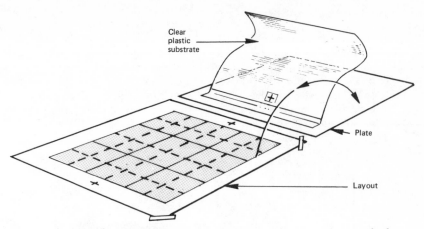

Fig. 123. The hinged transparent sheet is turned over and registered on to the layout.

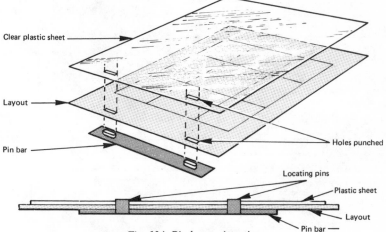

Fig. 124. Pin-bar registration.

It is not practical to attempt butting images by this technique if any other, more sophisticated method, is available to the planner. The smallest error or miscalculation will produce a gap or printed line between the butting images.

Remember, accuracy will be determined by the stability of the tape hinge! For greater accuracy between foil and plate, the Kodak register punch may be used to punch the plate, and the assembly located on a low-pin-bar during exposure. Plate punching will cause rapid wear of the punches and it is advisable to keep a separate register punch for film and paper.

(3i) BURN-OUT MASKS

Considerations

Burn-out masks have a wide range of application with positive film in platemaking. The most common uses include:

(i) Selectively reducing the size of the film image. Where it is not practicable to cut the image of the film to select a certain area, a burn-out mask is used to crop the image to the required proportion (*see fig. 125*).

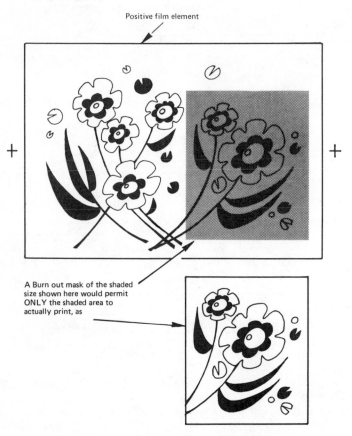

Fig. 125. Image cropping with a burn-out mask.

(ii) When a mask is exposed to the plate before or after the normal plate exposure, this is called a "pre-" or "post-burn". As a pre-burn the mask may also carry marks to serve as a guide for stepping images in addition to the technique outlined in (i) above.

(iii) The burn-out mask is used to remove film and tape edges. These are caused by shadows produced at the edges of tape and film during exposure. A burn-out mask is made slightly larger than the image(s) but smaller than the film edge and tape positions (*see fig. 126*).

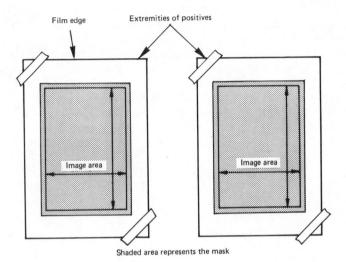

Fig. 126. A burn-out mask for eliminating film edges.

Masks can be produced from the peeling membrane materials discussed earlier, or alternatively constructed with masking tape and paper. Where clean, sharp edges are required, the peeling membrane materials are to be preferred.

These are not rapid techniques but a high degree of accuracy is possible. They are suitable for process colour work but not recommended for a printing sheet size larger than A2. The technique affords a high degree of accuracy relative to the quality of the materials used and the expertise of the planner. Attention to correct working procedures, approaching each job with care and thought, will enable the planner to obtain accuracy and then speed as he becomes more competent.

Method

A laterally reversed layout is prepared for viewing on the light table. All relevant information, image size, register position, cutting marks, etc., must be included.

There are two common techniques for producing burn-out masks:

 (i) A sheet of peeling membrane substrate (e.g. Amberlith) is placed over the layout with the membrane side uppermost. A steel straight edge and sharp blade are used to cut and peel away the membrane, leaving the areas which are to be masks. Register marks, cut and fold lines, etc., are then added to the burn-out masking flat.

 (ii) An alternative method is to use a sheet of clear plastic for the masking flat. This is positioned and secured over a laterally reversed layout. Masking tape is now fixed to the sheet and positioned over the required mask areas with an overlap of approximately 3 mm ($\frac{1}{8}''$). Where a number of mask boxes are to be made, the tape is continued across the width of the sheet to cover all the boxes in that row (*see fig. 127*). With a sharp blade and straight edge cut along the mask lines and remove the surplus tape. The interior of the box is usually filled with goldenrod paper or black masking paper. This is cut to fall within the width of the masking tape and fixed on the reverse side of the plastic sheet to prevent the transfer of moisture from the hygroscopic paper to the plate during exposure. Tape-and-paper masks are more difficult to produce than peeling membrane masks, especially when cutting accurate corners to the mask. This must be taken into account when planning multiple masks (*see fig. 128*).

The completed burn-out masking flat must be clearly labelled with job name to avoid confusing it with other job masks.

The mask is printed down with either the membrane layer or tape in contact with the plate coating.

(3j) NON-REPRODUCING KEYS. PHOTO BLUE
Considerations

This method is almost obsolete now as a planning technique and is used by only a few specialist printers. This type of blue key should not be confused with blue key on film.

Non-reproducing photo blue is a technique of printing down a blue image on to the lithographic plate which can be clearly seen but which will not print.

It may be used in conjunction with a metal key, or a film element may be printed down to produce a blue outline image. The technique is used in poster printing to add spot colour to work which does not provide space for register marks to fall on the printed sheet (*see fig. 129*).

An outline image in blue is printed down to the plate prior to the application of whirler or wipe-on coating.

Photo Blue coating is produced from equal parts of stock solutions:

"A" solution. 60g iron of ammonium citrate in 250 cm^3 water.

"B" solution. 22g potassium ferrocyanide in 250 cm^3 water.

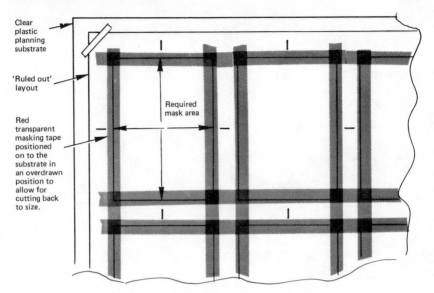

Clear plastic planning substrate

'Ruled out' layout

Red transparent masking tape positioned on to the substrate in an overdrawn position to allow for cutting back to size.

Required mask area

Fig. 127. Preparing a burn-out mask for multiple images.

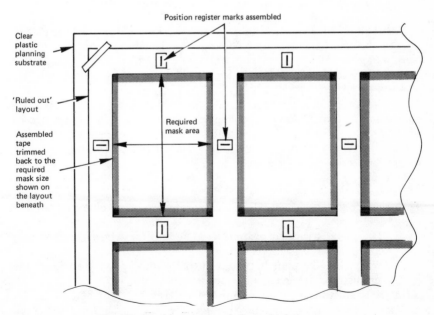

Position register marks assembled

Clear plastic planning substrate

'Ruled out' layout

Assembled tape trimmed back to the required mask size shown on the layout beneath

Required mask area

Fig. 128. Final burn-out mask for multiple images.

The stock solutions must be kept in opaque bottles, stored in a cool place and clearly labelled as poison.

When required for use the solutions are mixed thoroughly and used within a short space of time.

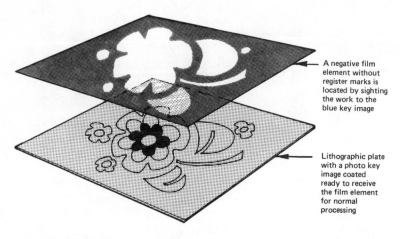

A negative film element without register marks is located by sighting the work to the blue key image

Lithographic plate with a photo key image coated ready to receive the film element for normal processing

Fig. 129. Positioning multicolour images with photo-blue technique.

If the photo blue image produced on the plate is not dark enough to be seen through the subsequent coating, an intensifying solution of dilute ferric chloride (50g in 1000 cm^3 water) applied to the blue image will darken it. Branded Chemicals under the title "Ferro Prussiate Blue", are also marketed.

This process can only be used in conjunction with plates which are coated in the platemaking department. This eliminates a wide range of presensitised plates which are available to the lithographer. A whirler is necessary to apply the photo blue coating and extended exposures required to produce a clear blue image on the plate.

Method

The following steps are used in the production of a blue key on the plate:

 (i) The plate is washed prior to coating and the whirler speed set to 40 r.p.m.

 (ii) When dry, the plate is placed in the printing down frame and the template or film element(s) positioned.

 (iii) A trial exposure must be made to establish a firm blue image on the plate. This is usually double the time given for Deep Etch coating.

(iv) The plate is developed under running water with a piece of cotton wool. The intensifying solution will provide the necessary acidity to aid proper development if the water supply is alkaline.

(v) The plate may be gummed up for later use or appropriately coated for immediate use.

The process is negative working, producing a positive image from a negative template or film element. If a positive is used, a negative key is produced. If the Deep Etch process is used as the platemaking process, it may be desirable to have a positive blue image on the plate. In this case the blue key should be produced with the negatives from which the contact positives were made

(3k) BLUE AND RED KEYS ON FILM

Considerations

Many developments have taken place in this area of the market over the last ten years to provide a wide range of key techniques.

- We will first define the nature of blue and red keys on film.
- Secondly, we will consider how they are used.
- Thirdly, we will classify the methods that are in popular use.

Both negative and positive processes are available. Most are rapid in use and the base materials dimensionally stable.

The blue and red key systems are suited to multi-illustrated pages of process colour work, advertising, publicity magazines, packaging, etc., where tight register standards are required. These standards can be achieved with very little additional equipment. This is where blue and red keys come into their own. The specially treated polyester base materials are of low hygroinstability (*see glossary for definition*), are coated with light sensitive substances which are simply and clearly resolved into transparent blue or red images. The cost of these materials is relatively high compared to the low cost of processing. Perfectly acceptable four-colour process work involving the fitting of up to eight sets have been produced by novice planners without previous experience of these systems.

Common Principles of Production

Detailed methods of production and use of blue and red keys are dealt with later under the heading "Method". We will first consider the common principles of production.

(i) Prepare a laterally reversed layout containing all relevant information.

(ii) Each process colour set is inspected to select the film element offering the greatest detail to act as a key.

(iii) The key film elements are assembled on a sheet of the key material or on to a sheet of clear plastic.

(iv) The key material is exposed and processed.

Using the key as a planning guide. Blue keys may be used as a planning substrate, the film elements being fixed on to the blue key. Actinic light will pass through the blue key image without recording on positive working plates. This makes the blue key substrate quite suitable as a base for the planning flat.

Red keys will not transmit actinic light and are therefore not suitable as planning flats. Their usefulness is in providing a stable image layout for normal planning.

The blue key may be used with negative planning. In the production of the key, negatives are printed down to the key material to produce positive images. Red keys are primarily used in positive assembly, a positive film element producing a positive key image. When planning to a red key, a clear sheet of plastic is placed over the key and the film elements on to it. These are positioned by aligning the film image "dot for dot" to the key image (register marks are not necessary with this method). When positioning the film element (positive) to the red key a red halo occurs around the image when the position is not precise. This is usually visible without magnification, although we recommend the use of a magnifying glass to check the final position before it is secured (*see fig. 130*).

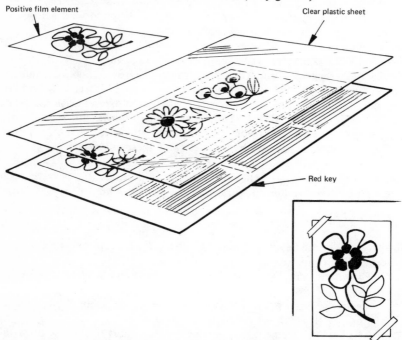

Fig. 130. The red key is placed under a clear plastic sheet upon which the positives are positioned 'Dot-for-dot'.

When assembling negatives, most planners find it easy to sight and position the negative half-tone dots (which are clear holes in the black emulsion) to the light blue dots on the key material (*see fig. 131*).

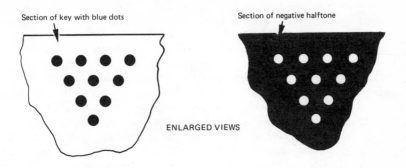

Fig. 131. The negative half-tone dots are registered to the dots of the positive blue key.

With a little experience, the planner will know how to adapt blue and red keys to the type of work he is involved with.

The methods and processes available. Before pre-coated key materials were developed the common key process was whirler coated. This involved the coating of a clear sheet of plastic with "Carto" dye solution (negative process) or the dying of the sheet after coating and developing (positive process). Modern key materials are superior to these whirler processes with the result that they have become virtually obsolete.

We therefore classify the methods under three headings:

(i) *Whirler coated red and blue keys.* The negative key is produced in a similar manner to the Albumen platemaking process. The positive method is produced in a similar manner to the Deep Etch platemaking process. With experience, clear plastic keys can be produced. Lightly grained plastic sheets are easier to coat but more difficult to view through.

(ii) *Pre-sensitised red and blue keys.* Diazo and photopolymer coated sheets of plastic are processed with either special solutions or the standard platemaking chemicals. This is made possible by the same type of coatings being used on both plates and keys—a sound economic factor to consider.

(iii) *Diazo keys developed by ammonia vapour.* Key development is effected by passing the exposed material through an ammonia vapour processor. The dyeline processor (commonly used for producing diazo prints of engineering drawings) may be used for processing these materials.

Methods

We will divide this section into three stages:
1. Selection of key elements and the assembly of the master.
2. Production of the key, exposure and processing.
3. Use of blue and red keys.

Before we consider the methods we must point out that these are general statements; specific manufacturer's instructions should be closely followed.

1. *Selection of Key Elements and Assembly of the Master*

The first stage is to produce a master planning flat from which the key is produced. There are two methods of assembling the master:

(a) The master film elements are directly assembled on the key sheet, with the film emulsion in contact with the coated side of the key sheet. The problems involved in handling the light sensitive material in this manner are considerable. The assembling of film elements on to the key sheet must be carried out over a light table with a filter to prevent fogging of the light sensitive coating.

(b) The less troublesome alternative is to assemble the film elements on a separate sheet of clear plastic. This requires the use of a laterally reversed layout and the elements are positioned emulsion side uppermost. When completed, the assembly is laterally reversed on to the key material, to bring the key coating and film emulsion into contact for printing down.

The next stage is to select those film elements which will be used to produce the master planning flat. With process colour work, the four positives (or negatives) supplied for each full colour illustration are called "a four-colour set". Each set must now be laid out side by side and inspected to see which element in the set offers the best outline image for fitting the other set elements.

The selected key elements are now assembled according to the methods (a) or (b) above, together with all additional information, register, trim and fold marks, etc. After the exposure and production of a satisfactory key, strip off the film elements and place them in their respective sets for subsequent planning.

2. *Production of the Key, Exposure and Processing*

This stage involves the suitable exposure and processing of the key material. A sheet of black paper should be placed behind the key material to absorb extraneous light during exposure.

Negative Process (whirler coated)

The specially prepared dyed coating is placed in a dispenser which permits easy pouring in the whirler. The following steps are now followed:

(i) Clean the sheet plastic (smooth or grained). The sheet must not be greasy if the coating is to flow properly and dry uniformly. If the

surface is brushed with tripoli powder and water (made into a paste) this will degrease the surface and reduce surface tension. A drop of water spread on the whirler turntable before placing the sheet in the clamps will help to keep it flat and secure. Another alternative is to dry the turntable (without heat) and stick the plastic sheet down with water-proof tape.

(ii) Coating the sheet. Apply the coating at the centre of the turntable by pouring steadily from a point as low as possible, until the coating covers the entire sheet. Recommended coating speed is 75 r.p.m. Close the lid of the whirler carefully and do not overheat the sheet while drying the coating. When dry, remove the sheet to a dry surface and dry the back thoroughly. Take care not to allow moisture on to the dry sensitised coating.

(iii) Exposure. Place the sheet of black paper into the printing down frame and locate the coated sheet and master planning flat together. Close the frame carefully and obtain adequate vacuum. Exposure time for this material is usually half that required for a presensitised plate (approximately 2 minutes with a 30 amp lamp).

(iv) Development. This is simply performed by placing the exposed key sheet into a large sink and gently swabbing the surface with a ball of cotton wool under running water. When all the unexposed coating has been removed the key is squeegeed and hung up to dry.

Positive Process (whirler coated)

The following steps should be followed:

(i) The sheet is prepared for coating in the same manner as the negative process.

(ii) Coating the sheet. The normal Deep Etch gum coating is filtered and whirler coated at approximately 100 r.p.m. and dried.

(iii) Exposure. The same procedure is followed as for the negative working process. Exposure time will be the same as for Deep Etch plates.

(iv) Processing. The Deep Etch developer is applied to the exposed key sheet thus effectively removing all unexposed coating. This will take about $1\frac{1}{2}$ minutes. An optional stage at this point is the application of Deep Etch solution to etch the plastic slightly for 30 seconds. The surplus chemicals are squeegeed off and the "Carto" dye rubbed in. Removal of the gum coating is effected by submerging the key sheet in a sink of warm water. When clear, the key is squeegeed and hung up to dry.

The Pre-coated Processes

As with presensitised plates there is no great difficulty in mastering the production technique of blue and red presensitised keys. They are rapidly

processed, more consistently reliable and easier to produce than the two methods described above.

Key production is in two steps:

(i) Exposure. The technique is exactly the same as described for whirler coated keys.

(ii) Development. This stage takes only a matter of seconds to complete. The presensitised keys are based on either diazo or photopolymer materials. The proprietary solutions may be purchased with the key sheets and are simple to use. This is usually the application of solution to the key sheet with cotton wool swab until the image is clear. When development is complete the key is washed with water and dried.

Ammonia vapour development is effected with diazo keys which have a dye coupler which changes the light green coating to the key image colour. Unfortunately, ammonia vapour processing produces an unpleasant odour. The dyeline processing machine (with outside exhaust system) is the only suitable method of processing such key material. We do not recommend the development of keys in an open tray in a restricted area.

The process has the advantage of producing a dry key for immediate use.

3. *Use of Blue and Red Keys*

We shall now briefly recapitulate the method and sequence of production before describing how blue and red keys are used.

(i) A suitable laterally reversed layout was prepared.

(ii) The master film element from each colour set was selected and assembled on clear plastic sheet according to the information on the layout beneath.

(iii) The presensitised key sheet was exposed to the master planning flat. The film elements were then returned to their sets.

(iv) The key material was processed.

The following outline procedure is an example of how the key sheet is used in planning process colour work.

(a) The key is secured to the light table top and a clear sheet of plastic located with it by butting the grip edges and centralising. A punch register system may be used to locate the sheets to the key and to the plates which will be used. Tape the sheet securely to the key. The whole efficiency of this system may be lost if the key and planning sheet are not held together as one.

(b) The colour sets are divided into their respective colour groups, cyan, magenta, yellow and black. Empty film boxes and their lids serve as useful containers for the film elements during this stage. It is usual to assemble the first planning flat which will produce the first plate

required by the printer. We will assume that the press sequence will be cyan, yellow, magenta and black. There may be the need of a burn-out mask. This is usually made up after the four planning flats are complete. It will then be a simple task to check each flat with the burn-out mask to see that no error of masking occurs.

(c) The cyan film elements are now positioned and secured to the plastic planning sheet by sighting through to the key. A suitable film weight and magnifying glass will assist in the accuracy of this operation.

The assembly is now removed from the key and the next planning flat prepared using the yellow printer elements. The procedure is repeated until all four planning flats are complete.

(3l) ADHESIVE AND TRANSFER SYSTEMS OF ASSEMBLY

Considerations

These techniques cover the assembly of film elements without the use of adhesive tape. They fall into two classifications:

(a) Pre-coated adhesive assembly materials.

(b) Adhesive solutions and aerosol adhesive sprays.

There are many instances where tape is not suitable for planning. For example, in cases where a line correction is necessary, where film edges butt, or in situations where there is no space for tape to secure the film element to the assembly sheet.

Advantages of Using Adhesives for Planning

These adhesive techniques have the advantage of reducing the formation of tape "edges" on positive working plates. With this in mind an additional advantage may be gained in the use of grained plastic sheet for the planning flat. Diffusing the exposure light slightly (and an increase exposure to compensate) may prevent "film edges" from reproducing. It may be argued that the efficiency of the diffusion sheet will also affect the re-production of a sharp highlight dot. If this is so, the elimination of film edges will be better tackled by placing a diffusion sheet just under the printing down frame glass.

Disadvantages of Using Adhesives for Planning

Constant problems are experienced in unclean working conditions where dust in the air will readily settle on the adhesive surface. Some adhesives tend to discolour slightly after a period of time, but this does not usually cause problems. The bond made between film and substrate is usually very firm with the result that dismantling of the flat is not easy.

Method

(a) The pre-coated adhesive substrate is laid over the layout tacky side uppermost. The coating of adhesive is protected by a cover sheet which is

removed prior to use. The film element (emulsion side uppermost) is positioned and pressed into firm contact with the adhesive surface. A thin film membrane is now laid over the finished flat to seal it and thereby form a sandwich. The assembly is made with the film elements in laterally reversed positions, the flat subsequently turned over to bring the thin protecting membrane (0.006 mm, 0.00025″) into contact with the plate coating prior to exposure.

(b) The alternative is to use a transparent adhesive which is brushed or sprayed on to the film elements prior to assembly on a clear plastic sheet. As the adhesive is only applied to the film elements, a protective membrane is not required. A wide selection of adhesives for this purpose are available. The Monotype Corporation market a system which is mainly designed for book page make up and corrections. This may be adapted by the planner for a variety of applications. The recommended use is described in the Monotype Booklet T 117.

Another technique is based on the use of a plasticised PVC sheet which has a tacky nature. This readily forms a pressure bond with photographic film elements. Delicate page make-up and difficult corrections are simplified with small pieces of the PVC sheet. Film elements are assembled on PVC sheet as a temporary substrate. In this case the sheet is referred to as a "transfer sheet" and the assembled film elements are transferred to a proper printing down substrate, which may be:

(i) TF52 pre-adhesive coated "Transpasheen" on a melinex base; or
(ii) Monotype "Make-up Base"; or
(iii) Adhesive applied by brush or aerosol to an uncoated plastic sheet.

(3m) PUNCH REGISTER SYSTEMS

Considerations

It will now be clear to the reader that the more precise the technique of planning used, the greater accuracy realised in the final product. In the next two classifications to be considered (m and n) planning techniques are taken to near perfection. We shall consider these techniques separately, but in many cases they are used together. In both systems there is a wide choice of equipment and materials available from which a system may be selected to suit a special category of work.

System costs can be reasonably low rising to many thousands of pounds. For the extra financial outlay a higher degree of accuracy, speed and technical capability is offered.

The basic principle of punch register is relatively simple. The engineer's concept of precision design, tooling and measurement has been utilised to give the planner a highly sophisticated register system. Precision punches or drills are used to produce regular and irregular shaped holes in planning layouts, keys, film elements, planning flats and plates.

The punched or drilled materials are related to each other by aligning the holes produced upon pins or pegs. The nature of the fit between holes and pins is of such a high standard that perfect registration is obtained between the materials.

Punch register systems are suitable for the following:

(i) Simple close register work.

(ii) Complex assembly of process colour work. Jobs which involve many different illustrations such as the imposition of full colour mail order catalogues.

(iii) Assemblies in which accurate double exposures are required to produce special effects such as burning out reverse lettering.

(iv) Location of masks (or mating masks) as a technique of producing perfectly butting images.

It is impractical to attempt an analysis of all the systems which might be included under this heading. We will look at a selection from the range available. Some systems are modular in construction which means that they can be added to or duplicated if necessary. Manufacturers usually suggest how their systems can be used and in general these cannot be bettered. Occasionally individual jobs or particular classes of work may be handled better by adapting these techniques. Some punch register systems link the planning flat to the plate only; other complete systems link every stage of production. Equipment from the camera to the press plate clamps may be related with common location pins at each stage. Such a system may be adapted to existing equipment and machinery, and in many cases this is done by simple modification.

Predominant manufacturers of punch register systems that have proved efficient and popular are given in alphabetical order:

Bacher (Heidelberg U.K.).

Billows Graphic Equipment Ltd.

Carlson Register System.

Protocol Engineering Ltd.

Most of these companies have a programme to develop and improve their systems. Potential purchasers of a punch register system must take into account cost, ease of operation, accuracy, speed, versatility and suitability of the system to their production needs.

The three systems we have selected to discuss are:

(A) Protocol.

(B) Billows.

(C) Bacher.

The first two systems are "total" systems used for the printing down of tightly fitting work. They can be adapted for step and repeat work. Protocol is the older, well established system. Billows is a more recently formed company. Thirdly, we consider the less comprehensive Bacher system.

Fig. 132a. Protocol darkroom punch.

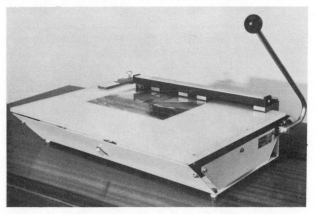

132b. Protocol illuminated film punch.

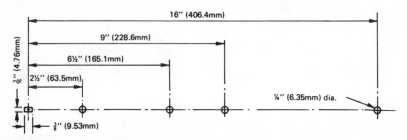

PROTOCOL PUNCHING DIAGRAM – 2 PIN SYSTEM

Fig. 132c. The Protocol punch system.

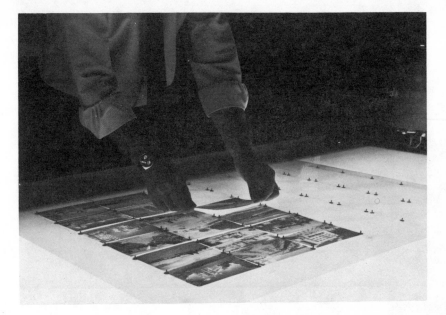

Fig. 132d. Post card assembly using Protocol Registrator.

(A) Protocol

The Protocol system incorporates a film punch (illuminated or darkroom model) with a variety of standard punch positions for two locating holes. The centres of these holes may be selected to suit film element size: 63.5 mm ($2\frac{1}{2}''$), 165.1 mm ($6\frac{1}{2}''$), 228.6 mm ($9''$), and 406.4 mm ($16''$) (*see fig. 132 a,b,c and d*). The illuminated punch enables a set of process colour positives to be registered and punched together. Ideally the film elements are pre-punched prior to camera exposure. This eliminates the risk of error in fitting the set together by eye. Suitable pins are fitted in the camera back or enlarger base to register the sheet film and similar pins are used for film contacting in the contact frame. Each four-colour set produced can be registered on two pins.

The layout is now punched. The master punch produces an 8 mm ($\frac{5}{16}''$) slot and another 8 mm diameter hole at a selected distance from it on the grip edge of the layout sheet (*see fig. 133*).

The layout is located on the "register machine" master pins and ruled up using the pen attachment (*see fig. 134*). The four plastic sheets for planning are now punched in the same manner as the lay out sheet (*see fig. 133*). These are located on the register machine with the layout on top. A set of fitting film elements is laid into the correct layout position,

116

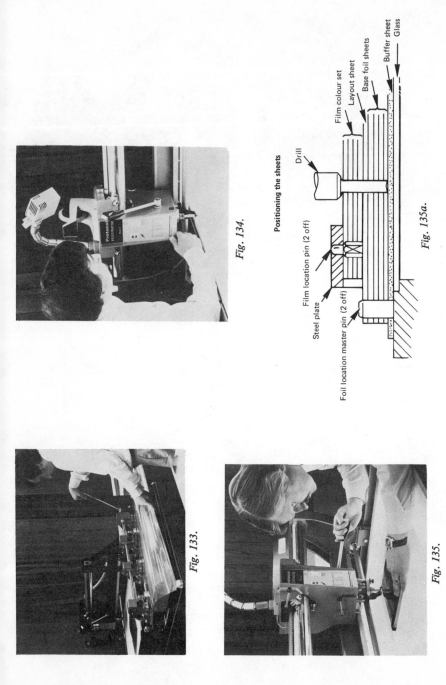

Fig. 133.

Fig. 134.

Fig. 135.

Positioning the sheets

Drill

Film colour set

Layout sheet

Base foil sheets

Buffer sheet

Glass

Film location pin (2 off)

Steel plate

Foil location master pin (2 off)

Fig. 135a.

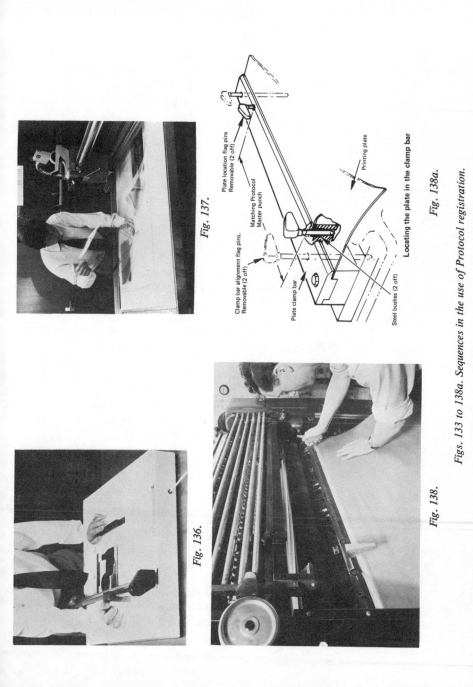

Fig. 137.

Fig. 136.

Plate location flag pins
Removable (2 off)

Matching Protocol
Master punch

Clamp bar alignment flag pins.
Removable (2 off)

Plate clamp bar

Steel bushes (2 off)

Printing plate

Locating the plate in the clamp bar

Fig. 138a.

Fig. 138.

Figs. 133 to 138a. Sequences in the use of Protocol registration.

secured, and one hole drilled in a gutter or double cut area and a pin inserted. The second hole is then drilled (*see figs. 135 and 135A*). Note that all film elements in the set and all four planning sheets are drilled together.

The surplus film areas are then trimmed from the set while held together (*see fig. 136*). This procedure is followed with all the colour sets on the layout and afterwards they are split up, placing all of the cyan elements together, all the yellow, the magenta and black.

The layout is removed and pins are inserted through the holes in the four planning sheets. The first colour film elements (e.g. cyan) are located on to the pins and taped to the planning sheet. When all film elements are assembled, the planning flat is removed, (*see fig. 137*) and the procedure repeated on the next sheet with the second colour and so on until all four flats are complete.

The master punch is used to punch correlating holes in the grip edge of the press plates in the identical manner as the layout and planning flats (*see fig. 133*). The planning flat and plate are now located together on pins in the printing down frame to produce all four plates identically.

A plate bender is required to form bends on grip and back edges of web offset plates. The Protocol plate bender locates plates for bending on pins which relate to the master punched holes on the plate.

Sheet-fed presses may include a Protocol plate location device as standard. Protocol engineers can adapt existing presses (*see fig. 138*). This ensures rapid plate positioning on the cylinder (*see fig. 138A*).

Critics of the Protocol (and similar systems) claim that perfectly round holes are not produced when using a drill, especially if a large number of sheets are being drilled at one time. Protocol claim that there are great advantages from the technique of drilling all the planning flats simultaneously and elements relate more precisely than they might if drilled at different times in varying temperatures or atmospheric conditions. German, Japanese and Danish companies also market register systems which are based on the drilling technique.

(B) Billows

Like Protocol the Billows system is comprehensive. In addition to the Montage machine, Billows produce punches for film, planning flats and plates. Pin register is also available for cameras, scanners and printing presses.

The Billow's philosophy is that "punching is more accurate than drilling".

The Protocol register table requires a motorised drill and a pump to vacuum away drilling waste. The Billows punching technique collects the

waste in a tray and requires only manual power to punch holes. The Billows Montage table is therefore less expensive to produce (*see fig. 139*).

It is claimed that punching gives more consistent accuracy than drilling. The case against drilling is made on the following points:

(i) Drilling of film involves rotational eccentric failures due to the manufacturing difficulties of producing a precision drill spindle and cutting edge to the drill.

(ii) Due to the rubbing action of the drill when drilling several layers the drill produces slightly larger holes in the top than in the bottom, elements.

The other functions of the system are similar in principle to those discussed in the Protocol system.

(C) Bacher

This punch register system is less comprehensive than those previously described. At present the system applies only to:

(i) The layout and planning flat.

(ii) The planning flat and plate.

(iii) The plate and press clamps.

It therefore excludes the individual register of film elements to the planning flat. These are assembled in the conventional hand method to layout or key. Within these areas its usefulness is both simple and efficient. Not only are quality and wastage factors improved, but press make-ready time can be appreciably reduced.

Method

The laterally reversed layout is ruled up on the Bacher table after having been punched and mounted on the special mounting bar. This locates the two attachments which fit on to the front rail of the table.

The clear plastic planning sheet is similarly punched and located over the layout on the ruling up table. Film elements are fixed to the sheet in the usual manner, emulsion side uppermost. The finished flat is laterally reversed into contact with the plate coating prior to exposure.

Bacher punches are supplied to suit a range of plate sizes. Horizontal punches are used for smaller plates, and near-vertical punches for the larger plates. A self-centering device is fitted on the large vertical punch.

The punch system incorporates a centre hole with a slotted hole either side at a fixed pitch. Slots for locating the plate in the press clamp are also punched simultaneously.

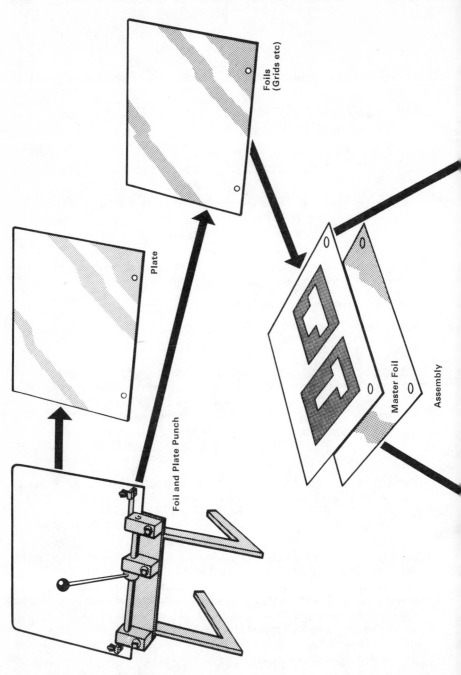

Foils
(Grids etc)

Plate

Foil and Plate Punch

Master Foil

Assembly

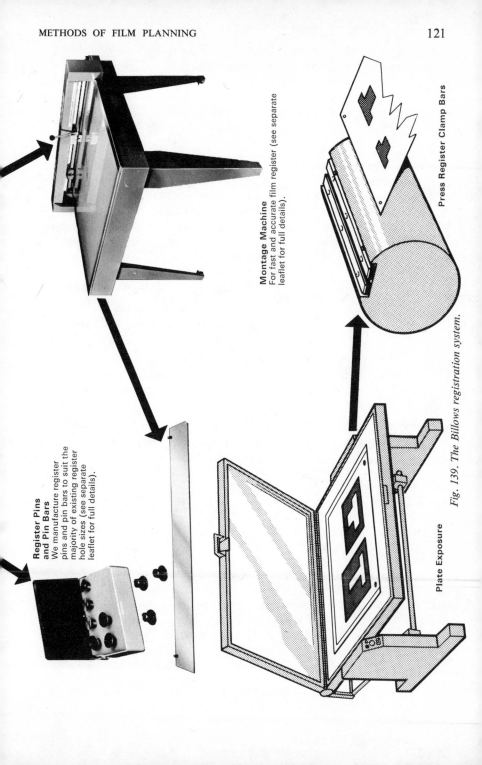

**Register Pins
and Pin Bars**
We manufacture register
pins and pin bars to suit the
majority of existing register
hole sizes (see separate
leaflet for full details).

Montage Machine
For fast and accurate film register (see separate
leaflet for full details).

Press Register Clamp Bars

Plate Exposure

Fig. 139. The Billows registration system.

A feature included on the large vertical punch incorporates a micro-switch warning light to indicate a mis-registered plate before it is punched. The clamp is lowered on the initial travel of the operating arm to hold the planning flat or plate firmly. The punches are operated by staggered cam followers with the result that holes are punched slightly, one after another, thus minimising the risk of distortion. With this system only one sheet can be punched at a time.

When printing down, the planning flat is registered to the plate by a low-pin register bar.

Plate register to the press plate cylinder is a relatively simple operation. Press clamps are not modified with the Bacher system; they are replaced completely with new clamps which have built-in micrometer adjusters. Most popular presses can be fitted with this system, which is installed by a Bacher engineer. Plate fitting is simple. The grip edge clamp locating slots fit to the pins in the press clamp. As the slots in the plate are open ended, this is performed without problem prior to locking the plate clamp. The following sequence is followed:

(i) The leading edge clamp micro-adjuster is set 1 mm below its required position. The front and back edges of the plate are clamped.

(ii) The back edge lamp is tensioned to pull the plate into snug contact with the cylinder. The leading edge clamp is now tensioned to move the adjuster to the zero position.

This system ensures rapid fitting of colour plates on the press with high precision, thus reducing make-ready time (*see figs. 140 to 145*).

(3n) STEP AND REPEAT SYSTEMS

The first thing to appreciate with a step and repeat system is that it may be used for the production of multiple images on film in addition to stepping multiple images on lithographic plates.

The type of work which is commercially suited to step and repeat is commonly associated with individual small elements which are required to be printed down in large quantities on the plate. For example, postage stamps, paper currency, labels, bottle tops and postcards.

In many cases the number of images to be printed down may run into the hundreds. Here the individual image will be quite small and is therefore photographically stepped to produce a "gang" film element. This is multi-image (e.g. nine or 12 postage stamps), but still quite small. Problems which might be associated with large sheets of film due to dimensional instability are thus avoided.

The "gang" film element is stepped on to the plate using a reduced

number of steps (proportional to the number of images which appear on the film). The number of images which appear on the film element is determined by the following factors:

- The dimensional stability of the film base.
- The method employed for step and repeat to the plate.
- The degree of accuracy that is required for the job.
- The relative time and cost factors involved in production.

Obviously the accuracy of register will increase inversely with the number of images stepped on to the gang element.

With the developments of techniques and machines for printing down by step and repeat, plates requiring a high degree of accuracy can be produced with relative ease. Limitations may occur, however, when the plate is put on the press. The plate size, number of images up, the type of press, the experience of the pressman, the working conditions and the paper to be printed are all factors which may affect the register of images from perfectly made plates.

Methods

These are classified into the following categories:

(i) Hand methods, using template, metal key, burn-out mask, etc.

(ii) Hand methods, using pins and tabs, dowells and fitters, etc.

(iii) Punch register.

(iv) Hand operated step and repeat machines.

(v) Automatic step and repeat machines.

(i) *Hand Methods, using Template, Metal Key, Burn-out Masks*

These methods have been described earlier as printing down techniques. The type of work suitable for hand methods is obviously limited in size, number of steps and degree of accuracy possible.

The principle involved is simple; register positions are reproduced on the plate and the film element positioned, exposed and stepped by hand to each register position. The technique is limited by the skill of the planner.

(ii) *Hand Methods, using Pins and Tabs*

In this method, mating male and female shapes are used; one mounted on to the film element and the other on to a carrier sheet in accurately predetermined positions. The film element is moved from one position to another on the male shapes and exposed in each step position.

The American manufacturer, "*Accurate Step and Repeat Systems Inc.*", market a "dowel and fitter" system. This has wide applications in the

124

Fig. 140.

With the CONTROL 2000 Register Punch, work sheets for register and position, as well as millimetre foils and all mounting foils, are punched with a round and a slot hole. These die-cut holes form the basis, during all preparatory processes, for exact location of the image, up to the mounting of the plate on the printing press.

Fig. 141.

On the light table, the punched sheets are placed on a mounting bar, and thus located correctly. This mounting bar is fixed, on the BACHER Mounting-Light-and-Ruling Tables, by means of two special register lays. On light tables without a line-up bar, the mounting bar can be taped directly on to the glass plate.

Fig. 142.

Prior to exposure, the printing plates for the single colours are punched on the CONTROL 2000 Register Punch with a round and a slot hole, to locate the mounting foil on the unexposed printing plate when printing down; the plates are also punched with two U-form holes to take the register pins of the plate clamping bar of the printing press.

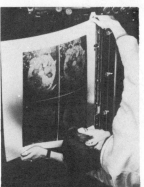

Fig. 145.

The front plate clamp bars of the individual presses are fitted with two register pins to fix the printing plates in the U-form punch holes. Gauges placed on the clamping screws of the plate clamp bar serve to obtain zero setting. When making corrections as needed, off-zero settings are made in exactly measurable fractions of a millimetre; zero setting can be re-obtained at anytime.

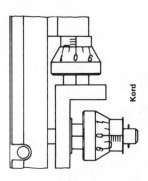

Roland Ultra

Kord

Fig. 144. Sections of press plate clamps with Bacher micrometer adjusters.

Figs. 140-145. Sequences in the Bacher registration system.

Fig. 143.

On the printing-down frame, the printing plate and the mounting foil of the corresponding colour are placed on a register bar with correspondingly low pins, and thus registered, the one on the other. This procedure guarantees the same distance from image to plate edge on all plates. Such a reliable line-up prevents spoiled plates when printing down.
When working with a step-and-repeat machine, the plate positioning device of the s & r machine is fitted with two register pins.

graphic arts industry. The manual produced by the manufacturers lists the following potential uses:

Art overlays.

Double printing down techniques.

Burn-out masks.

Screen angle locator.

Die cutting templates.

Again the system will be limited by the skill of the planner. The method can be adapted to use positive film, but it is mainly designed for negative planning. It is simple and effective, the "dowels and fitters" can be adapted in a variety of ways to suit a particular job (*see fig. 146*).

The "dowels and fitters" are plastic buttons and matching tabs. The fitters are attached to the planning flat of goldenrod (or similar) and the dowels mounted on the film element for location in registered positions.

The dowels are made of vinyl and colour coded for easy identification of the range of sizes which are from 0.254 mm (0.010″) to 1.524 mm (0.060″).

To allow for the possible incomptibility of dimensionally unstable planning sheets and film elements, one round dowel and fitter is used as a control. This is placed along the grip edge or in a position of tight

Standard Fitters
Made of dimensionally-stable ·010″ thick plastic with five punched holes per strip. Strippers cut them apart as required while working. Full strip measures about 1½″ x 6″ (Half-inch system only).

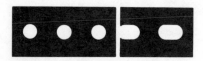

Centreline fitters
Individual 1⅛″ x 1½″ rectangular fitters made of dimensionally-stable plastic, ·010″ thick. Improved reference notches make this an excellent fitter. (Half-inch system only).

Snap fitters
Individual pieces, 1¼″ square, made of dimensionally-stable black plastic, approximately ·010″ thick. Position diamond-fashion over cross-lines and tape in place. (Half inch system only).

Standard dowels
Made in three diameters, ¼″, ⅜″ and ½″; and as many as four thicknesses; dimensionally-stable plastic. Pressure-sensitive adhesive backing anchors the disc or 'button' to almost any clean, flat surface such as film, paper, plate, glass, etc. The small area of the dowel permits attachment on almost any spot on the plate. Follow instructions carefully to achieve maximum reliability in the use of dowels.

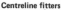

Fig. 146. Fitters and dowels.

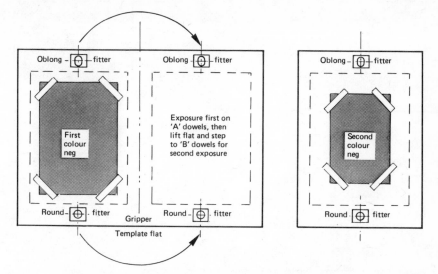

Fig. 147. Examples of 'Step and repeat' using dowels and fitters.

register, together with one or two slotted sets. Possible movement between sheet and element may therefore take place without buckle, distortion, or loss of register.

The two examples shown in *figs. 147 and 148* illustrate how this system may be used for step and repeat planning.

Step'n register. Marketed by Openshaw, the step and repeat kit contains:

Precision moulded pins and matching tabs, and

A bottle of "Table-cote" solution, together with

An instruction book suggesting ways of using Step'n Register.

Simple techniques using pins and tabs in conjunction with a suitable substrate are outlined to give the planner a wide range of step and repeat applications.

(iii) *Punch Register*

Many punch register systems of film assembly may be used for step and repeat work. Most of these principles have already been covered under this heading (*see fig. 149*).

A sheet of film (negative or positive) is punched or drilled with two holes and located to a stable substrate which has similar holes. The holes are made in a regular pattern, each pair of holes relating to the film element. The element is moved from one step to another when printing down by locating on pins fitted through the substrate sheet. The substrate sheet is also registered to the plate by the normal grip edge punch register system.

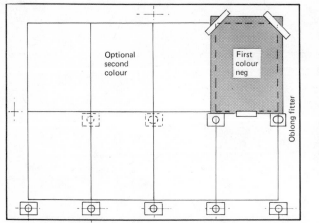
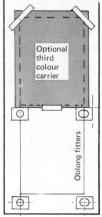

Template layout flat. On this layout all fitters are round except one at each neg position. Insert dowels in gripper edge fitters only.

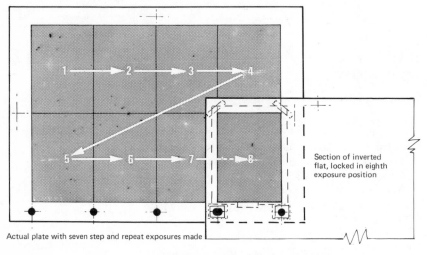

Actual plate with seven step and repeat exposures made

Fig. 148. 'Step and repeat' . . . eight up, one neg.

Before each exposure, suitable masking must be placed over the rest of the plate.

Before multi-colour work is printed down, the colour set is either pre-punched (prior to camera production), or registered together and punched. A single assembly sheet is then used to print down all the exposures on each plate. An alternative is to punch four assembly sheets simultaneously. If four plates are therefore required at the same time (for

Fig. 149. The Kodak register punch.

use on a four-colour press), it will be possible for four different planners to produce the plates without risk of mis-register.

(iv) *Hand Operated Step and Repeat Machines*

Finely engineered step and repeat machines with an accuracy working tolerance of ±0.025 mm (0.001″) are produced by many manufacturers. These machines are precision tools and heavily constructed for stability. Most step and repeat machines are based on the following configuration (*see fig. 150*):

(*a*) A plate (or film) bed called a "platen". This may be vertical or horizontal and contain a vacuum back.

(*b*) A detachable film holder which is removed from the machine to allow the film element to be positioned accurately.

(*c*) A light source. As the exposure area is relatively small, the lamp distance from the plate is short and the lamp must be shrouded. Cooling fans are featured in most designs.

(*d*) The film holder traverses the exposure area of the plate in both vertical and horizontal planes, on extremely accurate drive mechanisms.

Problems associated with step and repeat machines have mainly concerned wear in the drive mechanisms. Although the finest drives are vulnerable to backlash error, this problem has been largely eliminated from modern machines.

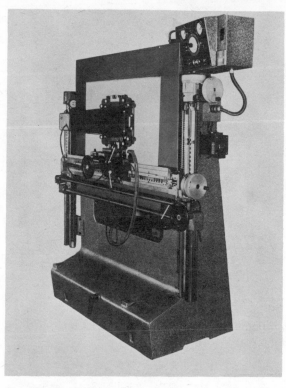

Fig. 150. The 'Lithoprintex' Junior step and repeat machine.

All sophisticated machines rely upon accurate handling for good results. The data, the calculations in preparing the layout, the movements on hand operated machines must be made with care to obtain the best results.

Most manufacturers produce more than one model of a step and repeat machine. These types are classified in the following manner:

(i) Small, manual step and repeat frames which handle small plates to A2 size.

(ii) Medium to large manually operated step and repeat machines. These are made in two basic styles, vertical and horizontal. The space-saving vertical model holds the plate in position on a vacuum back platen.

(iii) Fully automatic machines. These are operated by punched card or tape. Their versatility is often extensive. The machines may be used semi-automatically.

Method of Operating the Step and Repeat Machine

We shall here give a brief outline of the use of the step and repeat machine:

 (i) Collect planning information and prepare a statistical layout. For programmed machines, prepare tape or punched card (*see fig. 151*).

 (ii) Mount the plate into position on the plate bed of the machine.

(iii) Precisely register the film element in the film holder and mask it.

 (iv) Fit the film holder into the machine, lock in position, and connect vacuum lines (*see fig. 154*).

 (v) Manual. Establish the correct position for the first exposure, move the film holder into contact with the plate, expose. Break contact, move film holder to the next position and repeat until all exposures are made.

 (vi) Automatic. Feed the punched tape or card into the machine and start the programme. All steps will be made automatically.

(vii) Remove the plate and process in the normal manner.

Fig. 151. 'Autoprintex' tape control console.

Planning the Layout

The layout prepared for the step and repeat machine does not have to be a full scale technical drawing. The planner will prepare a set of figures

that relate to points on two right-angled scales on the machine. A sketch might help the novice operator, but this will soon prove unnecessary with experience.

The zero position on the machine scale usually relates to the leading edge of the plate. The datum point across the width of the plate may be either, a point which coincides with the plate centre, or a point at the extreme point of traverse (left or right).

An example of a conventional step and repeat layout is shown in *fig. 152*. The important information that must be known prior to making calculation are those which have been discussed under the heading, "The Layout and What the Planner Should Know".

To produce a set of layout figures it is necessary to know:

The width of half the image, plus any space (e.g. double cut allowance), plus half the width of the image. This will give the distance between each step.

The principle is repeated in both directions by adding the calculation to the last step figure (*see fig. 152*).

The printing press manual should be consulted to obtain the correct clamp and gripper allowances for the layout.

Although some machines have film holders which carry register pins to locate the film element, this is not the common method. Film positioning is a hand method and is usually carried out on a registration frame or table. This is illuminated, and houses in close register the film holder (relating precisely to its position in the step and repeat machine). Fine lines are engraved on the translucent glass of the register frame to act as central datum lines to which the register marks on the film elements are aligned (*see fig. 153*).

The film must be masked with extreme care, irrespective of whether a negative or positive element is being used. Masking will be effective only if it is accurate and does not interfere with vacuum contact. The film emulsion must make good contact with the plate coating during exposure. Both sides of the glass in the film holder may be masked. A common masking technique uses thin aluminium foil which adheres to the glass with a thin layer of petroleum jelly.

Planning for Irregular Shaped Images

Standard techniques have been developed to handle irregular shaped images such as interlocking cartons, oval, round and triangular shapes which are punched out of the printed sheets.

In some cases the application of mathematics simplifies the layout calculations (for example, the placing of staggered rows of circular labels) (*see fig. 155*).

When calculating the position of interlocking labels it is helpful to lay carton blanks on to the job size paper and draw around them. This will enable the planner to make the most economical use of the sheet.

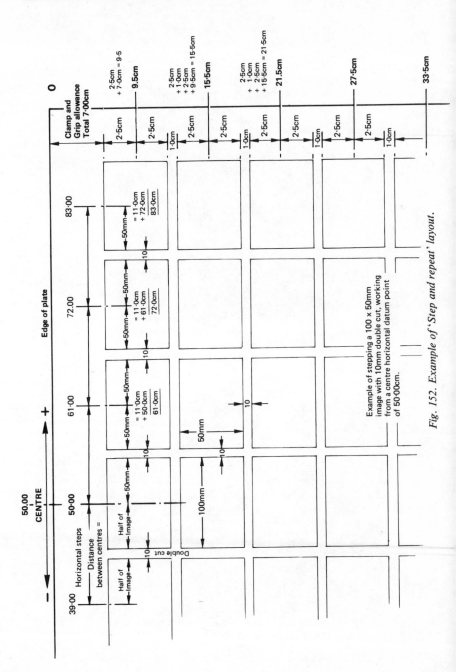

Fig. 152. Example of 'Step and repeat' layout.

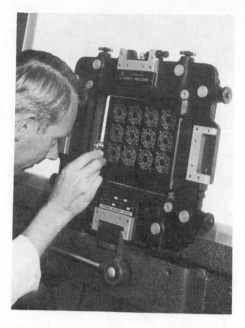

Fig. 153. Register of film element on film holder.

Fig. 154. Registration of the (Lithoprintex) junior machine.

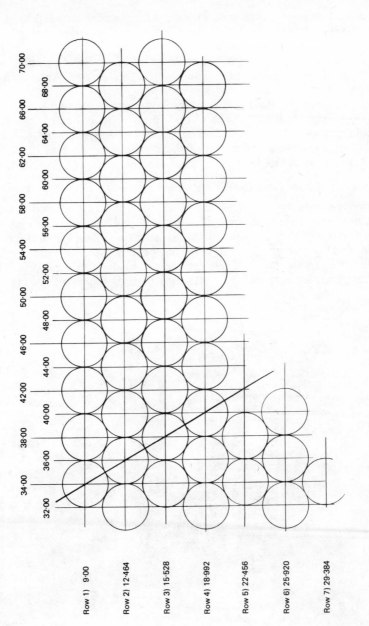

Fig. 155. Sample layout showing how staggered rows are planned for 'Step and repeat'.

Row 1) 9·00

Row 2) 12·464

Row 3) 15·528

Row 4) 18·992

Row 5) 22·456

Row 6) 25·920

Row 7) 29·384

136

Another technique employed with some interlocking shapes is to expose the first and third rows and then turning the film holder through 180° for the second and fourth rows.

Planning staggered circles. To make economical use of printing paper or board, circular shapes are planned in staggered rows. An example of stepping 40 mm diameter circles is shown in *fig. 155*.

The diameter of the circle is multiplied by the sine of the angle 60° (0.866) to plot the centre of the second vertical row of circles. This figure is compounded to plot each vertical row. The horizontal positions are calculated by making the centre of the even numbered rows (2, 4, 6, 8) the edge of the circles in the odd numbered rows (1, 3, 5, 7, 9).

(v) *Automatic Step and Repeat Machines*

These machines are based on the same principles as the hand operated machines. Since they require little hand setting, their output is high. The machine moves to its predetermined step position, vacuum contact between film holder and plate is made, the exposure completed and the holder moved to the next position automatically (*see fig. 156*). These movements are controlled by a punched card or tape which is prepared

Fig. 156. 'Autoprintex', Step and repeat machine, type 59.

by the planner who punches the tape according to his layout positions. Each hole punched represents a vertical or horizontal position for the film holder.

Once started, this type of step and repeat machine will go through its programme without attention. With a high number of steps, this leaves the planner time to work on other assignments without referring to the plate being stepped until it is finished.

Obviously the high cost of these machines is a factor which must be taken into account when considering them for their high productivity.

Sample Step and Repeat Machines

Small Machines to A2 Size:

Unigraph 20-24. (Island Equipment Co.).
Huber Fast Stepper. (J. J. Huber Ltd.).
Micro-step. (Howson-Algraphy Ltd.) (*see fig. 160*).
Rapid Repeater. (Repro-precision Equipment).

Medium Size Machines:

Lithoprintex Junior and Senior. (Pictorial Machinery).
Repetex. (U.K. Agent: Graphic Arts Equipment).
Dainippon. (International Screen Sales Printing Ltd.).

Automatic Machines:

Multinex Master. (Crosfield Electronics).
Krause Biagosch. (Pershke Price Service Ltd.).
Autoprintex. (Pictorial Machinery Ltd.).
Kobastep-Consolidated International. (U.K. Agent: H. Kauders).

Section IV

PLATEMAKING CONSIDERATIONS

(a) *Environment and Special Working Conditions.*
(b) *Platemaking Materials.*
(c) *Plate Surface Chemistry.*
(d) *Classification of Lithographic Plates.*
(e) *Platemaking Equipment.*

<div align="center">SECTION FOUR</div>

PLATEMAKING CONSIDERATIONS

(4a) ENVIRONMENT AND SPECIAL WORKING CONDITIONS

THE platemaking department requires careful planning, not only to facilitate the production of quality plates, but also to provide a comfortable working environment for personnel.

Properly designed platemaking rooms are rare and in many cases expensive equipment and materials are placed in unplanned situations which reduce their efficiency. Our examination of room layout for platemaking will consider the following factors:

- *Efficient work flow.* This will take into account the working movements of the platemaker to ensure efficiency of production.
- *Good working conditions.* Pleasant and comfortable working conditions enable personnel to work efficiently during a normal working day without fatigue.
- *Cleanliness.* This is an essential factor in the production of good lithographic plates. It implies that the working environment and the working attitude of the platemaker are clean and well organised.

The main constituents of a good platemaking department which we will consider are:

 (i) Room layout.
 (ii) Lighting.
 (iii) Ventilation.
 (iv) Air conditioning.
 (v) Flooring.
 (vi) Use of colour.
(vii) Waste disposal.

(i) Room Layout

The modern science of ergonomics (man in relation to his work) is applied to the layout of the platemaking room. Our first priority is to ensure good work flow within the department.

The example layout (*see fig. 157*), shows how the placing of benches, sinks, frames, etc., takes into account the working movements of the platemaker. This will vary of course with the particular processes used by the department.

The room is theoretically divided into a "wet area" and a "dry area" which are not directly adjacent to each other. Dry areas include benches for dry work, light tables, printing down frames and areas in which planning flats, film and unused plates are handled. Wet areas include benches for wet work, processing sinks and tables, whirlers and gumming benches.

142

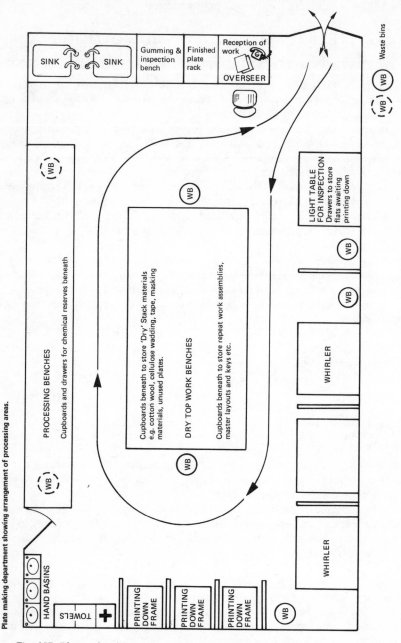

Fig. 157. *Platemaking department showing arrangement of processing areas.*

The layout of course should be practical and not involve excessive work in the provision of main services, water supply and drainage, electricity and air conditioning.

When preparing an initial layout it is common to prepare a scale plan of the room, indicating the position of doors and windows. On to this plan are placed the items of equipment which have been scaled down to pieces of cut card. These items are then moved about on the room plan until a suitable layout is obtained. Most manufacturers supply information for their equipment which includes the area of floor space required. With this information a room may be planned before equipment is purchased.

Sinks are placed in the wet areas of the room, preferably in line to simplify the provision of hot and cold water supply and common drainage. The size of the sinks should accommodate the largest litho plate with ease. Special drainage facilities are necessary for the corrosive liquid wastes, simple domestic plumbing is not suitable.

Adequate space must be provided around the work areas. Some items of equipment may be used from many sides if positioned sensibly. When placed centrally, benches, sinks and four-way printing down frames may be used in this way.

Included in the design are hand basins, washing facilities, towels, etc. It is important for a first aid cabinet to be installed in the room with suitable medication to cope with accidents related to the platemaking department.

(ii) Lighting

Lithographic plate coatings are sensitive to light at the blue end of the spectrum. Artificial light for room illumination must be sufficiently bright to provide comfortable vision without affecting plate coatings. Daylighting (through windows or skylights) is not suitable unless filtered to remove its U.V. and blue content. Light sensitive coatings will fog rapidly on exposure to white fluorescent light, sun light, or even indirect daylight. Blinds can be fitted or windows painted over. Special amber plastic sheeting can be used for this purpose or the window glass replaced with amber glass.

General room lighting should be orange/yellow with spectral emission outside the range of plate sensitivity. Plate manufacturers will supply data on spectral sensitivity of their plate coatings and lamp manufacturers will gladly supply the emission range of their amber fluorescent tubes. To check the safety of room illumination a coated plate is placed on a working bench and left to expose for a series of exposures, e.g. $\frac{1}{4}$, $\frac{1}{2}$, $\frac{3}{4}$ and 1 hour. When developed, the plate will clearly indicate how long it can be exposed to room illumination without fogging. Orange illumination, however, rarely supplies sufficient light for close scrutiny of lithographic plates. A good arrangement is to situate white and orange twin fittings over benches

144

and sinks. The orange lighting is switched on with the room light, the white lighting controlled by a separate pull cord switch on the lamp fitting. In areas where additional local lighting is required, an angle-poise lamp may prove useful.

Light fittings distributed uniformly over the entire extent of the ceiling gives the most favourable lighting conditions in the platemaking room. Diffused lights will provide illumination free from glare and shadow. Optimum light intensity should fall between 900 and 1 000 lux.

(iii) Ventilation

Special provision for ventilation must be made in the platemaking room. Although manufacturers of plates and processing solutions have to observe strict health and safety regulations before their processes are marketed, many of these processes produce vapours which should not be freely inhaled, and it is here that adequate ventilation is necessary. Special processing tables with built-in extractors are produced for plate processing.

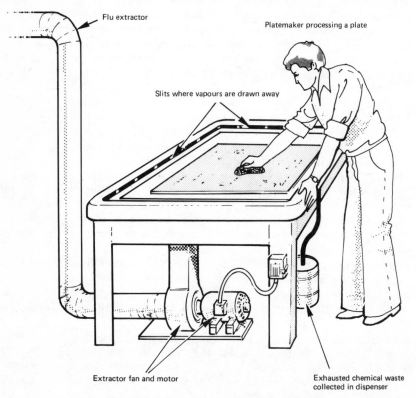

Fig. 158. A down-draught processing table.

The "down-draught table" consists of a working platform surrounded by a gutter for conveying waste processing solutions away. Chemical vapours rising from the plate during processing are drawn away by passing a gentle draught across the plate surface. A motorised fan draws the air, laden with vapours, into the exhaust trunking before they have time to rise and be inhaled by the platemaker (*see fig. 158*).

Provided that the installation is carried out correctly, these down-draught tables are quite adequate and are preferred to ventilation systems which feature a hood over the processing table.

Expert advice which will take into account individual circumstances may be obtained from the Factory Inspectorate, Industrial Safety Centre, or from ventilation consultants.

(iv) Air Conditioning

Air conditioning is economic and advisable for the platemaking room. An air conditioning plant regulates temperature, humidity, oxygen content, air cleanliness and circulation. A complete system will be costly to install in existing buildings and best results are obtained from air conditioning which is custom built into new premises.

Running costs of a system may appear high. But when losses and wastage due to poor atmospheric conditions are equated with the improved working performance of employees working in comfortable conditions, a very different set of statistics will appear on the annual statements of accounts.

The alternative to air conditioning is the unregulated control of temperature and humidity by opening windows. This will not only let in dust and street noise but produce such wide variations in room humidity as to make some plate processes (such as Deep Etch) impractical. Control of R.H. (relative humidity) is one of the most important factors related to platemaking materials and processes. Variations of R.H. may have an adverse effect on the following:

Stability of photographic film.
Planning materials and substrates.
Light sensitive coatings, and
Plate processing.

Temperature and R.H. are closely linked. At any time the air around us contains some water vapour. The maximum amount that a given volume of air may hold depends upon the air temperature and its moisture content may increase rapidly as the temperature rises. Generally air contains much less moisture than it can potentially hold at a given temperature.

Relative humidity is the difference between the water vapour actually present, divided by the maximum that the air can hold at the same temperature. The resulting fraction is multiplied by 100 to bring it to a percentage.

146

The effect of temperature change on R.H. is considerable especially when the temperature is raised or lowered artificially (*see fig. 159*). It is also possible to control R.H. by adding to, or subtracting, water vapour from the atmosphere. Portable and sited humidifiers and dehumidifiers can be obtained. They are available in a variety of sizes to suit different locations. Most units can be pre-set by an automatic switching device known as a "Humidistat".

(a) **(b)**

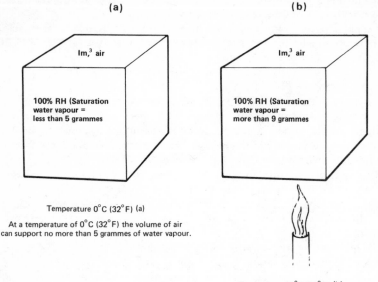

1m,³ air

100% RH (Saturation water vapour = less than 5 grammes

1m,³ air

100% RH (Saturation water vapour = more than 9 grammes

Temperature 0°C (32°F) (a)

At a temperature of 0°C (32°F) the volume of air can support no more than 5 grammes of water vapour.

Temperature 29°C (85°F) (b)

At a temperature of 29°C (85°F) the same volume of air can support more than 9 grammes of water vapour.

Fig. 159. Relative humidity.

The humidifier is a simple device for raising the relative humidity of the atmosphere to a required level. It functions on the aerosol principle. Water is injected on to a rapidly rotating disc thus producing thousands of water droplets. By directing these through a fine screen the smaller particles are dispersed in an air stream passing through the unit into the room. As the droplets are microscopically small (less than 20 microns) they possess the property of mutual rejection and therefore do not join together to form larger droplets of free water. This phenomena is known as "dry water".

An important feature of dry water is that it does not produce condensation side-effects or possess corrosive characteristics. Sophisticated humidifiers will control relative humidity, mix fresh air with circulating air and remove dust by washing.

The dehumidifier is used for extracting unwanted water vapour from the atmosphere, and this makes it of particular interest to the platemaker. Room air is drawn by means of a fan over the cold coil of a refrigeration circuit. Because low temperature air supports less moisture than warm air, the moisture chilled by the coil condenses out and is drained away. The cool air is then re-heated and passed into the room. The chilling and re-heating cycle has the combined effect of reducing the R.H. of the room air.

Air cleaning. Dust and air-borne particles can create problems in both the planning and platemaking rooms. A simple air cleaning unit will continuously filter and recirculate room air without changing its temperature or moisture content. The unit is based on the electrostatic principle and will reduce dust levels by up to 90 per cent.

(v) Flooring

Along with other working conditions the floor of the platemaking room may be far from ideal for the tests being undertaken. The platemaker has to stand for long periods at the processing table. Processing chemicals are often spilt and drip off the edge of the table on to the floor. This soon produces a sticky and unpleasant area to stand on. Absorbent floors such as wood can become saturated with processing chemicals and become a safety hazard. Flexible rubber link mats or duck boards are more comfortable than standing on a concrete floor and they have the advantage of being easily replaced and removed for cleaning.

The floor itself should be solid with ceramic or thermo-plastic tiles which are chemically inert and easy to clean. One important consideration should be to see that the floor surface has good non-slip properties. Water and chemical solutions inevitably wet the floor of the platemaking room and without a non-slip surface the wet floor could prove dangerous.

Provision should be made to see that the platemaking room floor is regularly swept and chemicals removed with a suitable solvent.

(vi) Use of Colour

There are two main considerations related to the use of colour on walls and ceiling in the platemaking room.

The first is to prevent reflective glare produced by printing down lights from affecting light sensitive plates in other parts of the room. Plate fogging may occur if actinic light is allowed to reflect off gloss painted walls. Multiple reflection of light in the area of printing down frames may cause undercutting of the plate being normally exposed.

A matt, non-reflecting black or dark grey paint is recommended around the areas used for printing down plates. Other walls and ceiling should not be painted with gloss paint or with white or light colours.

The second consideration is more aesthetic than technically essential. Psychological research has concluded that the working environment, particularly the lighting and colour of workrooms is a crucial factor which influences the interest and enthusiasm of working personnel.

Of course, orange room lighting will limit the choice of colour for walls and ceilings. The colour scheme should be more than decorative, aimed at helping the platemaker to see clearly, and promote safety, accuracy and tidiness. Colour can be used to serve the same end as lighting in many respects, and it is essential that colour and lighting be considered together as two complementary aspects of the visual environment.

(vii) Waste Disposal

Local authority safety regulations may require special disposal of both solid and liquid wastes from the platemaking room. Waste materials require careful disposal when such items as cotton wool, cellulose wadding and cloth wipers are saturated with processing chemicals and solvents. Some of these materials will burn readily or give off highly volatile vapours. This must be taken into account especially where such wastes are placed together in waste bins, creating a fire hazard.

Most platemaking waste is of a wet nature and receptacles used for disposal should contain the waste without breaking open as a paper sack may. The polythene domestic refuse bin or frame supported disposable plastic sack are both suitable for waste. Receptacles should be emptied when full and not left in the factory overnight or at weekends. Chemical wastes of this nature will not only serve as fuel for a fire, but may cause fire by spontaneous combustion.

Fire and safety regulations must be consulted when planning the disposal of platemaking wastes. Such regulations may outline the precautions to be taken regarding ventilation, cigarette smoking, use of open arc lamps, etc.

Platemaking equipment is discussed at the latter part of this section.

(4b) PLATEMAKING MATERIALS

There are many consumable materials required to service the platemaking department. It is usual for the planning and platemaking sections to share a common store room. Below are listed some of the common materials:
Uncoated plates.
Presensitised plates.
Coating solutions.
Developing solutions.
Other processing chemicals.
Concentrated acids: acetic, citric, phosphoric, sulphuric.
Concentrated ammonia.

Gumming up solutions.
Deletion materials.
Processing pads, cotton wool, cellulose wadding, mutton cloth.
Sponges, squeegees.
Painting-out brushes.
Masking materials, masking tape, clear adhesive tape.
Marking pencils.
Replacement bulbs, tubes, arc lamp carbons.
Glass and film cleaners.
Drawing implements, pens, pencils, rubbers, straight edges, scalpels, rulers.
Selection of containers/dispensers.

Storage of Platemaking Materials

Proper facilities for the storage of platemaking materials is essential. It is common to provide a small store within the platemaking room of materials for immediate use with the bulk of the supply situated in a main store room elsewhere. This is especially important with the storage of inflammable liquids, acids and other dangerous chemicals; these should be stored in a secure fire-proof building separate from the main department.

Another important factor is to store materials in a suitable temperature. This must be emphasised because the store room is very often regarded as unimportant and not worth heating. Some processing chemicals will deteriorate rapidly if stored in adverse conditions such as low temperature or strong sunlight. Plastic planning sheets may become brittle and split easily if stored in a very dry atmosphere. Variations in R.H. can affect some of the hygroscopic materials used for platemaking. No situation can be better than to supply the platemaking store with the same level of air conditioning as is provided for the rest of the department.

Storage on racks is limited to the height of a man's reach and should not exceed 2 metres (6 feet) unless ladders are used. Light materials should be shelved high on the rack with the heavier goods at a lower point for safety and ease of handling.

The shelf life of many materials is indicated on the packaging, but even undated materials may deteriorate with age. A system of stock rotation on the basis of "first in—first out" will prevent unnecessary wastage. Rotation is made easier with storage racks which have access from both sides. New stock is placed on the shelves from the back of the rack pushing old stock to the front. Stock may also be marked with the date as it arrives at the store to ensure proper rotation. Acids and chemicals located within the platemaking room should be kept in a clearly marked metal cabinet and for safety reasons placed at a low point on the shelves.

Handling Materials

Many platemaking materials require careful handling. Metal litho plates can be kinked or scratched and presensitised plate packaging if damaged can result in plate fogging. Concentrated acids and dangerous chemicals should be carried in a special bottle cage. A general safety rule when carrying chemicals is to use both hands, one placed under the base and the other firmly grasping the neck of the container.

When mixing chemical solutions a suitable impervious apron should be worn and the hands washed thoroughly afterwards. When mixing concentrated acid into a dilute solution the acid must always be added to water and never the reverse. Care must be taken to ensure that all chemical solutions are clearly labelled and that they do not become illegible with use.

(4c) PLATE SURFACE CHEMISTRY

The original surface to bear a lithographic image was limestone, which for many reasons remains a superior material. The limestone has the ability to absorb the greasy image-forming ink and the damping solution into its surface. These limestone slabs (called "stones" in the trade) had several disadvantages; they were several inches thick, very heavy, extremely cumbersome to handle and store, relatively fragile and, of course, restricted to use on a flatbed press.

"Stone-age" lithography gradually gave way to the more practical lighter, flexible and durable metals. Zinc and aluminium have been the two most popular metals with the latter proving to be better suited for lithographic work. Many other materials have now been developed to form the basis for lithographic plates, multi-metal plates and paper plates are an example.

Early experiments with metal proved unsatisfactory as polished plates were being used. It was later discovered that a roughened surface (or grain) not only increased the surface area, but aided the adhesion of the

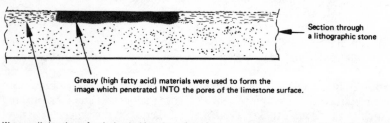

Section through a lithographic stone

Greasy (high fatty acid) materials were used to form the image which penetrated INTO the pores of the limestone surface.

Water applied to the surface is absorbed into the surface of the stone. Lithography derives its name from the use of limestone. The Greek words lithos = stone, and graphe = writing, were placed together to express "stone-writing".

Fig. 160. Lithography on stone.

Fig. 161. A section of a metal plate with the microscopically thin image and adsorbed desensitized layers ON the surface. Early use of metal in place of limestone was called 'Metalography', but the original name survived.

image to the surface. Plate damping was also improved by the grain because the minute valleys acted as reservoirs for water on the surface.

Lithography functioned well on limestone because of the absorption properties of the surface (see fig. 160). Absorption is defined as "The penetration of a substance into the body of another". The use of metals for lithography relies on the phenomenon of adsorption, which in this case is defined as "The adhesion of a substance to the surface of another".

The production of the lithographic plate involves the creation of two vital areas on the plate surface (fig. 161). The image must adhere to the surface and have oleophilic (oil-loving) characteristics. The non-image areas must be hydrophilic (water-loving) and this condition is obtained by treating the surface to produce an ink-repelling, water attracting layer. This process is called "desensitisation" and it consists of the adsorption of a hydrophilic layer on the plate grain. Proper desensitisation is critical to trouble-free printing and the correct use of chemicals by both plate-maker and pressman is necessary to achieve this.

An understanding of the surface chemistry requirement of the litho-graphic plate has resulted in the range of modern plates available to the lithographer. With such a wide choice, plate selection will be determined by economics and suitability of the plate for the class of work, length of run, etc., required.

(4d) CLASSIFICATION OF LITHOGRAPHIC PLATES

There are probably less than 20 plate making processes marketed inter-nationally by over 100 suppliers. With such a bewildering array of plates and processes available it is necessary to classify their particular features to make selection easier:

 (i) Materials used as plate substrate.
 (ii) Type of grain.
 (iii) Anodised plates.
 (iv) Plate coatings.
 (v) Methods of forming the image.
 (vi) Negative and positive working plates.
 (vii) Surface or recessed image.
 (viii) Additive or subtractive process.
 (ix) Potential press life.
 (x) Shelf life.
 (xi) Production: time and cost.

(xii) Production: degree of skill.
(xiii) Purchase price.
(xiv) Plate corrections.
(xv) Choosing a suitable plate.

(i) Materials used as Plate Substrates

Aluminium is the most common metal used for the major processes. Zinc has almost been completely superseded as it does not possess the tensile or surface properties of aluminium. Paper and plastic are used widely in the production of small size, short run plates. Multi-metal plates are produced with a variety of metal combinations; chromium, stainless steel, aluminium forming non-image areas, copper and brass forming image areas. Bi-metal plates comprise two metals which function lithographically, tri-metal plates contain two lithographic metals plus a third metal as the supporting substrate.

The gauge (thickness) of the plate is normally recommended by the press manufacturer. Those who attempt to use thinner plates than recommended may run into problems such as plate stretch, tearing and kinking.

(ii) Type of Grain

The type of plate grain, its fineness or coarseness, its hardness, etc., is determined by the method of graining. The following techniques are common:

Marble graining. This traditional method is rapidly becoming obsolete because of its slow production and level of skill required by the operator. Plates are grained by rotating the plate under marbles in the presence of abrasives and water. Used for regraining zinc and aluminium plates.

Sandblasting. Produces a grain by forcing abrasive particles through a "gun" on to the plate surface at high velocity.

Brush graining. Produces a grain by one of two methods: dry-brush graining uses rotary wire brushes; wet-brush grain uses nylon rotary brushes, wetting agents and abrasives. The grain produced is finely scratched indentations which run in one direction.

Chemical graining. Produces a grain by dipping the metal plate into a hot alkaline bath (caustic soda or potassium alum). The corrosive action produces a matt, semi-porous surface grain.

Electro-chemical graining. The metal plate is suspended in an electrolytic bath (nitric, hydrochloric or sulphuric acid may be used depending on the type of grain required). A low voltage current is passed through the electrolyte thus forming a grain by reduction.

(iii) Anodised Plates

Anodising is an extension of electro-chemical graining. Plates are suspended in an electrolyte (usually sulphuric acid). As electricity is passed

through the bath, oxygen forms on the surface of the aluminium, producing an aluminium oxide layer which is formed integral with the metal. This is followed by a sealing process (hot water or sulphuric acid solution). The type of sealing determines the quality of the anodic surface. Anodised plates are now quite common as they produce an ideal surface for lithography. The anodic film is tough and porous giving it good water-retaining properties. It is resistant to wear on the press, with surface oxidation almost completely eliminated. The aluminium oxide layer is approximately 0.025 mm (0.001″) thick and requires only a fine grain to function satisfactorily. This of course is an important factor in the reproduction of fine tones.

(iv) Plate Coatings

Plate coatings are studied in detail in Section Five, "Methods of Plate Production". The diagram (*fig. 162*) shows how plate coatings are classified: Presensitised coatings are applied by the manufacturer, the remaining plates are whirler coated, or hand coated like the wipe-on process. The brackets (N) and (P) denote if the process coating is negative or positive working.

Other plate making processes have been developed for small size plates which are used widely by in-plant departments, instant-print shops, and small jobbing printers. They are generally used for short run work which rarely involves difficult half-tones or process colour work. Many of these processes use pre-coated plates which are not pre-sensitised; examples are the diffusion transfer plates (C.T.) and the electrostatic plates. The photo-direct systems of Kodak (Verilith) and 3 M (camera brand plate) utilise a photographic silver sensitised coating on their plates.

Another modern development is the dry-offset plate (Letterset). This is a shallow relief plate with either silver sensitised or photopolymer layers bonded to a base metal substrate.

Reference to the diagram (*fig. 162*) will help in following items v, vi, vii and viii of plate classification.

(v) Methods of Forming the Image

Sensitised coatings are used in the formation of a lithographic plate image in either of the following ways:

- The coating is photochemically fixed permanently to the plate forming the image, and the unfixed coating is removed by development.
- The coating is photochemically fixed to the plate forming a stencil in the non-image areas. The image areas are processed to form a permanent image on the plate and the stencil is removed at the final stage.

154

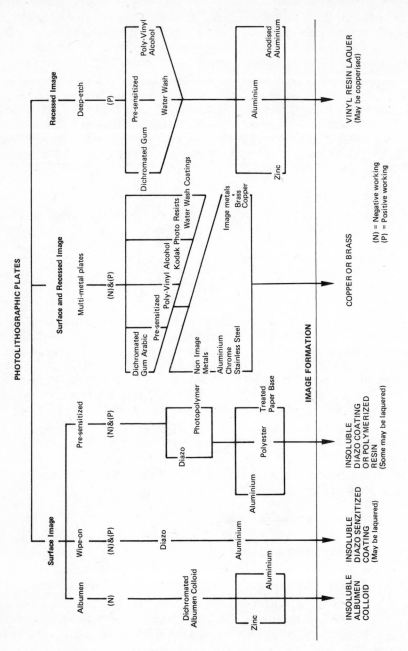

Fig. 162. Photolithographic plates.

(vi) Negative and Positive Working Plates

Lithographic plates can be made from either negative or positive photographic film. Plate coatings when processed produce a sharp solid image, with little gradation in tone possible; therefore suitable photographic film for platemaking must be either line or half-tone (Lith film).

The choice of working with negatives may be based on the following factors:

- Normal camera processes produce a negative from original copy; positives require a further photographic step.
- Spots and blemishes on negatives are easily seen and can be spotted out with opaque paint.
- Simple register work can be planned using inexpensive materials.
- Platemaking processes for negative working plates are simple and rapid.

The choice of working with positives may be based on the following factors:

- A second generation film element produced by contacting the camera negative with a fresh sheet of film will give a positive with a hard half-tone dot. Positives are therefore more expensive to produce than negatives.
- Planning with positives is much easier than with negatives, especially with process colour work.
- Positives are necessary for the Deep Etch process.
- Positive working plates (P.S.P.) may not perform as well on the press as negative working plates.
- The perennial problem of "film edges" and their prevention may be time consuming.

Both negatives and positives for lithographic platemaking are classified as "reverse reading". This means that the image appears reversed as in a mirror when the photographic film is viewed from the emulsion side.

(vii) Surface or Recessed Image

Plate images may be either "surface", that is, with the image-forming material fixed on the surface of the plate; or "recessed", that is, with the image slightly recessed below the surface of the plate (*see fig. 163*).

The physical position of the surface image makes it more vulnerable to wear on the press than the recessed image.

As a general rule the recessed image plates are more durable because the image is protected from frictional wear on the press. They are therefore suited to longer run jobs and work in which the printing stock leaves abrasive dust on the blanket causing plate wear. The recessed image plate is time consuming to produce, resulting in higher production costs than surface image plates.

A wide selection of surface presensitised plates are available to the industry. Manufacturer's claims of press run life of up to 250,000 impressions can only be obtained under the very best conditions. Most surface plates have a ceiling of about 100,000 impressions. "Heat fusing" of presensitised plates extends the run life considerably. (Dealt with under the heading of Pre-sensitised plates).

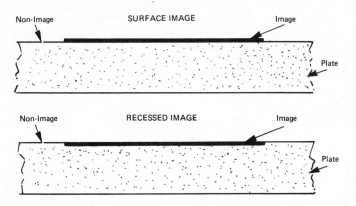

Fig. 163. Schematic diagram of surface and recessed plates.

(viii) Additive and Subtractive Processes

This classification is applicable to presensitised plates of the diazo and photopolymer type.

The diazo coatings are giving way to the modern photopolymer resin coatings. The diazo image does not possess high resistance to wear and because of this usually receives an application of lacquer after processing. It is this application of lacquer which classifies it as "additive" because lacquer is added after processing to reinforce the image.

The diazo coating is formulated by adding the light sensitive diazo material to a suitable liquid vehicle which is photochemically changed by light to form an image (negative working), or rendered unstable by light (positive working).

The tougher photopolymer coatings are classified as subtractive. These materials produce a plate image of high strength, durability and chemical inertness. After exposure of the negative working photopolymer plate simple development consists in the removal of the unexposed coating.

The positive working photopolymer plate produces an image in a similar manner as the positive working diazo plate. Actinic light has the effect of depolymerising the coating in the non-image areas allowing them to be removed by development.

(ix) **Potential Press Life**

There are a number of variables which can influence the performance of a plate on the press. This can be assessed providing the following points are considered:

- Careful plate handling after processing.
- Correct press settings.
- Trouble-free quality materials are used as the printing stock.

Of these points the latter is a common factor in plate potential press life. There is an increasing tendency to use inexpensive paper for printing with the result that press problems such as linting, fluffing and picking occur. Particles such as these can produce an abrasive action on the plate surface and thus reduce its press life. Papers with an unsuitable pH value may also have a deleterious effect on the life of the plate.

When manufacturers quote potential press life of their plates it should be remembered that these performance ratings are based on press use under near ideal conditions. Let us look at the reasons for plate breakdown:

Image failure. The surface image plate is more vulnerable to frictional wear on the press than the recessed image plate. Apart from multi-metal plates, most plate images are formed with a resin based material which is always capable of losing its ink receptivity, either partially or completely (known as "blinding"). Incorrect use of solvents (such as Methyl Ethyl Ketone) carelessly splashed on to the plate when cleaning the blanket may damage most image forming materials, and should be avoided at all costs.

Non-image failure. The non-image areas of the lithographic plate are as important as the image areas. The desensitised layer and the plate grain itself can be damaged by both chemicals and friction resulting in non-image areas losing their ability to refuse ink.

Substrate failure. The other cause of plate failure is the breaking down of the metal substrate. Carelessness when tensioning or moving the plate on the press cylinder can cause the metal to tear. It is important that the plate is fitted to the cylinder tightly and no movement allowed to take place during the run. It is the slight movement of the plate at the point of impression that is the major cause of plate cracking at leading or back edge (*see fig. 164*). This problem can be minimised by using a multi-metal plate with a malleable base metal.

Aluminium, mild steel and stainless steel are subject to fracture problems on long runs. This is especially true on web-offset presses where the plate is bent at an angle in excess of 90° in the clamps. Brass is a metal which has good malleable qualities and has been found suitable to overcome this problem. Using solid brass plates does increase the initial costs and this might deter some from choosing it. Plate selection is not easy, but

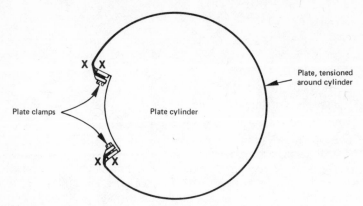

The points between the marked crosses are where the plate is likely to fracture when subjected to many thousand impressions.

Fig. 164. Plate failure.

plates should be chosen which will last longer than the press run. It is very frustrating to be within a few thousand impressions of the end of the job when the plate fails.

Below is a list of plates in common use and the range of their performance:

Process (Photolitho)	*Runs*
Wipe-on	Up to 100,000
Presensitised Plates	Up to 250,000*
Deep Etch	Up to 500,000
Multi-metal	Up to 5,000,000

Other Processes	
Photo Direct	Up to 10,000
Diffusion Transfer	Up to 40,000
Electrostatic	Up to 100,000

*Heat fused plates up to 1,000,000

(x) Shelf Life

The term "shelf life" is normally associated with presensitised plates. The dichromated gum coatings used for Deep Etch platemaking are active for only a number of hours after their application. This is because they are subject to a condition known as "dark reaction" (the spontaneous reaction of the coating due to chemical ageing independent of exposure to light).

Wipe-on coatings have a shelf life of a few weeks depending on temperature of the store.

Presensitised plates are coated under factory controlled conditions and will remain in good order for at least six months providing the packaging

is in good condition. Plate storage conditions recommended by the manufacturer should be followed closely.

Most presensitised process chemicals have a good shelf life which may be shortened by improper storage. Our remarks under "Storage of platemaking materials" should be observed, in particular the rotation of stock in the stores.

(xi) Production: Time and Cost

Plate production times are linked with the next item (xii), in which plate-making skill factors are considered.

Processes involving whirler coatings obviously increase the production time as compared with presensitised plates. For example; a Deep Etch plate may take up to five or six times longer to produce than a presensitised plate.

Automatic plate processors reduce the individual attention given to a plate by the platemaker. However, it should not be overlooked that automatic processors require routine attention, cleaning, chemical changing, etc., and that someone has to perform these tasks. The decision to use a processor must take the following factors into account:

- The number of plates made each day. An automatic processor becomes a viable proposition with large-scale production.
- A single processor without an alternative method of processing plates may cause considerable problems during breakdown.

Cost of production is a domestic factor and will depend upon the type of work and plates required, and the quality standards and times that are expected.

Three other factors which relate to cost of production are:

- The cost of plates, chemicals and sundry materials.
- Plate production time, labour costs.
- Overheads, plant, equipment, etc.

The modern presensitised plate costs a little more than the uncoated plate but has the cost advantage of not requiring the use of a whirler. Processing is simple and rapid thus reducing production costs. The Deep Etch process on the other hand requires capital expenditure on whirler and down-draught table, requires considerable skill and time to produce. Choice between these two common platemaking processes cannot be limited to costs alone. High quality long run plates may demand the more costly process.

(xii) Degree of Skill

At this stage, little more than the general degree of skill required for platemaking will be considered. As the methods of producing images on lithographic materials have improved in terms of resolution, durability, press-life, speed, etc., so also have the processing methods become easier.

The experienced "craft platemaker" is no longer essential for the processing of modern presensitised plates. They are straight forward and simple to process compared with older processes. Established whirler coated multi-metal and Deep Etch processes are giving way to presensitised successors.

Automatic plate processors require little skill; and all modern industrial trends are to replace methods which require skill with simple processes. This will effectively reduce manpower and production time requirements in the platemaking room.

(xiii) Purchase Price

A number of factors, some of which have already been discussed, will influence the price paid for lithographic plates. The working quality of the plate on the press must be equated with the purchase price. There is no economy in buying inexpensive plates if they give trouble on the press (which has a high cost hourly rate) or need replacing frequently.

Since plate price is relatively small in comparison with other factors of printing production it would be bad economics to jeopardise production for the sake of saving a few pence on plate price.

Some manufacturers offer presensitised plates with a light sensitive coating on both sides of the plate for economy. Another economy may be made in buying plates in bulk, but here the plate shelf life must be taken into account.

Finally, when costing the purchase of aluminium plates, one can take into account the scrap value of used plates.

(xiv) Plate Corrections

Correction of the finished lithographic plate is not always possible. Deletions (the removal of unwanted work) are possible on most plates, but additions (adding work) are limited and not always practical.

These subjects will be considered in detail later; here we outline the methods used:

Plate type	Deletions	Additions
P.S.P. Deep Etch	Abrasive stick	Simple line scribing
,, ,, ,,	Abrasive eraser	Use of wipe-on coating
,, ,, ,,	Chemical fluid	Localised photo-litho, "drop-in"
Multi-metal	Chemical/electrolytic	Electrolytic

Important factors related to plate corrections:
- The correction must be worthwhile, lasting the press life of the plate.
- The time taken making the correction should not be impractical.

- A new plate may prove a better economy than lengthy corrections.
- Chemical deletions are preferred to abrasive stick deletions.

(xv) Choosing a Suitable Plate

Many of the factors which relate to choosing the right plate for the job have now been considered. A few simple questions will enable one to narrow the choice out of this large array of factors:

- Is one supplier able to provide all the plates to meet your needs?
- What is the quality of the supplier's sales service?
- Does the supplier provide a technical service to back up his plates?
- Is it a good policy to obtain all your plates from one supplier only?
- If you are buying for automatic processing, can the plates be processed by an alternative method if the processor breaks down?

Conservative policies in the past few years have resulted in many printers staying with well-tried plates, with the result that modern developments have not been exploited to advantage. A progressive policy of keeping up with plate developments and encouraging field trials within the works of new products ought to be encouraged among platemaking staff.

(4e) PLATEMAKING EQUIPMENT

The Whirler

The whirler is a simply constructed piece of equipment. It consists of a variable speed turntable upon which litho plates are clamped and coated. Coating is distributed uniformly over the plate by centrifugal force. Warm air, produced by a heater in the whirler lid dries the coating on the plate surface. Water supply to the whirler is provided either through a moveable arm or flexible hose. Whirlers vary in design, size, quality and style. There are two basic designs, "horizontal" and "vertical". The horizontal whirler (see fig. 165) requires more floor space than the vertical whirler (see fig. 166). Where floor space is a critical factor in terms of utilisation of space the low space requirement of the vertical whirler makes it popular in small print houses (see fig. 167).

Services to be connected to the whirler will include electricity, water and drainage. The bearings which support the whirler table require periodic lubrication and should be checked annually for bearing wear and bearing water seal condition.

Printing Down Equipment

In the past, the printing down frame and light source were manufactured as individual pieces of equipment (see fig. 168). Many modern printing down units comprise a vacuum frame and a fixed distance light source in one module (see fig. 169).

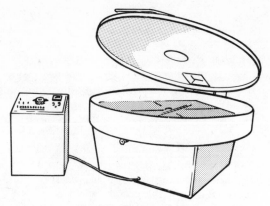

Fig. 165. Horizontal whirler.

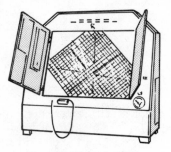

Fig. 166. Vertical whirler.

The vacuum frame unit. This consists of a metal frame which houses a sheet of flawless plate glass. A common method of securing this glass frame to the lower frame is by hinges at the back edge of the frame. Other methods involve the lifting of the glass frame vertically on a rack and pionion track, or by scissor lever device.

The lower section of the unit has a metal frame and base which supports a flexible rubber blanket. This usually has a dimpled, ribbed or irregular surface with a raised beading around the blanket perimeter. The beading ensures an air-tight seal to the glass when the two sections are locked together. A flexible hose connected to the blanket passes through the base of the lower frame to a vacuum pump.

When in use, the planning flat is secured to the litho plate and placed on the blanket. The glass frame is lowered and locked, the vacuum release valve is closed and the pump switched on to vacate the captive air. When all of the air has been extracted, the created vacuum draws the plate and flat into tight contact between the blanket and the glass.

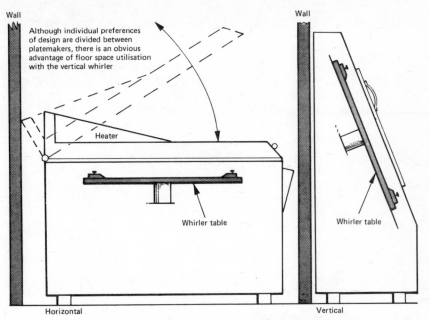

Wall

Although individual preferences of design are divided between platemakers, there is an obvious advantage of floor space utilisation with the vertical whirler

Heater

Whirler table

Horizontal

Wall

Whirler table

Vertical

Fig. 167. The space requirements of horizontal and vertical whirlers.

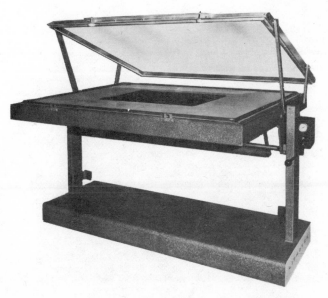

Fig. 168. 'Lithotex' printing-down frame. Type 80.

Complete vacuum within the frame is not necessary. Vacuum pressure is measured in cm of mercury, the normal atmospheric pressure being about 76 cm of mercury. Vacuum frame pressure within the region 40-50 cm will ensure good contact for printing down. The higher the pressure, the greater is the risk of breaking the frame glass. An effect known as "Newton's rings" (rainbow coloured irregular-shaped rings) may be formed between the glass and the film or plastic flat. This will indicate that sufficient contact is obtained.

Thin aluminium plates may pull down irregularly on a blanket with prominent dimpled pattern. A discarded flat plate or sheet of 3M "Sphercote" laid over the blanket and beneath the plate will overcome this problem. Hygroscopic materials such as paper should not be left in the frame as they may attract moisture and cause problems with water-soluble coatings.

If a suitable level of vacuum is not obtained between frame and blanket, undercutting of the planning flat may occur during exposure. A similar

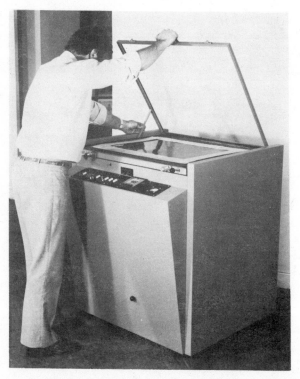

Fig. 169. Grant 'flip-top' printing down unit.

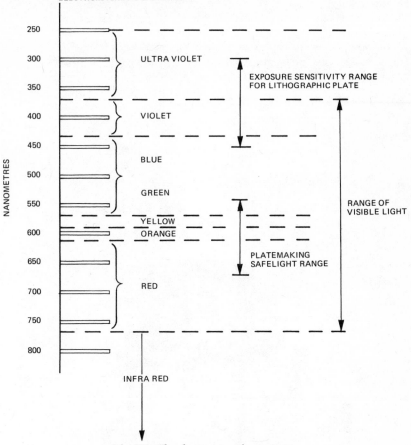

Fig. 170. The electromagnetic spectrum.

problem will arise if particles of dust and dirt get between the film and the plate. Foreign matter of this nature will hold the film away from the plate coating during exposure with the result that undercutting will occur.

Apart from a spot of oil on moving parts around the frame, little maintenance is necessary other than regular attention to the following:

- The oil level in the vacuum pump.
- Cleaning the blanket periodically (vacuum cleaner).
- Cleaning the frame glass.

Light Sources

Various types of light source are produced for printing down lithographic plates. The majority of light sensitive platemaking materials are affected

by "actinic light" (short wave radiation which produces a photochemical effect). Exposure lamps are selected for their spectral emission within the range 300 to 450 nm (*see fig. 170*).

Carbon arc lamps. This was the first successful lamp used for printing down, but is now being replaced by modern discharge lamps. The lamp produces high intensity light (up to 5,000°K colour temperature) by passing a low voltage electric current through two electrodes made of mineral carbon. High temperatures are produced at the tips of the carbons, causing them to burn away. Mineral additives in the carbons give off an incandescent light which is rich in ultra violet radiation.

Carbon arc lamps have the following disadvantages:

- The lamp is often unstable during use; slight changes in line voltage will cause the lamp to flicker or even fail during exposure.
- Burning carbons produce unpleasant fumes and quantities of fine dust which may cause problems in areas which should be dust-free.

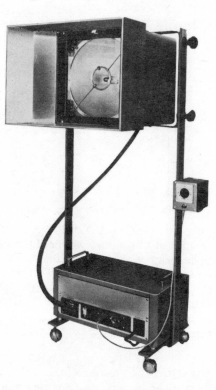

Fig. 171. Metal-halide lamp.

- Lamp efficiency is impaired if maintenance is neglected. It needs frequent cleaning and adjustment to give consistent results.
- Carbon arcs are a potential safety hazard, producing dust which may be inhaled, and because of their open construction, presenting the danger of electric shock from unguarded electrodes.

Xenon discharge lamps. This is one of the modern discharge lamps which is replacing carbon arcs for camera and platemaking exposures. The lamp consists of a quartz envelope containing xenon gas. When an electrical discharge takes place through this gas it gives off high intensity light with a colour temperature of 6,000°K. To gain a "point source" effect, many of these lamps are produced in a tight spiral shape. The lamp runs at a high temperature and therefore most units contain fan cooling.

Mercury vapour lamps. This type of lamp produces actinic light in a similar manner to the xenon lamp. Electrical discharge takes place through mercury vapour. Since the mercury in the lamp is in liquid form a short period of "warm-up" is necessary before the mercury is sufficiently vapourised to function efficiently. This also means that when the lamp is switched off it must cool down before it is used again. This problem is overcome in some lamps by keeping the lamp on continuously, exposures to the plate being made via a shutter arrangement.

Metal halide lamps. This is a variation on the mercury vapour lamp. Light output is increased by metal halide additives and special reflector design (*see fig. 171*). Like mercury vapour lamps this lamp requires a shutter or blind mechanism for continuous use. Many lamps are designed to switch to half power when the shutters are closed with rapid change to full power when required for exposures. This increases lamp life and saves electricity. Metal halide lamps allow shorter exposures on most plates than other light sources. A comparison of lamp efficiency is shown below:

Xenon discharge lamps: $\frac{1}{4}$ the equivalent output of metal halide lamps.
Mercury vapour lamps: $\frac{1}{2}$,, ,, ,, ,, ,, ,, ,,
Carbon arc lamps: $\frac{1}{3}$,, ,, ,, ,, ,, ,, ,,

When selecting a light source for platemaking the following points must be considered:

(i) If a separate lamp is purchased it will allow a wider selection of light sources than may be provided with integral printing down units.

(ii) Overhead lamps (especially carbon arcs) have a tendency to drop particles on to the frame glass. Lamps placed below the frame may lose their efficiency if foreign matter falling on to the lamp is burned off during use.

(iii) The intensity of the lamp must be compatible with the frame size and the distance of the lamp from the frame.

(iv) Colour temperature should be above 4,000°K.

(v) Some provision ought to be made to regulate the variables of fluctuating line voltage and lamp ageing.

(vi) Lamps emitting light from a point source are ideal for avoiding exposure undercutting of the planning flat. They have the drawback of producing a greater intensity of light in the centre of the frame than its edges. Lamps with bright reflectors, tube shaped lamps and multiple lamp units have the disadvantage of causing undercutting of the planning flat during exposure. This can be particularly troublesome with half-tones.

(vii) Lamps emitting ultra violet radiation are a potential health hazard and should be positioned in such a way to reduce exposure to personnel within the platemaking room.

Integrating Light Meters

The integrating light meter has already been mentioned in relation to platemaking exposures (Section 5). With the increased speed of modern plate coatings accurate exposure is becoming of greater importance. For example; a four second variation within a five minute exposure is only a 1.6 per cent error which most coatings will allow without adverse effect. With a short exposure of one minute, the same variation is equivalent to an 8 per cent error which the coating cannot accommodate. The integrating light meter (*see fig. 172*) overcomes the following possible problems:

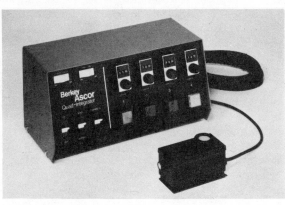

Fig. 172. Berkey integrating light meter.

- Lamp output will deteriorate with age giving reduced intensity and colour temperature.
- Changing the distance between lamp and frame can be made without calculations.

- Fluctuation in mains voltage may affect lamp output (especially with carbon arc lamps).

The meter unit contains presector switches which are set before plate exposure (light output is measured in light units and these are equated by making test exposures). A photocell unit connected to the meter by flexible cable is placed on the printing down frame where it will receive similar illumination as the plate. The photocell records the amount of illumination taking place during the exposure and the meter computes this until the preselected exposure is complete and the lamp is automatically switched off. Meters with digital display count down the light units with the advantage that the exposure may be broken and restarted without exposure error.

Processing Benches

Benches for processing plates must be large enough to accommodate the largest plate used. Many of the chemicals and solvents used to process plates may be corrosive and therefore the bench surface should be non-absorbent and chemically inert (PVC or stainless steel). There are a large variety of processing benches available which may be obtained as standard units or custom built to suit special requirements.

Fume Extraction Tables

This subject has already been discussed under "Ventilation". The principle of the fume extraction table is to remove noxious fumes from the processing table before they are inhaled by the platemaker (*see fig. 173*). This type of processing table is essential for multi-metal plate production, Deep Etch processing and ought to be considered for presensitised plates when produced in confined areas.

Automatic Plate Processors

The majority of litho plate manufacturers market simple machines which process their plates automatically. After normal exposure the presensitised plate is placed in the processor where a timed sequence of operations is carried out automatically; developing, rinsing, gumming and drying. The finished plate may be presented, ready for the press, in under 40 seconds.

The basic design of the processor consists of a conveyor system which carries the plate under applicators made of sponge, rubber, brush or pads which apply the processing solutions to the plate. For economy, these solutions may be temperature controlled, metered, filtered and recirculated. This also prevents early oxidation and evaporation of chemicals.

Some processors can process a range of plates by simply changing the processing solutions. Many units are free-standing and do not require special plumbing or electrical supply (*see figs. 174, 175 and 176*).

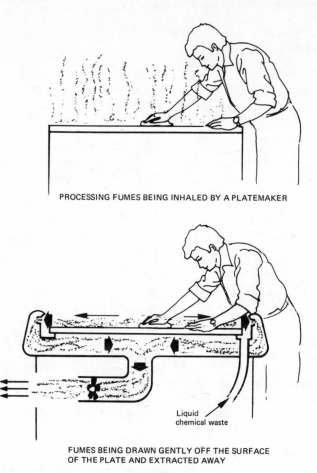

PROCESSING FUMES BEING INHALED BY A PLATEMAKER

Liquid
chemical waste

FUMES BEING DRAWN GENTLY OFF THE SURFACE
OF THE PLATE AND EXTRACTED AWAY

Fig. 173. Principle of the down-draught table.

The following factors might be considered before purchasing an automatic plate processor:

- Is the daily production of plates high enough to justify the capital outlay?
- Will the installation require special plumbing or electrical connections?
- Provision for maintenance of the processor must be made. There will be periods when the system must be cleaned and solutions changed.
- Will an alternative method of processing be possible during breakdown or maintenance? This may require hand processing of the plates or a second processor.

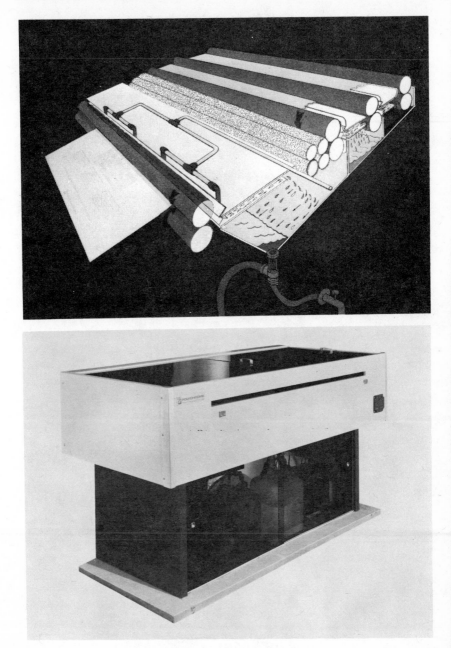

Fig. 174. Polychrome PC48 processor.

Howson-Algraphy, Marathon 30 Processor

Designed to handle the highly successful 'Marathon' (negative working) pre-sensitised plate. Processes, gums and dries plate. No special services required, 13 amp, single phase, portable.

Dimensions of processor

Developing and control rollers

990mm

2030mm

1220mm

1170mm

Fig. 175. Howson-Algraphy-Marathon 30 Processor.

Fig. 176. Lulh automatic processor.

More sophisticated automatic processors may be obtained for processing Deep Etch and multi-metal plates.

Total Systems

A variety of special platemaking processes for the small offset market are dealt with under Section 5, "Methods of Plate Production". Many of these processes are total systems; the plates, process solutions and automatic processors must be purchased as a complete package and are not interchangeable with other systems. Plates (or "Masters") for small offset have a variety of substrate materials; aluminium for long press runs and paper and plastic plates for short run work. Equipment for these total systems range from simple bench-type exposure and processing units to highly sophisticated camera systems. Below is a list of prominent manufacturers of such systems:

Agfa-Gevaert Ltd., Brent House, Great West Road, Brentford, Middx.

Addressograph-Multigraph Ltd., Maylands Avenue, Hemel Hempstead, Herts.

A. B. Dick & Co. of Great Britain Ltd., 3, Warple Way, Acton, London.

Gestetner Duplicators Ltd., Gestetner House, P.O. Box 23, 210, Euston Road, London, N.W.1.

Kalle U.K. Ltd., Hoechst House, Salisbury Road, Hounslow, Middx.

Kodak Ltd., Kodak House, Station Road, Hemel Hempstead, Herts.

Rotaprint Ltd., Rotaprint House, Honeypot Lane, London.

3M (U.K.) Ltd., 3M House, Wigmore Street, London.

Rank Xerox Ltd., 388, Euston Road, London, N.W.1.

Platemaking Furniture and Sinks

The platemaking room should be designed to allow free movement with plenty of space for platemaking. Adequate wall cupboards for containing lightweight materials are preferable to open shelving which may soon become dust-laden.

Benches with suitable working surfaces may contain cupboards and drawers for storage. Planning flats should be stored flat in shallow drawers or hung in special filing cabinets. New plates should be stored flat on shelving which is situated away from strong illumination. It is common to store finished plates near the door of the platemaking room in upright racks. Platemaking furniture of this kind is readily available on the market in unit form or custom built to suit special requirements.

Platemaking sinks may be made of stainless steel or PVC. Sinks for washing plates should be shallow with a wooden duck board covering the bottom of the sink. A deep sink is necessary for mixing chemicals.

Hot and cold water supply is necessary and mixer taps with flexible hose is recommended (*see fig. 177*).

174

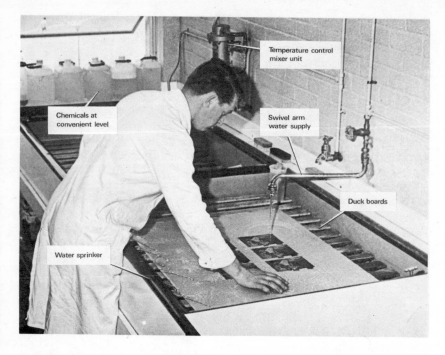

Fig. 177. Platemaking sink.

Section V

METHODS OF PLATE PRODUCTION

(a) *The Importance of Correct Working Procedures.*
(b) *Presensitised Plates.*
(c) *The Wipe-on Process.*
(d) *Kodak Photo Resist.*
(e) *The Deep Etch Process.*
(f) *Multi-metal Plates.*
(g) *The Diffusion Transfer Process.*
(h) *Electrostatic Plate Processes.*
(i) *Photo-direct.*
(j) *Direct Image Plates.*
(k) *Dry-offset.*

SECTION FIVE

METHODS OF PLATE PRODUCTION

(5a) THE IMPORTANCE OF CORRECT WORKING PROCEDURES

Plates that perform well on the press are the direct result of correct plate-making procedures. Although we consider a number of "home-made" platemaking processes in this section, the majority of modern processes are supplied ready made for use. This is especially true of presensitised plates. Manufacturers are reluctant to give technical details about their plates and processes and this leaves the platemaker with no alternative other than to follow processing instructions carefully.

An important point must be emphasised here regarding ready made plate processes. It is not uncommon to find techniques used which are not recommended by the manufacturer. To neglect to follow their recommendations will only result in plates which are below the optimum quality. Most manufacturers produce a platemaking system after considerable research and technical development and their processing instructions are formulated to produce the best results from their plates. It is impossible for any platemaker to improve on plate processing without the technical information on the plate coating and processing solutions.

A variety of quality control devices and platemaking aids are available (*see Section 6*, "Quality Controls") and these should be exploited fully. Platemaking production contains many variables which require close control if consistent quality plates are to be produced. The platemaker should know how good his plates are before they are used on the press.

PLATE EXPOSURE

The establishment of correct plate exposures depends upon three factors:
 (i) Light intensity.
 (ii) Control of light fluctuation.
 (iii) Lamp distance from the printing down frame.

(i) *Light Intensity*

The assessment of lamp output in terms of intensity and colour temperature is not easy to equate with the timing of exposures. The standard method is to make a series of test exposures to a plate with half-minute increments (e.g. 1, 1½, 2, 2½, 3 minutes, etc.). Many plate manufacturers will recommend exposure to a numbered step on a continuous tone step wedge (or "Stouffer Sensitivity Guide"). The Star Target is also used to indicate image resolution and dot gain or loss.

A half-tone step wedge will indicate how well half-tones are formed from highlights (10 per cent dot) to shadows (90 per cent dots).

The test plate will therefore carry aids such as these to establish the correct exposure for the type of plate used.

(ii) *Control of Light Fluctuation*

Carbon arc lamps suffer the drawback of frequent fluctuation in light output due to changes in mains voltage and the burning away of the carbon electrodes.

Discharge lamps are more consistent but light output does deteriorate as the lamp ages and allowance must be made for this.

The most accurate exposures are made with the use of the integrating light meter (*see Section 4*, "Platemaking Equipment"). The meter is connected to a photocell detector which is placed on the printing down frame to monitor the amount of light falling on the plate. The exposure is measured, not in minutes, but in light intensity units. When set correctly the meter will compute the correct exposure and switch off the lamp when it has been given.

The integrating light meter will overcome all problems associated with light fluctuation and lamp ageing.

(iii) *Lamp Distance from the Printing Down Frame*

Printing down frames with a separate light source allow the lamp to be placed at any distance from the frame. The recommended minimum distance between the lamp and the frame is calculated by measuring the diagonal of the exposure area on the plate (*see fig. 178*). The greater the distance between lamp and frame, the more even is the illumination of the plate. When the lamp is placed at the minimum distance light intensity at the centre of the plate may be as much as 25 per cent higher than at the plate edges. With fast plate coatings an intensity difference like this cannot be accommodated and the lamp must be placed at a greater distance from the frame.

Once a satisfactory test plate has been produced, the distance between lamp and frame must remain constant to produce consistent results. However, change in distance is often required and this means that a new exposure time will be necessary. This new exposure time may be assessed by making a fresh series of test plates or by making a mathematical calculation according to the "inverse square law". This law is defined in the following way: *"The intensity of light from a point source varies inversely with the square of the distance between source and object".* This means that as the lamp is moved away from the frame the intensity of the light falling on the plate is reduced in proportion to the square of the distance (*see fig. 179*).

The diagonal being measured

Frame diagonal
used as the exposure

lamp distance

Fig. 178. Calculating lamp from frame distance.

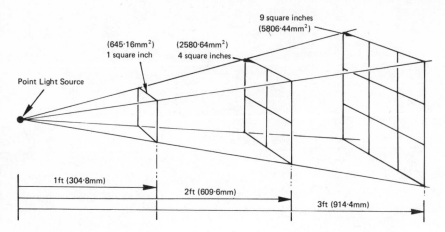

Fig. 179. The 'inverse square law' related to point source illumination.

Platemakers use the following equation to calculate new exposure times when changing the distance between lamp and frame:

$$\frac{\text{New Distance}^2 \times \text{Old Exposure}}{\text{Old Distance}^2} = \text{New Exposure}$$

Examples in imperial and metric measurements are given below:

(1) A normal exposure is 8 minutes with the lamp at 4 feet from the frame.
What is the exposure if the lamp is moved to 3 feet?

$$\frac{3^2 \times 8}{4^2} = \frac{9 \times 1}{2} = \frac{9}{2} = 4\tfrac{1}{2} \text{ minutes}$$

(2) A normal exposure is 4 minutes with the lamp at 0.75 m.
What is the exposure if the lamp is moved to 1 m?

$$\frac{1000^2 \text{ mm} \times 4}{750^2} = \frac{16 \times 4}{9} = \frac{64}{9} = 7.1 \text{ minutes}$$

(5b) PRESENSITISED PLATES

Presensitised plates (P.S.P's) are defined as "factory coated plates". Development and research into the use of light sensitive Diazo compounds began in the 1920's, but it was nearly 25 years before the first positive working plate was marketed in 1946 and the first negative working plate in 1951.

The technical and economic advantages of the presensitised plate are largely responsible for the tremendous growth of the lithographic process in the last 25 years. These advantages have been utilised by other types

of litho plates and even by other printing processes where they have been used to replace dichromated colloids. .

Under this heading we are going to consider the common surface image presensitised plates; presensitised multi-metal and Deep Etch are a late development and will be considered under their respective headings. Diazonium materials were utilised in the early presensitised coatings and are still marketed by many manufacturers. A modern alternative with improved long run capabilities is the photopolymer plate with a coating based on cinnamic-acid esters of epoxy resin.

The advantages of presensitised plates over whirler coated plates are listed below:

 (i) Factory coated plates produced under controlled conditions result in standard sensitivity and thickness.

 (ii) They are relatively unaffected by variations in humidity and temperature.

 (iii) At least six months shelf life is expected with modern plates.

 (iv) Plates may be purchased economically to suit a variety of requirements—negative or positive working plates, choice of plate substrate (paper or metal) and choice of plate coating.

 (v) The processing of presensitised plates is simple, requiring less craft skill than whirler coated plates and yielding consistent results.

 (vi) Less capital investment in plant and equipment is necessary. The whirler is an expensive piece of equipment which requires electrical, water and drainage services. It requires regular cleaning and maintenance and will need replacing every ten years.

(vii) Production speed is greatly increased. Most plates can be press-ready within three minutes of exposure.

The basic features of the presensitised plate are as follows:

• They are available for exposure to negative and positive photographic film.

• Plate coatings are based on either diazo compounds or photopolymers.

• Processing is classified as either "Additive" or "Subtractive". The "Additive" process involves a further stage after development in which an image building lacquer is applied to the plate (mostly diazo plates); the latter classification indicates that after exposure the unexposed coating is removed and the plate is press-ready (mostly photopolymer plates).

There are a few disadvantages associated with presensitised plates. Additions to a finished plate may be difficult, impractical or impossible. Many plates do not produce a visible image after exposure; this can prove awkward with certain types of work, e.g. multiple image jobs. The old

system of regraining used plates for further use cannot be used with presensitised plates. Once used the plate becomes scrap.

The patent rights covering presensitised plates prevents an open investigatory analysis of the platemaking materials and solutions. There are, however, a number of basic principles which can be considered.

Plate treatments. Special surface treatments are necessary with aluminium plates which are coated with diazo compounds. After the plate is grained the surface is coated with sodium or potassium silicate or aluminium oxide (anodising). This forms a barrier layer between the metal and diazo compound to prevent harmful reaction which would otherwise reduce its shelf life.

The type of grain on the plate surface is something which manufacturers do not appear to agree upon as different methods of graining are employed. The main aim is to produce a surface roughness which will increase the water-carrying properties of the plate, and provide an anchorage for the image material. Those who advocate a coarse grain for improved damping must concede a loss of image resolution especially in the reproduction of fine line and highlight half-tone dots. On the other hand, smooth surface plates which give high image resolution, may give damping problems on the press. A compromise between these two is necessary to provide a balance between the requirements of the platemaker and pressman.

Exposing presensitised plates. Plates will only perform to expected potential if the exposure and processing requirements outlined by the manufacturer are followed closely. Most manufacturers recommend exposure to a numbered step on a sensitivity guide to give optimum results.

Plates must be exposed to short wave radiation produced in the blue and ultra violet band of the spectrum (*see Section 4,* "Light Sources"). Exposure of the negative working coating produces a photochemical reaction which makes the coating insoluble and integral with the plate surface. The unexposed areas are removed during development.

Exposure of the positive working coating causes the coating to become unstable, allowing it to be removed with a suitable developing solution.

The negative working coating will therefore develop away clean unless exposed, and the positive working coating will develop away clean only if exposed (*see fig. 180*).

Processing. Most presensitised plates may be processed with little craft skill. Wide tolerances are permitted in development and processing and in general over-development has no harmful effect. Application of the developer solution causes the coating to soften slightly and hard rubbing of the image areas should be avoided at this stage. Some plates benefit from the application of heat or heated air to remove the developing solvent and consolidate the image when development is complete.

Some short-run plates are simply exposed, developed and inked in, but the same plate may be lacquered after development to reinforce the image and give longer press life.

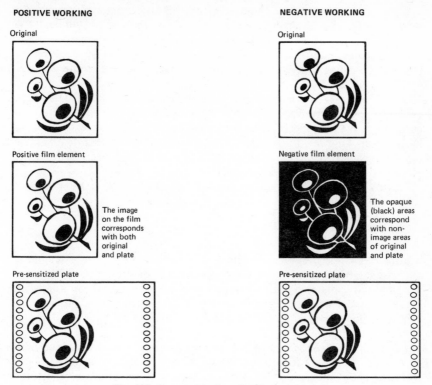

Fig. 180. Pre-sensitised surface image plates.

The following list indicates the solutions and agents used for plate development:

Diazo resin coatings (negative working)—Water development.

Diazo oxide coatings (negative working)—Acidified solution.

Diazo oxide coatings (positive working)—Alkaline solution.

Photopolymer coatings (positive and negative working)—Organic solvent.

Non-image areas of the plate must be made hydrophilic after development and this is achieved by applying a desensitising solution to the plate after development or by including the desensitising solution in the developer. Special gumming solutions may also be applied to the plate after desensitisation or be included in the developer.

Deletions. The removal of unwanted work is no problem with pre-sensitised plates. Of course, "prevention is better than cure" and with a perceptive approach much of the unwanted work, film edges, etc., can be avoided.

Deletions can be made with an abrasive stick or rubber but the superior method is the use of chemical deletion fluid which does not damage the plate grain. The plate should be desensitised after making a deletion.

Post process, heat fusing of presensitised plate images. In more recent years a technique has been introduced to extend the "press-life" of presensitised plates.

The potential of a normally processed plate may be multiplied as much as ten fold, giving runs, of up to 1,000,000 impressions. The treatment is to cure the image in a special oven, the effect is to produce an exceptionally hard image. One word of warning! Film edges or un-wanted dirt *must* be removed *before* fusing stage. One technique suggested is to process the plate, proof it, clean it, re-proof, wash out, re-develop and fuse.

Having established the image by heat fusing, there is no chemical method of deleting.

(5c) THE WIPE-ON PROCESS

Wipe-on plates are supplied uncoated, the light sensitive diazo resin coating is applied by the platemaker prior to use. The platemaking department which does not possess a whirler may on occasion have the need to coat a plate, either for dropping in additional work on a finished plate or simply as an alternative to the presensitised plate. The wipe-on process fulfils this need and bridges the gap between the presensitised and whirler coated plate.

An additional advantage of the wipe-on coating is that it can be used to produce half-tone images on inexpensive, non-sensitised paper plates used for short runs on small offset presses. For paper plates the same procedure for exposure and processing is used as for aluminium plates.

The characteristics and processing of wipe-on plates is similar to that for presensitised plates. At present most of the wipe-on processes offered to the trade are negative working, but at least one manufacturer is conducting field trials of a positive working wipe-on process.

Mixing the coating. Coating solutions will oxidise and become unusable if the ingredients are mixed together and allowed to stand for any length of time. It is therefore necessary to mix only sufficient coating which is required for immediate use. Coating ingredients are supplied in two separate bottles, one containing the diazo resin and the other the solvent and wetting agent. The coating is prepared for use by carefully pouring the diazo resin into the bottle containing the solvent, which is thoroughly shaken until the diazo is dissolved.

Wiping-on the coating. A quantity of coating is poured on to the centre of the plate and then smoothed evenly over the whole surface using a special lint-free wiper which has been folded to form a pad.

In the case of a small image, it is possible to coat the local area only. The coating should be smoothed with long straight strokes rather than

a circular action (*see fig. 181*), and fanned dry with warm air. Unevenness or streaks in the finished coating will have little adverse effect upon the quality of the image. When dry, wipe-on coatings behave in a similar mânner to presensitised plates, and are unaffected by humidity and temperature changes. They require short exposure times and have slow dark reaction. Because of this latter characteristic, it is possible to coat and dry a batch of plates which must then be stored in a light proof container for later use. In this way sufficient plates for up to one week's work can be prepared.

Fig. 181. Smoothing the wipe-on coating with long straight strokes.

Exposure. Treat these plates the same as presensitised plates.

Plate inking. Using a pad of cotton wool apply a small quantity of inking-in solution and rub down evenly over the image areas.

Development. A quantity of developing solution is poured on to the plate and swabbed until all the non-exposed coating is removed from the surface. Some developers contain a desensitising agent which prevents the ink on developed areas from attaching to the plate. A special develper which contains a lacquer may be used to reinforce the image for longer press life.

Rinsing off. Aluminium plates are washed under running water. Paper plates are washed clean with cotton wool and a minimum of water. Gumming is required as for presensitised plates.

Additions and deletions. Additions to the plate may be made in the following way:

- Rinse off the gum and apply a 2 per cent sulphuric acid solution for half a minute. Wash off with water and dry the plate quickly.
- Apply the wipe-on coating to the area requiring additional work.
- Expose and process in the normal manner.

Deletions are easily made using the special deletion fluid recommended by the suppliers of the wipe-on process.

Roller coating for the wipe-on process. An alternative to the hand application of wipe-on coatings is the use of the roller coating machine. This machine is uncomplicated and easy to use. It produces a smoother and more consistent coating in a shorter time than coating by hand.

Plates may be coated at a speed of 1829 mm (72″) per minute and machines are available in a range of sizes from 360 mm to 1520 mm (14″ to 60″) in width.

Manufacturers claim up to 60 per cent saving on materials with less risk of splashing or dripping when using a roller coating machine.

Wipe-on Process Suppliers

Supplier	Plate	Min. size—ins.	Material	Run	Pos./Neg.
Wipe-on					
Grant	Mervac Wipe-Coat	All small offset	Aluminium	100,000 +	N
S.D Syndicate	SD Coat	10 × 15 upwards	Aluminium	20,000	N
S.D Syndicate	SD Coat	17 × 21 upwards	Aluminium	70,000	N
S.D Syndicate	SD Coat	19 × 25⅛ upwards	Aluminium	100,000	N
S.D Syndicate	SD Posikem	17 × 21 upwards	Aluminium	20,000	P (Testing)
Quadrimetal	W.O.	—	Aluminium	—	N

(5d) KODAK PHOTO RESIST (K.P.R.)

This is a negative working, light sensitive coating originally introduced in 1953 for the production of surface image litho plates. It was a roller coated process for use on grained zinc and the light sensitive coating was three times faster than the albumen process used at that time.

Since its introduction, K.P.R. has found wider application and is now used in the production of printed circuitry, ceramics, metal decorating, U.V. cured paints, lithographic presensitised aluminium plates and multi-metal plate coatings. Little information is available regarding the chemical composition of K.P.R., but from the patents assigned to Kodak it can be assumed that the light sensitive component is polyvinyl cinnamate or a closely related compound.

Polyvinyl cinnamate when coated on a lithographic plate and exposed to actinic light reacts causing the polymeric chains of the compound to crosslink and become insoluble. During development the unexposed areas of the coating are removed (originally trichlorethelene vapour was used in a special processor and care was required not to damage the delicate image at this stage. Modern coatings are much improved and may be processed with a liquid solvent and friction during development).

For some years K.P.R. has been used by at least one major plate manufacturer for their negative working presensitised plates. Since K.P.R. is colourless early plates were processed by the "Additive" principle, the developer carrying a desensitiser and colouring medium. This did not prove to be very successful due to the "messy" processing stage and platemakers found it difficult to clear the non-image areas of the plate.

Modern K.P.R. plates are prepared by coating the aluminium with K.P.R. sensitised coating which is then sprayed with a coloured dye. The result is a plate which is processed as a "subtractive" coating using a modified developer based on methanol oxynyl acetate. Development now produces a clear, desensitised non-image area with evenly coloured images.

When pressure sensitive tape is used to secure a planning flat to a K.P.R. plate, it may remove the red dye on the plate when the tape is lifted off. This will have no adverse effect on the sensitive coating since only the dye is removed, the colourless K.P.R. coating remains intact and may be exposed to form a permanent image.

When K.P.R. is used in the production of multi-metal plates it forms a stencil resist which protects those areas of the plate which do not require etching.

K.P.R. is supplied in liquid form and is applied to plates by roller coating machines. The coating is developed with xylol.

(5e) THE DEEP ETCH PROCESS

Since 1945 the Deep Etch plate has reigned supreme as the most popular plate used by lithographic pressmen. It's tough, slightly recessed image, provides long press runs with good working qualities. With the introduction of anodised aluminium plates the only real problem which pressmen experienced with Deep Etch plates was overcome. Today, despite the problems of processing these plates, Deep Etch is used for long-run quality multi-colour printing all over the world. As with all lithographic plates, the number of copies obtained from Deep Etch plates will depend on many variable factors (as we discussed earlier). However, press runs between 200,000 and 500,000 copies can be expected.

Advantages of the Deep Etch anodised aluminium plate. The success of this plate is due to the following advantages:

(i) *Less fountain solution is required to dampen the plate.* This is due to the cell-like structure of the anodic surface layer (*see fig. 182*). Each cell contains a central capillary pore which gives the overall surface a slightly porous quality. The effect is to allow the pressman to run less water on the plate with the following benefits:

- Better ink/water balance.
- Colours print brighter without loss of density, particularly metallic inks.

- The dimensional stability of the stock is less affected by absorption of excess moisture.
- Ink emulsification problems are reduced.
- Better control of damping when printing on non-absorbent stock.
- Printed sheets less likely to curl in the press delivery.

(ii) *Reduced surface corrosion.* The anodic layer (electrochemical aluminium oxide), provides a surface which is resistant to corrosion.

- Surface wear of non-image areas of the plate is caused by friction from damping and inking rollers and accumulated particles on the blanket. Anodised plates have greater resistance to such wear.
- The non-image areas of the plate are more receptive to desensitising solutions.
- Fewer press stoppages. Gumming up of the plate is not necessary for short press stops and the press may be left on "crawl" during pile changes without adverse effect to the plate.

(iii) *Good image resolution.* The slightly recessed image is formed with a plastic vinyl lacquer which is oleophilic, acid resistant and durable.

- The etched recess provides a shoulder around the edges of the image which imparts a sharper quality to the printed image.
- The recess also protects the image from wear because it is slightly below the level of the non-image areas of the plate surface.
- Good image resolution is obtained for even the finest tones because the image is etched to provide a relatively smooth profile. Images are therefore unbroken by grain structure of the surface.
- The recess enables a slightly thicker ink film to be carried without spread of the image into non-image areas. This results in improved colour weight especially with printed solids.

There are no significant disadvantages for the press operator when using Deep Etch anodised aluminium plates. All of the factors above indicate a plate which is easy to control on the press with maximum quality of production.

There are, however, a number of disadvantages in the production of Deep Etch plates:

(i) A large number of variables are associated with plate production, each of which may adversely affect the final plate. Strict control over these variables is necessary if consistent results are to be obtained.

(ii) Dichromated gum arabic coatings are sensitive to. changes in humidity and temperature. The process works best in a controlled atmosphere. If relative humidity rises to 75 per cent the process may become unworkable.

(iii) Unfortunately Deep Etch plates can be made badly and the deficiencies may not become apparent until the plate is on the press. Quality control aids such as star targets and step wedges should be

used by the platemaker and left on the finished plate for inspection. If this is done, plate failure on the press may be traced to its proper source.

(iv) The many stages of Deep Etch production render it a lengthy process in comparison to other processes. Large plates may take several hours to complete.

(v) The process demands a high degree of skill to give consistent results. This is in direct contrast to the production of presensitised plates which can be processed with little expertise.

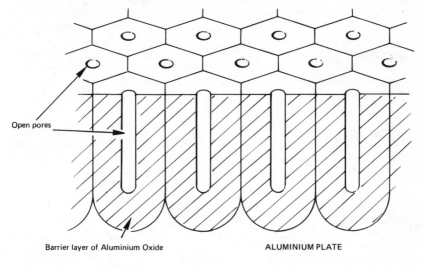

Open pores

Barrier layer of Aluminium Oxide ALUMINIUM PLATE

Fig. 182. A sectional view of the anodic layer.

Deep Etch Processing Procedure

The general objective of the process is to produce a hardened gum stencil over the non-image areas of the plate. The unhardened areas are developed away to allow the etchant to attack the plate until a slight recess is formed in the surface. These areas are then coated with lacquer to form the image. The main stages of processing are shown below: (*see fig. 183*)

(i) Washing and chemically cleaning the plate surface.
(ii) Coating the plate.
(iii) Exposing.
(iv) First stop-out.
(v) Development.
(vi) Etching.
(vii) Spirit washing.
(viii) Second stop-out.

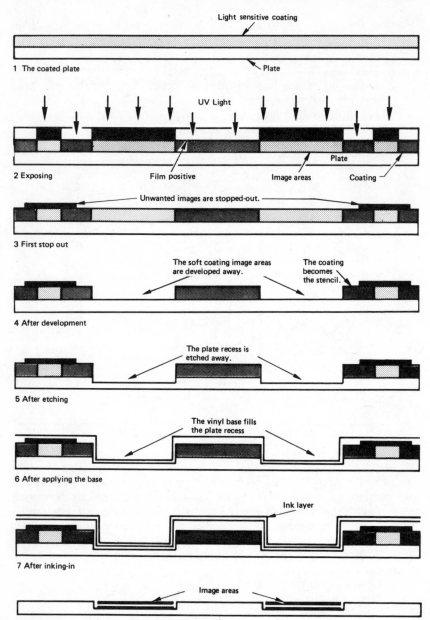

Light sensitive coating

1 The coated plate

Plate

UV Light

2 Exposing

Film positive

Image areas

Coating

Plate

3 First stop out

Unwanted images are stopped-out.

4 After development

The soft coating image areas are developed away.

The coating becomes the stencil.

5 After etching

The plate recess is etched away.

6 After applying the base

The vinyl base fills the plate recess

7 After inking-in

Ink layer

8 The finished plate with the stencil removed

Image areas

Fig. 183. Deep etch processing stages.

(ix) Applying lacquer base.
(x) Inking-in the image.
(xi) Removing the stencil.
(xii) Gumming up.

We will now consider these stages more closely:

(i) *Washing and chemically cleaning the plate.* The plate should be examined to ensure that it is free from kinks, or surface blemishes. Place the plate in the sink and thoroughly wash with cold water. Drain the water from the surface and apply a counter etch solution (5 per cent sulphuric acid solution) by liberally pouring it over the plate and rocking it gently for 30 seconds. After washing the counter etch from the surface it should be gently scrubbed under running water with a soft bristle brush. This treatment will ensure that the surface is chemically clean, free from grease, dirt and loose particles of aluminium oxide which would otherwise mar a good coating.

Some manufacturers do not insist on the application of counter etch during this preparatory stage.

(ii) *Coating the plate.* Deep Etch coatings, obtainable from most lithographic trade suppliers, are similar in manufacture to the following formula:

Gum arabic solution, 14° Baume: 3,410 millilitres (3 quarts).

Ammonium dichromate solution, 14.2° Baume: 1,137 millilitres (1 quart).

Ammonium hydroxide 28 per cent: 138 millilitres (4¾ liquid ounces).

The coating should be strained through a nylon filter into a container from which it will be poured on to the plate. Special pourers are marketed which allow a smooth, bubble-free flow of solution, but many platemakers find an enamelled teapot an excellent means of applying the coating to the plate.

After counter etching, the wet plate is secured in the whirler and whirled at approximately 90 r.p.m. with the water arm in the central position, flushing the plate with water. With the coating container in one hand, the water arm is removed and turned off. Calculating a 20 second delay to allow most of the water to flow off the plate, pour the coating on to the centre. The container must be kept close to the plate to prevent splashing and a sufficient volume should be poured quickly to cover the entire plate. After inspection to determine the quality of the coating the whirler lid is lowered gently and the fan heater switched on to dry the coating.

Dichromated gum arabic coating

Aluminium plate

Fig. 184. The coated plate.

After approximately three minutes the coating will be dry; it should be rejected if blemishes appear in those areas which will be occupied by the images. Reject coatings may be scrubbed off with water and reprepared as before.

Before removing a successful plate from the whirler, damp spots at the edges of the plate and clamp marks should be carefully dried with a cloth. Thoroughly dry the back of the plate before placing it into the vacuum frame.

Note. After the plate has dried, the ammonia in the coating will continue to evaporate during the next 50 minutes. This will lower the pH of the coating and thus increase its light sensitivity. If a half-tone image is stepped several times during this period the difference in coating sensitivity will be apparent when the results of the first and last exposures are compared. To eliminate this variation the coated plate should be placed in a light-proof box to enable the coating to stabilise before exposures are made.

Coating sensitivity is also affected by variations in humidity and temperature (*see fig. 185*).

The light sensitivity of the dried coating increases with an increase in temperature

The light sensitivity of the dried coating increases with an increase in the relative humidity

Fig. 185. The effects of relative humidity and temperature on cooling sensitivity.

(iii) *Exposing.* The purpose of exposing the plate is to harden the coating in the non-image areas and form a stencil resist to developer and etchant. The opaque areas of the positive will prevent the light hardening the coating in the image areas which are then easily removed by the developer.

Thoroughly clean the glass of the printing down frame before positioning the plate in the frame. Carefully position the positive flat with the film emulsion contacting the coating. The frame is now closed and locked and the vacuum pump switched on. Ensure that good contact is obtained before exposing.

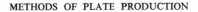

Fig. 186. Exposing the plate.

The following exposures will serve as a guide to expose the Deep Etch plate:

Using a 50 amp open arc lamp at 1 metre (39″)—5 minutes.

Using a flip-top with mercury halide lamp—1 minute.

After exposure the positive flat is removed and the plate placed on a clean dry bench.

A burn out exposure may be made to harden unwanted images such as film edges to avoid unnecessary delays at the stop-out stage. Burn out exposures may be made before or after the image exposure.

(iv) *The first stop-out*. In order to protect unwanted images (such as dust spots and film edges) from development, a spirit-soluble stop-out paint is brushed over them (*see fig. 187*). The solution should be applied in a thin even layer; thick layers of stop-out only take longer to dry.

A wooden bridge should be used as a hand rest when stopping-out, this will prevent moist hands touching the coating, impairing its quality (*see fig. 188*).

Proprietary brands of stop-out are based upon spirit based lacquer.

The first stop-out prevents the development of unwanted areas

Fig. 187. Stop-out protecting the unwanted areas.

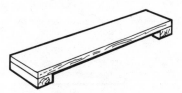

Fig. 188. Wooden hand rest for stopping-out.

(v) *Development.* The purpose of development is the complete removal of the unexposed coating from the image areas. This will leave a hardened stencil to protect the non-image areas during the etching stage.

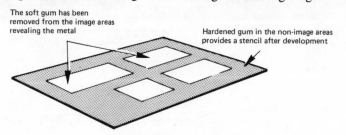

The soft gum has been removed from the image areas revealing the metal

Hardened gum in the non-image areas provides a stencil after development

Fig. 189. The gum stencil.

Deep Etch developers work best when they are used in conjunction with the coating for which they were formulated. Most developers are similar to the following formula:

Zinc chloride	1,360 grammes (3 lbs).
Calcium chloride	2,721 grammes (6 lbs).
Lactic acid	654 millilitres (23 liquid oz).
Water	4.575 litres (1 gallon).

Density adjusted to 41; 5° Baume at 25°C (78°F).

Special proprietary developers with a different density from the above are marketed to give either fast or slow development where certain difficulties are experienced.

Method of development. Place the plate on a down-draught table and pour on sufficient developer to cover the image areas. Using either a soft bristle brush or pad of cellulose wadding, gently circulate the developer over the image areas. Replenish with fresh developer occasionally taking care to maintain an even circulation and thus avoid uneven development of the images.

Development time will vary due to atmospheric condition and may be judged by eye, watching the highlight areas (the smallest dots) clear. Better control of development is obtained by using a continuous-tone step wedge (sensitivity guide). As a general rule, a clear step 7 on the wedge will indicate correct development at which point the developer should be squeegeed from the plate.

The coating from the image areas has been removed during development

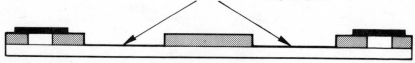

Fig. 190. Following development.

(vi) *Etching.* The purpose of the etching stage is to recess the image areas slightly below the plate surface. It is recommended to use an etchant which has been formulated to work with the other chemicals used and the metal (anodic layers may require special etchants to open the pores of the oxide cells).

A typical etchant for anodised plates is as follows:

Magnesium chloride 41° Baume	1,000 millilitres (35 fluid ozs).
Ferric chloride solid	250 grammes (9 av ozs).
Hydrochloric acid	200 millilitres (7 fluid ozs).
Fluoraboric acid	10 millilitres (0.35 fluid ozs).

The etchant should be poured over the plate and gently circulated with either a soft bristle brush or cellulose wadding over the image areas. Etching time is between three and four minutes during which time the etchant may need replenishing. Slight effervescing of the plate may occur.

The gum stencil prevents the etchant
from etching the non-image areas The aluminium is deep etched by the etchant in the image areas

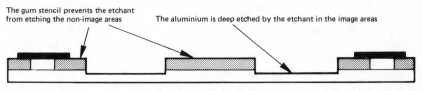

Fig. 191. Etching the plate.

When complete, the etchant must be squeegeed from the plate and the remaining etchant removed with a pad of cellulose wadding.

Note. When using brushes for development and etching care must be taken to keep the brushes separate. Painting the handles in different colours and keeping them in plastic containers of the same colour will avoid confusion. The salts used in developer and etchant will also absorb moisture from the atmosphere over a period. Brushes and pads ought to be washed out and thoroughly dried regularly.

(vii) *Spirit washing.* The purpose of the spirit washing stage is to remove all traces of chemical from the plate surface. A perfectly clean image is necessary for the vinyl lacquer to make perfect adhesion to the plate surface. It is at this washing stage that most errors concerning image quality occur. The slightest trace of chemical remaining on the image area will prevent adherance of the lacquer to the metal. This may not become apparent until the stencil is removed, when the lacquer in the contaminated areas will lift from the metal, producing a broken image. Such a plate will be useless on the press.

Method of washing with spirit. Anhydrous alcohol, such as "Isopropanol" should be liberally washed over the plate. Using cellulose wadding, wipe the surface, allowing the first stop-out paint to dissolve. Apply more alcohol and with fresh wadding swab the plate centre and move in an

enlarging circle, pushing the spirit off the edges of the plate. By this means all chemical residue will be moved from the centre to the edges (*see fig. 192*). Take care not to return the wipe from the edge to the centre, but

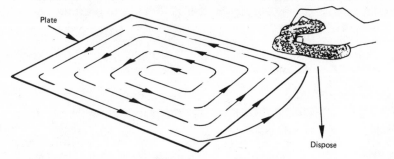

Fig. 192. *Spirit washing from the centre of the plate in enlarging circles to remove all chemicals.*

dispose of it and with a fresh wipe and more alcohol repeat the operation in the same manner. This should be done at least seven or eight times when, following the last operation, the plate is quickly dried with hot air.

Notes. If the wipe is moved from the edge of the plate back over the image areas, chemicals from the bench or plate edge will contaminate the plate centre again. This "wipeback" action may result in the formation of streaks of chemical over the image areas which when based in will form "blind" streaks and render the plate useless. The alcohol must not be allowed to dry off at room temperature during the washing operation. If evaporation does occur this may lower the surface temperature of the plate and produce slight condensation on the stencil. This problem is identified on finished plates by the appearance of irregular rings in the work.

(viii) *The second stop-out.* At this stage, unwanted images, pin-holes or blemishes in the stencil are more easily seen and can now be coated with a thin layer of water-soluble stop-out solution (*see fig. 193*). This will prevent the vinyl lacquer base from adhering to the metal plate in the unwanted areas.

The second stop-out prevents the lacquer base from contacting the plate and forming unwanted images

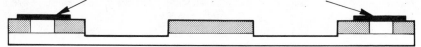

Fig. 193. *The second stop-out.*

Proprietary brands of coloured stop-out solution may be used, although the normal Deep Etch coating with a little liquid opaque added is quite satisfactory.

Method of stopping-out. Using a wooden bridge on which to rest the hands, carefully paint out unwanted areas, taking care not to touch image areas. Second stop-out on image areas is very difficult to remove; however, it may be possible to remove it while wet with a cotton wool bud soaked in developer. This will necessitate a fresh washing of the plate with alcohol before the process can be resumed.

When complete the stop-out solution should be dried with warm air.

(ix) *Applying the vinyl lacquer base.* This operation is known as "basing the plate", and its purpose is to apply a thin layer of lacquer to the image areas to form an oleophilic image (*see fig. 194*). The lacquer is water and acid resistant, ink attracting and very durable; it is unaffected by the normal cleaning solvents used on the press and makes an ideal lithographic image material.

Unwanted laquer on the
surface of the stencil
will be removed later

The laquer base adheres
to the aluminium
in the image areas

The laquer base

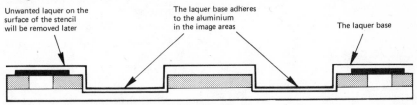

Fig. 194. Applying the Vinyl lacquer base.

Method of application. Due to the rapid evaporation of the solvent forming the base of the lacquer no delay must occur during the application of the lacquer to the image areas. Two pads of cellulose wadding are required, one to quickly spread the lacquer which is poured on the plate, and the other to smooth it down to a thin film in the image areas before it becomes tacky and dries.

Thick layers of lacquer will interfere with the removal of the stencil later. The lacquer must be thoroughly dried with warm air before inking in.

Note. In conditions of high temperature the rapid drying of the lacquer may cause problems. Slower drying lacquers are available to overcome this.

(x) *Inking in the image.* A layer of black, non-drying, greasy ink is now applied over the lacquer base. This serves to impart an oleophilic nature to the base and also protects it during the subsequent etching and gumming operations.

The layer of inking-in solution

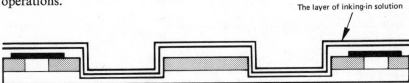

Fig. 195. Inking-in the image.

Applying the ink. Using a good quality inking-in solution, pour a small quantity on to the plate and spread evenly and thinly over the image areas with a pad of cellulose wadding. Smooth down to an even layer and dust with French chalk.

Note. French chalk will absorb the greasy ink lying over non-image areas and enable the ink to wash quickly away without adhering to non-image areas as the stencil is removed.

(xi) *Removal of the stencil.* This stage is concerned with removing the hardened gum arabic stencil from the non-image areas of the plate.

Place the plate in the sink under tepid water and allow the stencil to soften for a few minutes before brushing with a bristle brush. If the stencil is difficult to remove, drain off the water and flood the plate with 3 per cent phosphoric acid solution and allow to stand for about one minute. Brushing will now cause all the stencil to dissolve away.

Note. A small amount of residual coating which may remain as a slight yellowing of the non-image areas can be safely left on the plate. This slight deposit will aid the water attracting qualities of the plate on the press. If sulphuric acid solution is used to clear the stencil it should be remembered that the clean result is obtained because sulphuric is acting as a counter etch. The plate will require careful desensitising after such cleaning. A recommended alternative is to use a gum-etch supplied by the plate manufacturers.

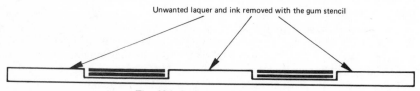

Unwanted laquer and ink removed with the gum stencil

Fig. 196. Removal of the stencil.

(xii) *Gumming up.* After rinsing the plate and draining off excess water, the plate should be gummed up, smoothed down and dried. Placing the plate face down on a clean, dry surface, remove any coating or other materials adhering to the back of the plate.

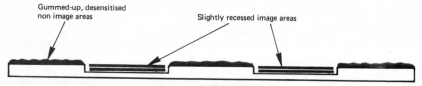

Gummed-up, desensitised non image areas

Slightly recessed image areas

Fig. 197. The completed deep-etch plate.

The finished plate should be compared with the film positive to see how accurately the tonal values have been reproduced. If a half-tone step

wedge has been used, inspection of the highlight and shadow dots will quickly reveal this.

Correct development will be indicated on the continuous tone step wedge and star targets. Image areas should be scrutinised for blemishes, wipe-back or incorrect development. Non-image areas should be clean and free from scum or film edges.

If there is the slightest doubt about the quality of the plate it should be rejected. A doubtful plate will usually deteriorate further when used on the press.

Deletions. Abrasives ought to be avoided when removing work from Deep Etch plates. The lacquer base can be removed with a suitable solvent such as amyl acetate. Proprietary chemical deletion fluids are recommended. These will ensure good removal of the unwanted areas without damaging the surrounding plate grain.

Before using a chemical fluid, the surrounding areas should be protected with a waterproof tape. Deletion fluids should be applied, either with a fine brush or with a cotton wool bud tightly wrapped around the end of a thin stick (matchstick). After making a deletion the fluid should be carefully washed off (away from image areas) and the plate regummed and dried.

ALTERNATIVE DEEP ETCH COATINGS: POLYVINYL ALCOHOL AND POLYMER COATINGS

Because of difficulties encountered when using dichromated gum coatings in humid conditions (hygroscopic gum arabic readily absorbs moisture from the air), alternatives were developed. Research has produced a number of plastic-based coatings such as polyvinyl alcohol (P.V.A.) which are used in a similar manner to conventional gum coating. Their main advantage is that they are unaffected by changes in relative humidity and development is therefore not so critical.

Polyvinyl alcohol. This type of coating is based on polyvinyl alcohol with ammonium dichromate functioning as the sensitiser. When exposed through a positive the non-image areas become insoluble in water. Exposure times are approximately half that required for gum coating.

A water spray is used to develop the image, brushes and pads must not be used. After development a dilute chromic acid solution is applied to the plate to harden and strengthen the stencil.

The etchant is applied with a brush or pad in the usual manner and then washed with water to remove all chemicals and dried. No alcohol wash is necessary with P.V.A. coatings.

Lacquering and inking-in are the same as for gum coating Deep Etch. Stencil removal is obtained by using dilute sulphuric acid solution on aluminium and stainless steel (bi-metals) while a hot alkaline solution is used for chromium surface plates (multi-metal plates).

P.V.A. coatings produce a tough stencil and this makes them ideal for producing multi-metal plates where the stencil has to withstand long etching times with highly corrosive etches. However, the process has not proved popular in the U.K. for the following reasons:

- There is limited control of development which may be critical in the reproduction of half-tones.
- The coating is inclined to swell slightly during development with a subsequent sharpening of the image.
- Unless the stencil is completely cleared from the non-image areas it may cause scumming on the press.

"Water wash" Deep Etch process. This process is a modern development and offers the advantage of water washing the plate after etching instead of spirit washing. The coating is based on polymers and uses an acid developer to give critical control at the development stage.

Howson-Algraphy market a "water wash" process called "Alcolith" which is designed for use with their A.S.3 anodised plate, but the process is suitable with any anodised aluminium or multi-metal plate providing suitable preparation is made before coating.

Main stages in processing:
- (i) Cleaning the plate.
- (ii) Coating.
- (iii) Exposure.
- (iv) Development.
- (v) Etching.
- (vi) Water washing.
- (vii) Stopping-out.
- (viii) Lacquer basing.
- (ix) Inking-in.
- (x) Removing the stencil.
- (xi) Bleaching.
- (xii) Gumming up.

Many of these stages are the same as gum Deep Etch processing, but significant differences are indicated as follows:

(i) *Cleaning the plate.* Thorough cleaning of the plate surface is necessary to ensure that the coating will not lift away during the water wash stage. A counter etch of 6 per cent sulphuric acid should be used on anodised plates followed by scrubbing with a soft bristle brush. No acid counter etch should be used on the A.S.3 anodised plate.

(ii) *Coat at 90 r.p.m.* The plate may be stored in a light-proof box for up to 24 hours.

(iii) *Exposure* through a positive will require about 40 per cent less light than the normal Deep Etch plate.

(iv) *Development.* The special developer must be used and is complete when a clear step 8 on the continuous tone step wedge is obtained.

(v) *Etching* is performed in the normal manner, minimum period, four minutes.

(vi) *Water wash.* The plate should be sprayed lightly with water for at least three minutes. Do not swab the surface. It is not normally possible to wash for too long. Stand the plate to drain and dry with warm air, or place the plate in the whirler, flush quickly with water and then spin under warm air to dry.

(vii) *Stopping-out.* The normal procedure is followed for stopping-out but the special stop-out solution for the process must be used.

(viii) *Lacquer basing and inking-in* are applied in the normal manner.

(x) *Stencil removal.* After wetting the plate with water it should be flooded with a 3 per cent phosphoric acid solution and scrubbed lightly with a bristle brush.

(xi) *Bleaching.* This operation is to remove any blue dye from the plate surface which may remain after stencil removal. A slight blue tint left on the plate will have no adverse effect on the working properties of the plate on the press.

(xii) *Gumming up* is performed in the normal manner.

PRESENSITISED DEEP ETCH PLATES

A number of presensitised Deep Etch plates are now on the market. They do not require a whirler for coating and are unaffected by atmospheric changes with little dark reaction. Presensitised coatings of this nature produce a hard stencil which has made them suitable for both Deep Etch and multi-metal plates.

The Krause V.S.P.7 is a presensitised, micrograined aluminium Deep Etch plate. It uses a positive working photopolymer coating which is developed with water. The same coating is used for presensitised multi-metal plates.

Main stages in the processing of Krause V.S.P.7 plates is as follows:

(i) Exposure.
(ii) Development.
(iii) Etching.
(iv) Spirit washing.
(v) Stopping-out.
(vi) Lacquering.
(vii) Inking-in.
(viii) Stencil removal.
(ix) Gumming up.

(i) *Exposure.* Remove the presensitised plate from its light-proof wrapper and carefully position and secure the positive planning flat on the plate. An exposure time of 40 seconds using a metal halide point source lamp at one metre is recommended. Exposure times, of course, will depend on the type of lamp used and a series of test exposures should be made to ascertain correct time and distance for the lamp.

(ii) *Development.* The plate is placed in the sink and sprayed with water and light swabbing with a plush pad for one minute. This should yield a clear step 6 on the continuous tone step wedge (*see fig. 198*). The plate should be stood on end for a few minutes to drain off surplus water.

Development is terminated when step 6 clears

Fig. 198.

(iii) *Etching.* Sufficient etchant to cover the image area is poured on to the plate and circulated with a plush pad for one minute. Squeegee off the surplus etchant.

(iv) *Spirit washing.* An anhydrous alcohol such as Isopropanol is used to clean the plate surface in the same manner as conventional Deep Etch plates. Dry with warm air.

(v) *Stopping-out.* All unwanted areas are now painted out with a water soluble stop-out solution and thoroughly dried with warm air.

(vi) *Lacquering.* An aluminium enamel lacquer is applied to the image areas with a pad of cellulose wadding and rubbed down to a thin film and dried thoroughly with warm air.

(vii) *Inking-in.* The protective ink solution is applied to the image areas with a cellulose wadding pad and rubbed down to a thin film. Dust the surface with talc.

(viii) *Stencil removal.* After flushing the plate with water a special solution containing potassium permanganate will quickly remove all traces of stencil. This is followed by flushing the plate with a solution of 3 per cent phosphoric acid for one minute. Wash the plate thoroughly with water and drain off the surplus.

(ix) *Gumming up.* This is performed in the normal manner using Krause Gum Gm 55.

United Kingdom agents for Krause plates are S D Graphics Ltd., Westminster Bridge House, Westminster Bridge Road, London, S.E.1.

(5f) MULTI-METAL PLATES

For convenience, the term "multi-metal plates" is used to describe lithographic plates that are of bi-metal and tri-metal construction. Both types use only two lithographic metals on the printing surface. In the case of tri-metal plates the third metal serves as a substrate metal support for the other two metals. This type of plate utilises the hydrophilic and oleophilic characteristics of certain metals which are used in their construction.

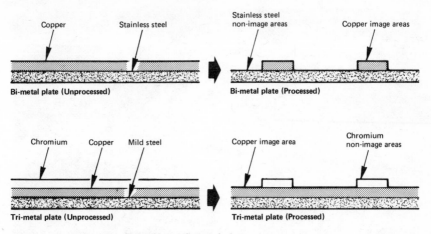

Fig. 199. Multimetal plate constructions.

The increasing popularity of multi-metal plates is due to the following factors:

Long press life. Multi-metal plates have been developed since the 1930's with modern plates yielding long press runs and good image resolution. They are capable of producing millions of high quality impressions and are resistant to press running problems. This is due to the relative hardness of the metals used in plate construction.

Improved processing techniques. Until recently all multi-metal plates required whirler coating, but now a large selection of presensitised plates are available. Chemical reaction between etchant and chromium surface layer produced very unpleasant toxic fumes on early plates. This has now been largely overcome on modern plates although they must still be processed on a down-draught table.

The growth of web-offset printing. High speed, long run printing from web-offset presses has created a demand for a long run plate.

The narrow "cut off" on the web press allows only a small area of the plate cylinder for the plate clamps. This means that the plate has to bend at a sharp angle into the leading and back-edge clamps of the cylinder (*see fig. 200*). If the plate does not fit tightly to the cylinder body, metal fatigue will cause the leading or back edge of the plate to split. For this reason the multi-metal plate with brass as the base metal has become popular on web presses (brass being less prone to splitting).

Printing heavy duty cartons. The resistance of the multi-metal plate to surface abrasion is an attribute which is of great value when printing on inexpensive fibre and carton board. The piling of loose fibres and abrasive particles from the stock on the surface of the press blanket causes rapid deterioration of less durable plates.

Fig. 200. Close-up of the narrow clamping arrangement on a web offset press.

Contact Angles and the Wettability of Liquids for Metals

The study of the contact angles produced when an oil drop comes into contact with a water-wet plate has done much to improve the manufacture of lithographic plates and chemicals. The contact angle (*see fig. 201a*) indicates the relative wettability of a metal by oil or water, and the profile of the droplet is measured as shown in *fig. 201b*.

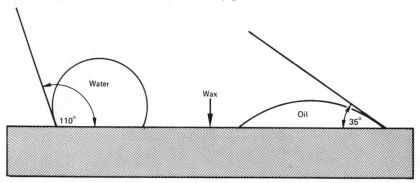

Fig. 201a. Contact angles and the wettability of liquids for solids.

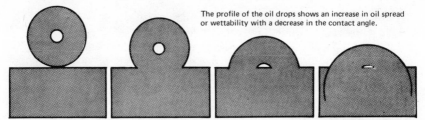

Fig. 201b. Projected profile of oil drops in contact with metal surfaces.

The principle of printing by lithography involves the simultaneous wetting of two metal surfaces (when using multi-metal plates) by two immiscible liquids—oil based ink and water.

Studies carried out by P.I.R.A. have indicated the relative oil rejecting nature of different metals in the presence of water, the results of this study are shown in *fig. 202.*

CONTACT ANGLE MEASUREMENT
OF THE SYSTEM OIL/WATER/METAL SURFACE

Metal	Normal Metal Surface (2)	Chemically Cleaned Metal Surface (3)	Normal Oxide in Air
Silver	$64°$	$50°$	Ag_2O
Zinc	$30°$	$30°$	ZnO
Copper	$77°$	$60°$	CuO
Brass	$86°$	$75°$	—
Nickel	$100°$	$83°$	NiO
Stainless Steel	$110°$	$86°$	—
Aluminium	$140°$	$50°$	Al_2O_3
Chromium	$150°$	$107°$	Cr_2O_3

Fig. 202. Table of contact angle measurements.

It can be seen from the resulting contact angles that metals such as copper are readily wetted by oil, while a metal such as chromium is strongly oil repellent. In the construction of multi-metal plates oleophilic-type metals are used to form image areas and hydrophilic-type metals for non-image areas of the plate (*see fig. 203*).

HYDROPHILLIC METAL (Non image areas)	OLEOPHILLIC METAL (Image areas)	BASE METAL
Stainless steel	Copper	Stainless steel
Chromium	Copper	Copper
Chromium	Copper	Mild steel
Chromium	Copper	Aluminium
Chromium	Brass	Brass
Aluminium	Copper	Aluminium

Fig. 203. Combinations of metals used in multi-metal plate construction.

Surface and Sub-surface Images

The arrangement of metal layers in the multi-metal plate produce either a surface image plate (*see fig. 204*) or a sub-surface plate (*see fig. 205*). The difference in height between the plate surface and the image in both cases is slight (0.008 mm—0.0003"), but different press performance is obtained from the two types.

In the case of the surface image the oleophilic metal is formed on the surface of the plate and is unprotected from press wear. The ink film thickness is critical, a small increase may yield a loss of tonal definition.

Fig. 204. Bi-metal surface image.

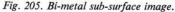

Fig. 205. Bi-metal sub-surface image.

Sub-surface images are protected from wear because they are recessed; this also allows the image to carry a slightly thicker ink film. Better resolution of the image is possible because the shoulders of the image inhibit image spread.

Metals Used in Multi-metal Plate Construction

Copper. A metal of reasonable hardness, it is resistant to oxidation and its fine crystalline structure enables the finest half-tone dots to be reproduced. The metal is always used as an image forming material, and is deposited on litho plates in manufacture by electro-deposition.

Chromium. Very hard and resistant to wear and corrosion, chromium is electrolytically deposited on the surface of either brass or copper. When processed it always forms the non-image areas of the plate.

The matt surface texture (or "tooth") is produced by electrolysis and obviates the need for graining.

Brass. This is an alloy of copper and zinc which is used to form the image areas and the base metal of some multi-metal plates. The good flexibility of the metal makes it an ideal plate for web-offset presses.

Stainless steel. This is an alloy of carbon steel and chromium or nickel. It is resistant to corrosion and always used as the non-image metal in multi-metal plates. Being less malleable than other metals it does not easily conform to the surface of the plate cylinder.

Processing Multi-metal Plates

Copper on stainless steel (surface plate). These plates are obtainable in presensitised and whirler coating form. The common whirler coated process uses dichromated gum arabic and is processed as follows (*see fig. 206*):

 (i) Removal of protective gum.
 (ii) Coating.
 (iii) Exposure.
 (iv) Development.
 (v) Alcohol wash and re-exposure.
 (vi) Etching.
 (vii) Stencil removal.
(viii) Sensitising the image.

(i) The plate is supplied with a protective gum coating on the surface. This is removed with water and the surface counter etched with a 4 per cent sulphuric acid solution and a fine abrasive (Tripoli powder). These should be gently agitated over the surface with a soft bristle brush and then washed off with water.

(ii) The plate is coated with normal Deep Etch gum coating at a whirler speed of 110 r.p.m. This will give a thin coating due to the higher whirler speed and the smoothness of the plate surface.

208

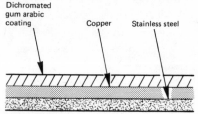

Dichromated gum arabic coating

Copper

Stainless steel

1 The coated plate

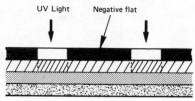

UV Light

Negative flat

2 Exposure

3 After development

4 After etching

5 After removing the stencil

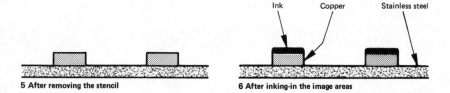

Ink

Copper

Stainless steel

6 After inking-in the image areas

Fig. 206. Processing the surface plate, copper on stainless steel.

(iii) Exposure is made through a negative flat; masking is required for non-image areas. Exposure is the same as for Deep Etch: 5 minutes at 1 metre (39″) using a 50 amp open arc lamp, or 1 minute to metal halide in a flip-top frame.

(iv) Develop as for Deep Etch, terminating the development at a clear step 7 on the continuous tone step wedge.

(v) Excess developer is now squeegeed off the plate and alcohol used to remove all trace of developer. The plate is now re-exposed (without masking or negative) to reharden the stencil prior to etching. Exposure will be the same as the original in stage (iii).

(vi) Etchant is now used to remove copper from the non-image areas of the plate. Rubber gloves should be worn and the plate etched on a down-draught table. The etchant should be gently circulated over the entire plate surface until the underlying stainless steel is revealed. When complete, the etchant should be squeegeed off and the plate washed clean with alcohol. If some traces of copper still remain around the edges of the plate they can be removed with local application of the etchant (but avoid image areas as over etching can cause sharpening of the image).

(vii) The stencil is easily removed by scrubbing the plate under warm water.

(viii) To sensitise the copper image to accept ink, a 5 per cent sulphuric acid solution is applied and the image rubbed up with a suitable ink. The plate is then gummed up and dried in the usual manner.

The Effect of Variables in the Process

Under-exposure. This produces a sharpening of the image with dot loss and possible breakdown of the entire image.

Over-exposure. This causes a thickening of the image and dot gain.

Over-development. This produces the same results as under-exposure.

Under-development. This produces the same results as over-exposure and also make the removal of copper from non-image areas difficult and result in background scum.

Over-etching. This will undercut the stencil and result in image sharpening and dot loss.

Under-etching. This will leave copper in the non-image areas which will print up on the press.

Chrome on brass or copper (sub-surface plates). These can be obtained with or without presensitised coatings. The following process steps are related to whirler coated plates using normal Deep Etch gum coating (*see fig. 207*).

(i) Removal of the protective layer.

(ii) Coating the plate.

(iii) Exposure.

(iv) Development.

 (v) Spirit washing.

 (vi) Re-exposing.

 (vii) Stopping-out.

(viii) Etching.

 (ix) Stencil removal.

 (x) Sensitising the image.

 (xi) Inking-in.

 (xii) Gumming up.

(i) Removal of the protective gum layer is achieved by scrubbing with a medium bristle brush under warm water. The surface is then counter etched with 2 per cent sulphuric acid solution lightly brushing for about 30 seconds followed by a rinse with water.

(ii) Coating is applied in the same manner as for Deep Etch, the whirling speed set at 80 r.p.m.

(iii) With the edges and back of the plate dry, the plate is exposed in the printing down frame through a positive. Use same exposure as for Deep Etch.

(iv) Development is the same as Deep Etch process, terminating the development when a clear step 7 is obtained. Surplus developer should be squeegeed off.

(v) Development is curtailed by washing the plate surface several times with alcohol, wiped with cellulose wadding and fanned dry.

(vi) An exposure equivalent to the original exposure (without positives or masks) will harden the coating for the etching operation.

(vii) Film edges and other surface blemishes must be stopped-out with normal Deep Etch stop-out solution. Ensure that the stop-out is thoroughly dry before proceeding to the next stage.

(viii) Etching will now remove chromium from the surface in the image areas and reveal the underlying copper or brass. An efficient down-draught table must be used.

The etchant is poured on to the plate and quickly circulated over the entire surface. Constant agitation should be applied with soft bristle brush or pad of cellulose wadding.

There may be an inactive period at the beginning, and if this continues for too long, the chrome surface should be touched with a small piece of zinc. This will act as a catalyst and activate the chemical action to vigorous effervescence. Spent etchant should be squeegeed off and fresh etchant applied. When the image areas are revealed etching should be terminated and after squeegeeing away the etchant the plate washed with alcohol to remove the stop-out solution.

(ix) The stencil will soften and lift away under running water. Stubborn areas of stencil can be removed with 2 per cent phosphoric acid solution.

(x) Although copper and brass are greasy metals, they do require some coaxing before they will accept ink. Surplus water is drained from the

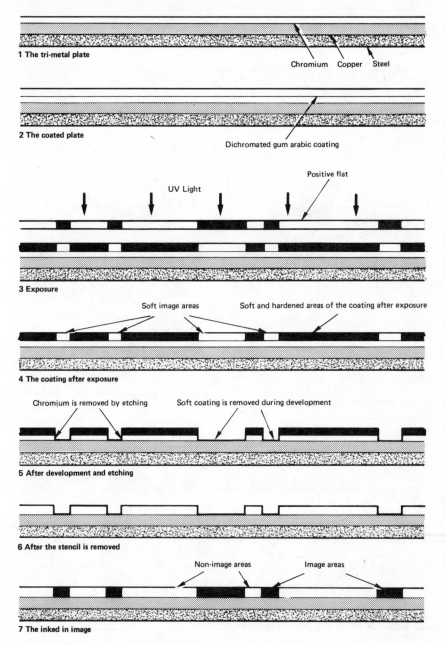

1 The tri-metal plate

Chromium Copper Steel

2 The coated plate

Dichromated gum arabic coating

Positive flat

UV Light

3 Exposure

Soft image areas Soft and hardened areas of the coating after exposure

4 The coating after exposure

Chromium is removed by etching Soft coating is removed during development

5 After development and etching

6 After the stencil is removed

Non-image areas Image areas

7 The inked in image

Fig. 207. Processing the sub-surface, tri metal plate, chrome/copper/steel.

212

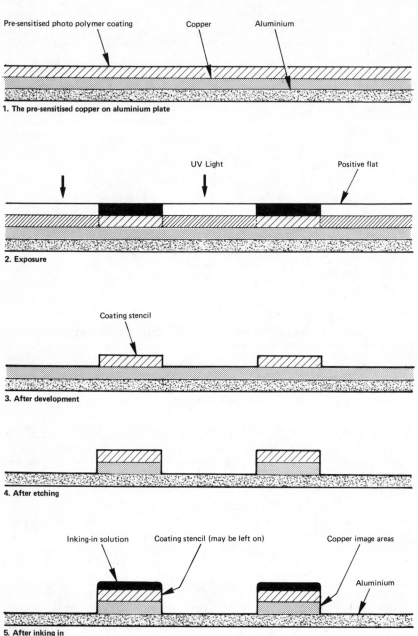

1. The pre-sensitised copper on aluminium plate

2. Exposure

3. After development

4. After etching

5. After inking in

Fig. 208. Processing the surface plate, copper on aluminium.

plate and a 10 per cent phosphoric acid solution applied to the surface.

(xi) Ink is applied to the image areas with the phosphoric acid solution still on the plate. Using a wad of soft cloth, the image is rubbed up with light pressure, damping the plate with more phosphoric solution as the non-image areas begin to pick up ink. In the final stages of inking-in, pour a few drops of gum on to the plate; this will assist in picking up surplus ink from the non-image areas. It is unnecessary to obtain a thick layer of ink on the image.

(xii) The chromium non-image areas are made hydrophilic by the use of phosphoric acid and gum solution. Gum up the plate in the normal manner and dry when complete.

Notes. The control of variables in this process are the same as for Deep Etch processing. Great care should be taken to protect the coating from water until the stencil is to be removed.

Copper on aluminium. This long-run plate with an aluminium base metal offers a comparatively inexpensive multi-metal plate. The aluminium is hard, cold rolled and tempered to resist cracking on plate cylinder clamps. It also possesses low stretch characteristics.

The copper surface metal is electrogalvanised to the aluminium with a total thickness of less than 0.03 mm (0.001″).

A positive working photopolymer, based on azo salts (diazo), is coated on to the copper surface of the plate. During exposure free acid salts in the coating are produced which readily dissolve in an alkaline-based developing solution. The stages of processing are as follows (*see fig. 208*)

 (i) Exposure.

 (ii) Development.

(iii) Removal of unwanted work and corrections.

(iv) Etching.

 (v) Desensitising.

(vi) Inking-in.

(vii) Gumming up.

(i) The photopolymer coating is relatively soft, and because it is coated on a smooth surface is easily scratched. To avoid surface damage the plate should be removed from the light-tight wrapping with its tissue interleaf still covering the coating. The positive planning flat is then positioned on the plate and the tissue carefully withdrawn.

Correct exposure should produce an open step 2 and a grey step 3 on the continuous tone step wedge (*see fig. 209*).

Correct exposure should produce an open step 2 and grey in step 3 on a Stouffer 21 step wedge

Fig. 209. A 21 step wedge.

(ii) A quantity of developer is poured on to the plate and gently circulated over the surface with a pad of cotton wool until all the soluble coating is removed (*see Fig. 211*).

(iii) Deletion will be necessary to remove unwanted work, film edges, etc. The manufacturer's deletion fluid must be used at this stage. Blemishes in solid areas of the image can be filled and protected from the etchant with litho tushe or Deep Etch lacquer base.

(iv) A non-fuming etchant, based upon modified ferric-chloride, is used to remove the copper from the non-image areas of the plate (*see fig. 212*). Rubber gloves should be worn. Pour a quantity of the etchant on to the plate and circulate with a pad of cotton wool. Etching is terminated when all traces of copper are removed and the aluminium is revealed in the non-image areas; squeegee off the etchant.

(v) The desensitiser will neutralise the action of the etchant and ensure complete desensitisation of the non-image aluminium surface.

(vi) The photopolymer remaining on the image areas can be left on the copper. It has a press life of about 150,000 impressions. This means that there is no direct wear of the copper image until the photopolymer has worn off, thus extending the press life of the plate. In common with most diazo coatings, if the finished plate is baked for up to ten minutes at 120°C, the coating is strengthened and will give an increased press life.

Any good quality inking-in solution may be used (*see fig. 213*).

(vii) The plate should be gummed up in the normal manner and dried.

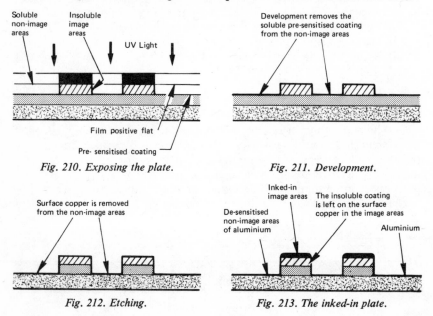

Fig. 210. *Exposing the plate.*

Fig. 211. *Development.*

Fig. 212. *Etching.*

Fig. 213. *The inked-in plate.*

Notes. Fine, reversed out work may be found difficult to keep open on the press. The aluminium will oxidise readily if not gummed up at each press stop.

Deletions on Multi-metal Plates

Deletion of surface images. Taking care to protect areas of the image, the unwanted areas are removed by applying the copper etchant locally.

Unwanted ink on the deletion area should be removed with alcohol. Waterproof tape or spirit-soluble stop-out solution should be used to limit the spread of etchant and protect adjacent images.

The copper etchant is applied locally with a bud of cotton wool wrapped around the end of a thin stick. After removal of the unwanted copper, remove the protective tape or stop-out and swab the plate with a phosphoric/gum solution. Rinse off and gum up in the normal manner.

Deletion of sub-surface images. This is achieved by patch plating. A thin layer of chromium is deposited over the copper or brass areas which are not required. Patch plating is performed with the use of an electrolytic kit supplied by the plate manufacturer. Deletions are made in the following way:

- All grease must be removed from the deletion areas with alcohol.
- Adjacent work should be protected with waterproof tape or spirit-soluble stop-out solution.
- Attach the crocodile clip of the negative lead of the electrolytic apparatus to the edge of the plate. The plating rod is connected to the positive lead. If these leads are reversed the process will not work.
- Prepare a bud of cotton wool around the end of the plating rod and then soak it in the plating solution. When this is applied to the deletion area the electrical circuit will be complete and vigorous effervescence will commence. The rod should be gently circulated over the deletion area for about ten seconds.
- Rinse away all plating solution with water. Remove tape or stop-out.
- Treat the plate with phosphoric/gum solution before gumming up in the normal manner.

(5g) THE DIFFUSION TRANSFER PROCESS

Also known as "chemical transfer" (C.T.) this process was originally marketed by Kodak Ltd. It has become popular as a rapid and inexpensive method of producing same size images (by the reflex method) and variable size images (by the projection method) on aluminium or paper plates for small offset use. Plates may now be obtained to fit the Solna 125, Harris 125, Heidelberg Kord and Roland Favorit presses.

Normally considered to be a short-run plate, the anodised aluminium plate will give up to 15,000 impressions, and with the aid of an enamelling solution this may be increased to 40,000 impressions.

Although mainly used for line work, good resolution of half-tone work can be obtained depending on the quality of the original "dot bromide". Five minutes is considered to be an average time for the production of a plate.

Since the process produces a plate direct from original copy, the copy must be prepared on white card or paper which is the same size as the negative paper used. The position of the images should take into account press clamp and gripper allowances in the same manner as a plate layout is prepared.

Reflex platemaking. The "contact speed" negative paper for reflex printing may be handled in subdued daylight or artificial room lighting, but must be kept away from bright light. Unused negative paper must be kept in its light-tight wrapper with the edges secured.

A sheet of "contact speed" negative and the original artwork are exposed together using the reflex technique. As light passes through the negative from the non-emulsion side it is reflected back by the white paper in the non-image areas of the original artwork on to the emulsion to form a latent image. The black areas of the artwork will absorb the light and this is not reflected back on to the emulsion (*see fig. 214*).

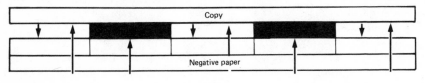

Fig. 214. The reflex process.

When using translucent or clear film positive originals, exposure can be made by transmitted light.

Processing Procedure

(i) Using a flat-bed exposing unit (*see fig. 215*), place the negative paper on the glass yellow (emulsion) side up.

(ii) Place the original artwork squarely on the negative paper face down and cover both sheets with a sheet of white paper slightly larger. The white sheet acts as a reflector and prevents a dark border being produced if the original does not fully cover the negative paper.

(iii) Close and secure the lid of the unit and switch on the vacuum pump. Ensure good contact is obtained before making the exposure.

(iv) Set the timer for the required exposure and switch on the light. A test strip should be used to determine correct exposure time which will be about 30 seconds and not less than 10 seconds.

Fig. 215. Flat bed exposing unit.

(v) Remove the negative paper from the exposing unit and place face down on to the grained (active) side of the press plate. Position squarely with the gripper edge 12 mm ($\frac{1}{2}''$) from the gripper edge of the plate; this will ensure that the negative will fall centrally on the plate after passing through the pressure rollers of the developing unit. Holding the two firmly so that they cannot slip, insert plate and negative into the developing unit (*see figs. 216 and 217*). Hold firmly until the pressure rollers have gripped both sheets (*see fig. 216*).

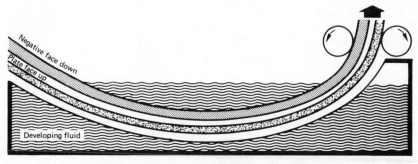

Fig. 216. Showing passage through the developing unit.

When both sheets have been ejected, 30 seconds should be allowed before stripping them apart with slow careful action. Diffusion transfer of the image from negative to plate (*see figs. 218 and 219*), cannot take place unless more than 20 seconds is allowed. The negative should be peeled off from the gripper edge first. The negative is then discarded and the plate inspected.

Fig. 217. Developing unit.

Negative

Plate

Fig. 218. Developing.

Image transferring from
the negative to the plate.

Fig. 219. Schematic diagram of image transfer.

Difficulties may be experienced in maintaining an accurate positioning of image to plate. This is due to the negative being separated from the plate until they reach the pressure rollers. More sophisticated developing units incorporate registration devices to overcome this problem (*see figs. 220 and 221*).

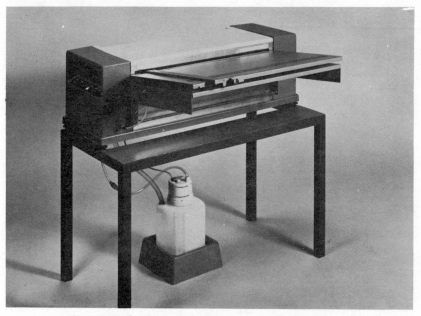

Fig. 220. Agfa Gevaert RE 410 registration transfer unit.

(vi) Fixing. After stripping the negative from the plate, place the plate face up on the bench. Apply a small quantity of fixing solution with a pad of cotton wool or soft cloth, wipe off the excess and gently smooth dry.

Turn the plate over on to a clean, dry surface and clean and dry the back of the plate. It is now ready for use on the press. There is no separate gumming stage as the fixer contains a gum desensitiser.

If the plate is not required for immediate use the image should be inked in. This is performed with proprietary developing ink. Using a soft cloth to rub up the image areas, damp the plate with gum etch and rub lightly until the image is inked. Wash the plate with water and gum up and dry in the usual way.

Deletions

Before making deletions the ink must be removed from unwanted areas. Small areas may be deleted with a hard-rubber eraser. Large areas may

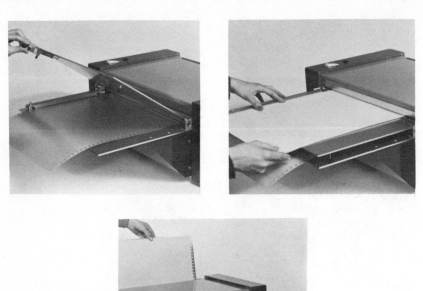

Fig. 221. Using the RE 410.

be removed by rubbing hard with a soft cloth soaked in brown iodine solution. Take care not to touch image areas.

After deletion the plate should be treated with desensitising etch such as Multilith "Platex" or Rotaprint "Fixing solution".

Diffusion Transfer Equipment

Exposure units. This must provide a good contact between original artwork and the negative paper. Units with a vacuum pump are recommended. Most flat-bed units contain their own light source of the correct intensity. If the unit is fitted with fluorescent tubes, or if exposure is made in a printing down frame to high intensity ultra violet light, a yellow filter sheet must be used between the negative sheet and the light to reduce its intensity.

Development processors. Care must be taken not to select a processor which is intended only for office copying on paper. These have sharply curving negative guides which make plate and negative processing

difficult and loss of image positioning. They are also too fast for processing plates. Development speed should be in the order of 380 mm (15″) per 20 seconds and developer temperature between 18-24°C.

Developer should not be left in the processor when not in use but stored in stoppered bottles. Some processors are fitted with an air-tight plastic reservoir to which the developer is returned after use.

Projection platemaking. The "projection speed" negative paper is produced for use in process and copying cameras, preferably those with a vacuum back. The negative paper must be handled under indirect red safe lighting, and is used in the camera in the same manner as ordinary photographic film.

Exposure times should be ascertained for each new batch of negative paper. Exposure will depend upon the usual variables associated with photography, e.g. type and number of lamps, nature of the original artwork, and ratio of enlargement or reduction.

All kinds of printed illustrations may be reproduced except originals in continuous tone which must be first screened with half-tone no finer than 120 lines to the inch.

Translucent originals can be copied using back lighting or backed by a sheet of white paper.

After exposure, the "projection speed" negative paper is processed with the press plate in a development processor in the same manner as "contact speed" negative paper.

Agfa-Gevaert and Kodak Ltd. are the major manufacturers of diffusion transfer processes.

(5h) ELECTROSTATIC PLATE PROCESSES

The great advantage of small offset lithography is its ability to adapt new developments in the field of photocopying to its own use as alternative methods of platemaking. This has produced many inexpensive and rapid methods and expanded the range of work printed by small offset and also had a profound effect on all areas of the printing trade.

One such process is the electrostatic platemaking process which established itself in the production of paper plates for small offset, producing press runs of up to 5,000 copies. However, development of the process now permits large plates up to a maximum size of 635 mm × 533 mm (25″ × 21″) to be made yielding runs of up to 100,000 copies on the press.

New techniques are constantly improving the quality of reproduction by electrostatic plates, at present half-tones to 80 lines per inch can be produced, but the process is not recommended for solid work.

Electrostatic platemaking is based on the phenomena that some materials (photo-conductors) will hold an electrostatic charge until exposed to light. A plate carrying a positive electrostatic charge can be

exposed in a camera to form an image which can then be processed to make a plate.

There are two methods of platemaking by electrostatic photography, "Indirect" (or "Transfer") and "Direct".

The Indirect Method

This process uses the photo-conductor selenium which is coated on to a metal drum or flat metal plate which can be re-used many times. The stages in the process are as follows:

 (i) Charging the selenium plate or drum.
 (ii) Exposing.
 (iii) Developing the image.
 (iv) Transferring the image to the press plate.
 (v) Removing unwanted work.
 (vi) Fixing the image.
(vii) Gumming up.

(i) *Charging the selenium plate.* The selenium plate or drum is sensitised by passing a corona discharge unit over its surface, producing a positive electrostatic charge on the selenium coating (*see fig. 222*).

In the case of the Rank Xerox 1385 camera the selenium plate is used in a conventional dark slide. Once sensitised, the slide is closed to prevent light falling on the plate while the slide is fitted to the back of the camera.

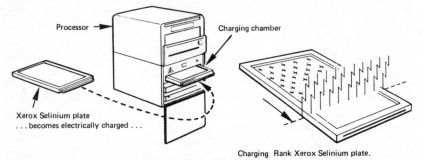

Processor

Charging chamber

Xerox Selinium plate
. . . becomes electrically charged . . .

Charging Rank Xerox Selinium plate.

Fig. 222. Charging the plate.

(ii) *Exposing.* The camera is set for reproduction size, focused and the lens set for correct aperture. With the lens cap in place, the dark slide shutter is opened and the lens cap removed to make the exposure to the original artwork (*see fig. 223*). Reflected light from the non-image areas of the original falling on the selenium plate causes the positive static charge to leak away. No light is reflected from the black image areas of the original and therefore the static charge on the selenium plate remains on the surface in these areas.

The lens cap is replaced to terminate the exposure and the dark slide closed.

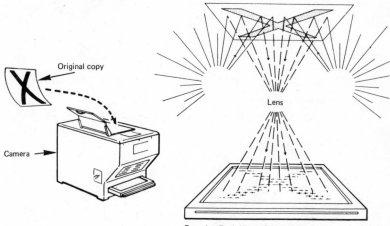

Exposing Rank Xerox Selinium plate.

Fig. 223. Exposing the Selinium plate.

(iii) *Developing the image.* The dark slide is now locked into a light-proof tray in the processor and the slide shutter removed. The processor contains a quantity of very small glass beads and carbon resin powder. When the processor is rotated the glass beads impart a negative electrostatic charge to the particles of resin powder which then become attached to the positive electrostatic image on the selenium plate as the powder cascades over its surface (*see fig. 224*). On completion of the development stage the plate can be removed from the processor and inspected in the light. Unwanted images can be wiped off the plate with cotton wool. If the exposure was incorrect, the plate can be cleaned and a fresh exposure made.

(iv) *Transferring the image to the press plate.* The platemaker now places the lithographic press plate face down on to the charging unit and the transfer switch operated. A positive charge is given to the litho plate which immediately attracts the negatively charged powder from the surface of the selenium plate (*see fig. 225*). It may be advantageous to give the litho plate a negative charge before the positive charge to obtain the best transfer of the image.

(v) *Removing unwanted work.* The press plate is carefully removed from the selenium plate and is inspected for unwanted work, dirty areas, etc. These can be removed with the use of a pliable plastic putty to which the powder will readily adhere, leaving the plate clean in those areas.

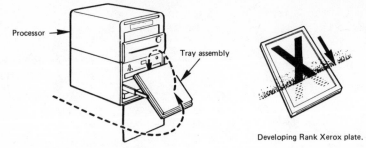

Processor

Tray assembly

Developing Rank Xerox plate.

... the electrical image is then developed ...

Fig. 224. Developing the Selinium plate.

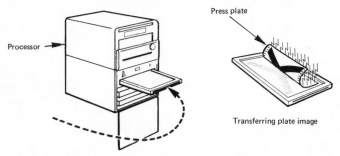

Press plate

Processor

Transferring plate image

... the powder image is transferred to the press plate ...

Fig. 225. Transferring the powder image to the press plate.

Alternatively, blemishes can be removed with a small camel-hair brush which is first rubbed on a clean piece of cloth to create a static charge.

Care must be taken at this stage because the image powder is held to the surface of the litho plate only by electrostatic attraction and may easily be damaged.

(vi) *Fixing the image.* Fixing or "fusing" is the operation of melting the carbon resin powder image to permanently bond it to the plate surface. This can be carried out with heat or vapour, depending on the material used as a substrate for the plate (paper, polyester or aluminium) (*see fig. 226*).

Paper and aluminium plates are placed for a short time in a heat fuser, the temperature of which can be varied from 107° to 190°C (225°-375°F).

Polyester plates are placed in a vapour fuser in which the plate is enveloped in tricoethelene fumes to fuse the image to the plate surface. Care must be taken with tricoethelene as it is a very dangerous solvent; use only in a well ventilated environment.

(vii) *Gumming up.* The aluminium plate may now be gummed up in the normal manner. Paper and polyester plates may be left without gumming

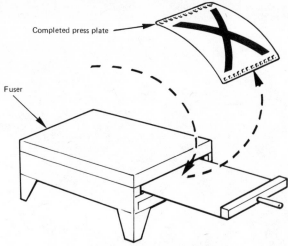

Completed press plate

Fuser

. . . and 'baked' or fused to make it permanent.

Fig. 226. 'Fixing' the image to the press plate.

until required on the press. Removal of background scum may be achieved by scouring the plate surface with a mixture of fountain solution and cleansing paste or any other mild abrasive.

Note. The transfer of the image powder from selenium plate to litho plate often results in a loss of definition. Tonal values may be lost and solid areas are difficult to reproduce by this process. Quality may be improved, however, by using different grades of toner powder.

The Direct Method

The second method of electrostatic platemaking was introduced by the Radio Corporation of America (R.C.A.) under the name "Electrofax". Using the same principle as Xerography, Electrofax uses zinc oxide as the photo-conductor which is coated in a resin binder on the surface of the litho plate. This allows the image to be photographed and developed directly on the plate, eliminating the need for an image transfer stage.

Office photocopying machines based on the Electrofax principle may also be used for making small offset paper plates. Most of these copying machines are automatic and litho plates can be produced in a matter of seconds (*see fig. 227*).

Method of production. The original artwork is placed face down on a glass platen situated directly above an optical scanning system. The litho plate, coated with zinc oxide, passes through a corona discharge unit where it receives a positive electrostatic charge. It then passes below the scanning lens for exposure. The plate then moves beneath a magnetic roller

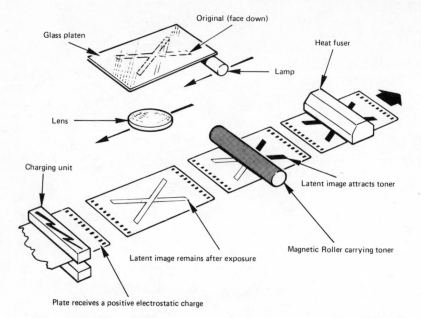

Glass platen

Original (face down)

Lamp

Heat fuser

Lens

Charging unit

Latent image attracts toner

Latent image remains after exposure

Magnetic Roller carrying toner

Plate receives a positive electrostatic charge

Fig. 227. Schematic diagram of a photo-copier based on the Electrofax principle.

which carries the negatively charged toner powder and the image is formed on the plate by attracting the powder to its surface.

At this stage it is possible on some machines to remove the plate and remove unwanted work.

The plate is now carried through the heat fusing unit where the toner powder is fused permanently to the surface of the plate. An "electrostatic etch" is applied to the plate when it is removed from the machine. This renders the zinc oxide hydrophilic by chemical modification of the zinc oxide particles. The plate is gummed up in the usual manner.

This method only produces paper plates and is used to reproduce same size images only.

Variable focus platemaking. A number of cameras have been developed to widen the scope of platemaking by electrostatics. These allow reduction and enlargement of the original direct to the zinc oxide coated plate.

The "Itek 175" is such a camera (*see fig. 228*). This is an automatic, self-contained electrostatic platemaker which produces press-ready plates on the Electrofax principle.

Zinc oxide coated paper is loaded in the camera in reel form and automatically cut to plate length (up to 460 mm—18″) as required. After adjusting and setting the camera, the plate receives a positive charge and the exposure is made. Liquid toner is sprayed on to the plate to form the

Fig. 228. Itek 175 electrostatic platemaker.

image, the toner particles adhering to the plate in the same way as toner powder.

Improved solids and sharper images are reproduced in this way.

The plate is delivered dry and ready for the press.

The "Elfasol" process. Developed by Kalle of Germany, this employs the Electrofax principle with the following important differences:

- The Elfasol process uses sulphur selanide as the photo-conductor coating.
- The process uses aluminium as the substrate which allows longer press runs. Paper plates are also used.
- Plates can be exposed on conventional process cameras.

The use of the process camera for these plates requires the plate to be positioned on the camera back and held by vacuum or held by magnets on a steel plate in the camera dark slide. The following equipment is necessary for processing Elfasol plates in the process camera:

- A charging unit.
- A developing trough.

- A fusing oven.
- A decoating tank.

All process stages must be carried out in the dark room.

A number of cameras have been developed specifically for use with Elfasol plates. These incorporate plate carrying systems which take the plate through the automatic stages of processing. After adjusting the camera for image size, focusing, etc., the plate is fitted to pins in the back of the camera and the exposure time set. All processing now takes place at the touch of a button. This allows the camera to be free-standing with the operator working in normal room lighting all the time.

The following stages indicate Elfasol plate production:

 (i) Charging the plate. ⎫ The first three stages must be carried out
 (ii) Exposure. ⎬ in a dark room if a process camera is
 (iii) Developing the plate. ⎭ used.
 (iv) Corrections.
 (v) Fusing the image.
 (vi) Decoating the plate.
(vii) Gumming up.

(i) *Charging the plate.* The plate is sensitised by passing a corona discharge over the plate surface. During this process the plate coating must face the corona discharge unit. The plate surface must not now be touched until the development stage is complete. Handle the plate by its edges.

(ii) *Exposure.* A prism must be fitted to the camera lens to laterally reverse the image to correct reading on the plate. Light source should yield a total rating of at least 50,000 lux (four 800 watt lamps).

Test exposures will determine correct exposure times. Over-exposure will produce a fine image (dot loss) and under-exposure produce scum in the non-image areas of the finished plate.

(iii) *Developing the plate.* This is carried out in a trough-type dish, the exposed plate passing three or four times through the developing powder with the coated side of the plate uppermost. Negatively charged powder particles become attached to the charged image on the plate during this operation.

(iv) *Corrections.* Blemishes are removed using damp cotton wool or a camel-hair brush.

A spoiled plate may be wiped clean with dry cotton wool and then finally polished with a fresh pad of cotton wool. After storing the plate in the dark for up to ten hours the coating will regenerate and may be used again.

(v) *Fusing the image.* The resinous powder particles are fused to the plate surface in a fusing oven for 30 seconds at 180°C (356°F).

(vi) *Decoating the plate.* The plate is immersed in a decoating solution for two minutes to swell the photo-conductor coating in the non-image areas allowing it to be rinsed away with a water spray and gentle rubbing

with a sponge. Removal of this coating will reveal the underlying aluminium in non-image areas.

(vii) *Gumming up.* The plate is gummed up in the normal manner. Inking-in is not necessary as the image shows black on the plate and will not blind.

Notes. These plates are popular with book printers and are particularly competitive for book reprints from ageing and yellowed originals. The process is still limited to coarse screen half-tones and small solids.

Rotalec platemakers. Rotaprint's new models in the "Rotalec" range of platemakers, the F.B.30 and B.F.70, are fully automatic (*see fig. 229*).

Fig. 229. Rotalec FB30.

They incorporate motorised copyboard and push button bellows, vacuum back and automatic fusing. After focusing and setting the aperture all the following stages, plate charging, exposure, development and fusing are carried out automatically within the camera. The plate is delivered ready for decoating and gumming.

Toner powder is applied to the electrostatic plate image by magnetic brush (*see fig. 230*) and not by the cascade method. The speed of the toner drum is variable to enable the correct amount of toner to be applied for different types of work, i.e. solids, line, or text. Rotaprint claim that the toner brush gives consistently cleaner backgrounds (non-image areas).

This type of camera can also be used for producing zinc oxide paper plates and chemical transfer projection speed plates.

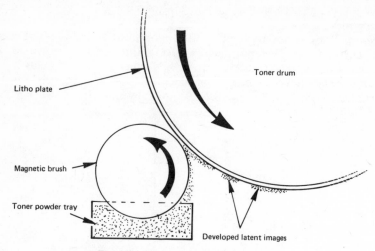

Litho plate

Toner drum

Magnetic brush

Toner powder tray

Developed latent images

Fig. 230. Magnetic brush development.

(5i) PHOTO-DIRECT

Although photo-direct is a method of plate production which has been predominantly used in small-offset, it is now available in plate sizes up to 508 mm × 610 mm (20″ × 24″).

Original plate emulsions were coated on high wet strength paper substrates which limited the plate to short press runs. The introduction of polyester and polyethylene substrates has greatly improved press life of these plates.

Photo-direct, or "direct-photo projection speed systems" is closely dependent upon photographic technology, many plates in the range being based upon orthochromatic type silver halide coatings.

The equipment required for the process is a conventional process camera with specially adapted plate holder or vacuum back. Special cameras such as the "Itek Platemaster" and the "3M Camera Plate System" are purpose built with automatic plate processing within the camera (*see figs. 231 and 232*).

Photo-direct produces a positive image plate direct from the original artwork. This is achieved by:

- The use of a prism lens or mirror system to laterally reverse the image to correct reading on the plate.
- Image reversal (producing a positive plate from a positive original) takes place within the photographic coating on the plate surface.

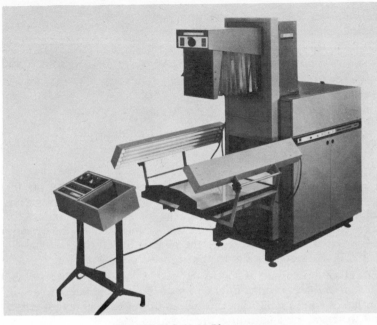

Fig. 231. Itek 10 15 Platemaster camera.

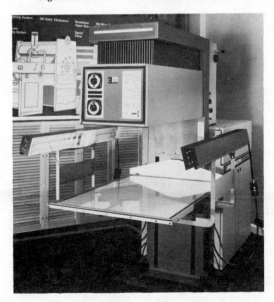

Fig. 232. 3M Camera plate system.

Three main substrates are used as lithographic plates:

3M System: polyester plates.

Kodak Verilith: paper plates.

Agfa-Gevaert: polyethylene plates.

The paper plate. Based upon high wet-strength paper, these plates are coated with a three-layer emulsion (*see fig. 233*).

The main stages in production of paper plates is as follows:

(i) Setting and loading the camera.

(ii) Exposing the plate.

(iii) Development.

(iv) Fixing.

(i) The original is positioned in the copyboard and adjustment for enlargement or reduction is made. Focus, aperture and exposure time are set. If a separate processing unit is used, the plate will be fitted into the camera dark-slide or located on pins on the vacuum back of the camera.

With integrated camera processing the plate is in roll form within the camera and is cut automatically to the required press size.

(ii) The effect of exposure is shown in *fig. 234*. Reflected light from the white background areas of the original produce a normal latent image in the silver halide emulsion (2). The dark areas of the original do not reflect light and therefore the emulsion is unaffected.

Light passes through the pre-fogged emulsion (3) without affecting it.

(iii) After exposure the plate is transferred to the activator bath containing a solution which penetrates all three layers of the plate coating. The activator causes the developer locked in layer (1) to diffuse upwards (*see fig. 235*). The unexposed silver salts in layer (2) dissolve in the developer and diffuse upward into the pre-fogged top layer (3).

Physical development then takes place in the pre-fogged emulsion as silver is deposited in sufficient quantity to produce an oleophilic image which will carry ink.

Those areas of the silver emulsion in layer (2) which have been exposed to light do not transfer silver to the top layer but are locked in by the developer.

(iv) After development the plate is transferred to a stop-bath. The fixing action results in the gelatine emulsion becoming hydrophilic and the image areas hardening and becoming oleophilic (*see fig. 236*).

The plate is finally wiped over with a cotton wool pad saturated in fountain solution and then dried.

Press treatment. Before use on the press the paper plate must be immersed in fountain solution to ensure that the gelatine layer in non-image areas is damp and water attracting.

Scum in non-image areas can be removed by wiping the plate with cotton wool soaked in fixing solution (mild caustic).

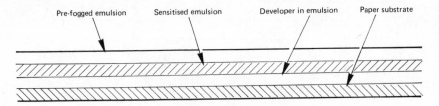

Fig. 233. The Verilith paper substrate, photo-direct plate.

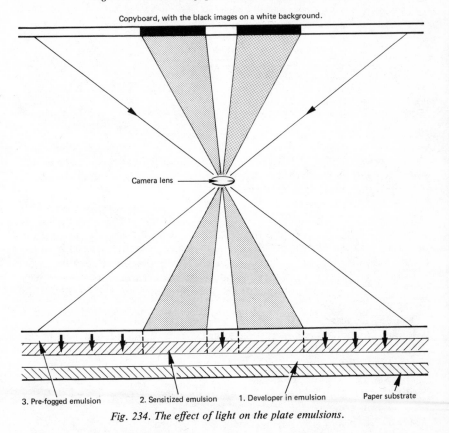

Fig. 234. The effect of light on the plate emulsions.

Present industrial trends indicate a move away from the photo-direct system towards the variable focus electrostatic platemaking systems.

The 3M polyester plate. Polyester provides a relatively stable substrate to which a water attracting coating has been bonded. This gives the plate similar characteristics to the aluminium lithographic plate and is treated in the same manner on the press (*see fig. 237*).

234

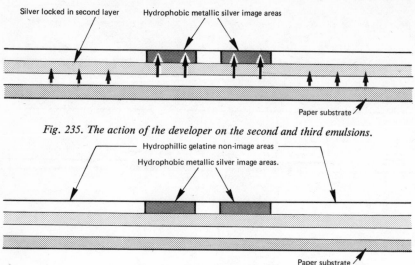

Fig. 235. The action of the developer on the second and third emulsions.

Fig. 236. The completed plate.

Care must be taken when handling the plate to avoid damage to the water attracting layer. Scratches will allow the underlying polyester to pick up ink.

Image areas of the plate are formed by silver halides locked in two emulsion layers on the plate surface (*see fig. 238*). These two layers produce a reversal effect (producing a positive image from an original) during the processing stages. During development a chemical reaction occurs between the two emulsion layers in the image areas to render them insoluble.

In the final processing stages the photo-sensitive emulsions are removed from non-image areas of the plate, leaving the hardened emulsion in image areas (*see fig. 239*).

The 3M camera plate system (*see fig. 240*). The polyester plate material is loaded in the camera in roll form and cut to required size during the process. The main stages of production are as follows:

 (i) Setting the camera.
 (ii) Fixing the plate length.
 (iii) Exposing the plate.
 (iv) Developing.
 (v) First rinse.
 (vi) Activating bath.
(vii) Final rinse.
(viii) Drying the plate.

 (i) Place the original in the copyholder and make the usual camera adjustments and settings for reproduction size, aperture and exposure time. The 3M camera will reduce to 45 per cent and enlarge to 150 per cent.

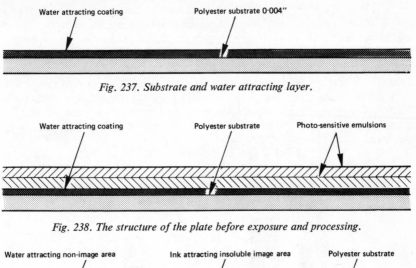

Fig. 237. Substrate and water attracting layer.

Fig. 238. The structure of the plate before exposure and processing.

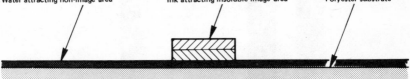

Fig. 239. The processed plate, ready for the press.

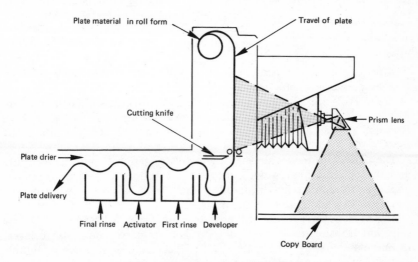

Fig. 240. The 3M camera plate system.

(ii) Plates may be cut from the roll to any length between 254 mm and 508 mm (10″ and 20″). After selecting the correct plate length a protective curtain is set to the same length to protect the plate roll during exposure.

(iii) The correct exposure should be determined when the processor contains fresh developer. Correct exposure is called "normal operating range", with upper and lower exposure limits. Tests show that this range falls between an open step 3 and open step 4 on the Stouffer grey scale (*see fig. 241*). After processing the test plate, rub the grey scale on the plate with a moist finger to determine the correct reading of the scale (*see fig. 242*).

Fig. 241. Normal operating range.

Fig. 242. Clearing the wedge after processing.

After exposure, the plate is automatically carried into the processing unit by pressure rollers.

(iv) to (viii) are all automatic operations performed within the camera. The plate is developed in a solution which is maintained at a temperature between 25°-28°C (78°-82°F) and then rinsed with warm water spray (43°C).

The plate then passes through the activator bath at room temperature and through the final water rinse. Heated rubber rollers now remove and evaporate moisture from the plate. Plates are delivered from the processor dry and ready for the press.

The Agfa-Gevaert "Rapilith" process. This system is based on improved diffusion transfer technology and combines negative and positive layers in one plate coating. The plate has a polyethylene base which is durable and dimensionally stable (*see fig. 243*).

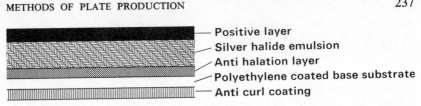

Fig. 243. Cross section of Rapilith plate.

The Rotaprint "Photomaster Platemaker Camera" is fully automatic and produces the "Rapilith" plate ready for the etch/wash unit which within a few seconds delivers the plate ready for the press.

PHOTO DIRECT (PROJECTION) PLATES

Manufacturer	Brand	Length	Structure	Length of run
KODAK	Verilith	250ft rolls (9"–20" wide)	Gelatine/paper	5,000 to 10,000
3M	3M Material	400ft rolls (9", 10", 11", 12" wide)	Polyester	10,000 to 20,000
AGFA GEVAERT	Rapilith	Cut sheets or 197ft rolls (8⅞" and 10" wide)	Polyethelene	to 10,000

PHOTO DIRECT CAMERAS

Manufacturer	Camera	Range of focus	Plate materials used
ADDRESSOGRAPH MULTIGRAPH	Meteorite	50% to 200%	Kodak Verilith
3M	Camera plate system	45% to 150%	3M Polyester Material
GRAPHIC PRODUCTS	Itek Platemaster		
	9·10	Same size	Kodak Verilith
	10·15	50%–110%	Kodak Verilith
	11·17	50%–120%	Kodak Verilith
	12·18	45%–150%	Kodak Verilith
	15·18	50%–150%	Kodak Verilith
ROTAPRINT	Photomaster		Agfa Gevaert Rapilith

Fig. 244. Photo-direct manufacturers.

(5j) **DIRECT IMAGE PLATES**

The class of work classified under this title is usually originated by a copy typist. Lithography was originally developed as a hand drawing printing process but this has been largely superseded by photographic techniques.

Small offset masters are available (paper and plastic plates) which are coated with a water attracting layer. There are a variety of image forming materials (of greasy, oleophilic nature) which are used to produce an image on these plates by hand. These include reproducing inks, pens and pencils, carbon papers, tapes and typewriter ribbons.

When typing on to these plates to produce a "direct-image" master, a few basic rules must be followed:

- Check that the correct ribbon is fitted to the typewriter. Normal typewriter ribbon is of little use for these plates.
- Apply uniform and light pressure to form the typed image.
- Don't handle the surface of the master.
- Make corrections to the master with care.

(5k) **DRY-OFFSET**

This is a relief printing process which uses shallow relief plates on a conventional lithographic press from which the dampers have been removed. Modern terms for this process such as "Letterset", "offset letter-press" and "indirect letterpress" imply that dry-offset is a comparatively recent innovation. The process has, however, been used by lithographers since the early nineteen-twenties when zinc plates were etched to a depth of 0.3 mm (0.010″) and used for special types of work on offset presses. The tremendous progress in the use of photopolymers has resulted in a much wider use of this process. A report on the U.K. printing industry in 1967/68 showed that almost 10 per cent of printers were using dry-offset.

Mainly recommended for the reproduction of line work, this process is firmly established for packaging, carton work, metal decorating, business forms, labels and varnishing. It is also used for printing cheques and similar work which require the use of fugitive inks which are water soluble.

The dry-offset plate is relatively expensive and therefore normally used for long press runs where it will outlast conventional lithographic plates on certain kinds of work. It finds particular application in varnishing which is difficult by lithography if scumming of non-image areas occurs. If varnish is printed on carton flap areas which will be later glued, difficulties with adhesion of the glue may result. Since the varnish is clear, scumming or thickening of the image is not easily seen on lithographic plates, but completely eliminated when using dry-offset plates.

Other advantages of the dry-offset plate are as follows:
 (i) Colour fidelity is improved, enabling the reproduction of true colour strength.
 (ii) The problem of ink emulsification is removed.
(iii) Variations in colour strength due to press stoppages is reduced.
 (iv) Spoilage is reduced.
 (v) Higher press speeds are achieved without variation and adjustment to damping.
 (vi) The dry-offset plate requires less attention than the litho plate.
(vii) Dimensional stability of the stock is unaffected.
(viii) Metallic inks can be used without the tarnishing of metallic effects which may occur when printed by conventional lithography.
 (ix) Plate wear is low, resulting in lower quality variation during the run.

The average depth of relief of these plates is 0.28 mm (0.011″) with overall plate thickness 0.635 mm (0.025″). This requires a plate cylinder "undercut" which will accept the dry-offset plate plus packing.

A wide range of plates are now available and these are divided into three groups:

(i) *Metals.* A small range including zinc, zinc/aluminium, zinc/steel, copper and magnesium alloy are used. The zinc plate is probably the most popular among lithographers in this range.

(ii) *Photopolymers and precoated plates.* This is a modern range of plates which because of their importance require more detailed information.

The Kodak relief plate. This consists of a 0.25 mm (0.010″) mild steel base to which is bonded the relief layer of cellulose acetate sensitised with silver halides (*see fig. 245*). It is a negative working process and plates can be exposed on conventional printing down frames.

The relief image is formed by etching and requires the use of a special processor (*see fig. 246*). This consists of a revolving magnetic drum to which the exposed and developed plate is attached. Etching is performed by passing the plate over a revolving plush belt which carries the etching solvent to remove non-image areas of the coating.

Etching takes approximately 30 minutes. Due to the inflammable nature of the solvent, flash-proof rooms are necessary to house the processor.

A range of Kodak relief plates are available:

Overall thickness	Depth of relief	Type number
0.44 mm (0.017″)	0.20 mm (0.008″)	8/17
0.63 mm (0.025″)	0.35 mm (0.012″)	13/25
0.80 mm (0.030″)	0.47 mm (0.018″)	18/30

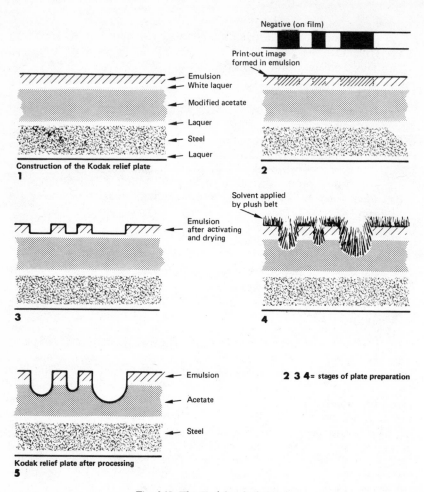

Negative (on film)

Print-out image
formed in emulsion

Emulsion
White laquer
Modified acetate
Laquer
Steel
Laquer

Construction of the Kodak relief plate
1

2

Solvent applied
by plush belt

Emulsion
after activating
and drying

3

4

Emulsion

Acetate

Steel

2 3 4 = stages of plate preparation

Kodak relief plate after processing
5

Fig. 245. The Kodak relief plate.

The Dycril relief plate. This plate has a light sensitive photopolymer laminated to a flexible steel base plate. It is negative working and during exposure the coating polymerises and becomes insoluble in the developer (sodium hydroxide).

Processing equipment is relatively expensive but more suitable for installation into existing platemaking departments. The equipment consists of a printing down unit and a wash-out unit for development.

A pre-exposure stage is required to activate the photopolymer coating; this is done by exposing the plate to a bank of ultra-violet tubes through a green filter. The negative planning flat is placed on the plate surface and

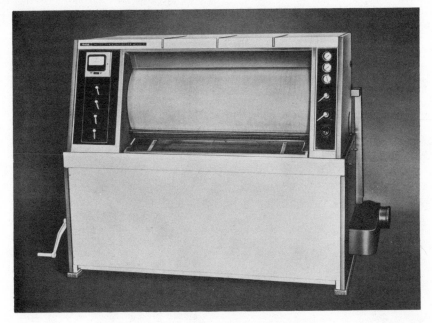

Fig. 246. The Kodak relief processor, Model 1.

exposed to a high powered light source in a special air-cooled vacuum frame. Due to the transparent nature of the photopolymer, light penetrates right through the coating, providing a straight edge contour to the relief image profile.

Development is performed in the wash-out unit by spraying the coating with sodium hydroxide under high pressure. Unexposed areas of the coating dissolve away leaving a relief image. Processing time is about 20 minutes.

A range of Dycril relief plates are available:

Overall thickness	Depth of relief	Type number
0.44 mm (0.017")	0.20 mm (0.008")	17
0.63 mm (0.025")	0.28 mm (0.011")	25
0.78 mm (0.030")	0.41 mm (0.016")	30

The BASF Nyloprint plate

The following six illustrations and accompanying text briefly describe the major processing stages in the production of this plate (*see figs. 247 and 248*).

Removing the protective film from the surface of Nyloprint material.

Exposure: flat plates. A negative being positioned on the Nyloprint in the Hans Sixt 21⅝" x 25⅝" (550 mm x 650 mm) model FB exposure unit and exposed to ultra-violet light. Exposure units are available in a range of sizes.

Exposure: rotary plates. Positioning Nyloprint material with negative attached on an exposure cylinder of the Moll "Ideal" rotary exposure unit. When positioned the foil is brought forward to cover negative and plate and the vacuum pump ensures good contact.

HE BASF NYLOPRINT PLATE

Other switches rotate the exposure cylinder and activate the ultra-violet light tubes.

Closing the Moll "Ideal" rotary unit prior to exposure. This model takes plates up to 43" (1100 mm) along the axis of the cylinder. Picture shows a 10⅝" (270 mm) diameter exposure cylinder in position, suitable for Heidelberg Rotaspeeds and "S" line rotary and rotary + flat printing presses. Exposure cylinders are available in a range of diameters to suit various sizes of printing machines. The bigger Moll "Standard" rotary exposure unit takes plates up to 56·3" (1430 mm) along the axis of the cylinder.

Spray washing. The exposed Nyloprint material is washed-out in the flat. It is fixed to a holder and reciprocating jets of alcohol solution wash away the unexposed, unhardened areas. Picture shows the Neumag 31" x 43" (790 mm x 1100 mm) spray washer. Spray washing equipment is available in several sizes.

Fig. 247. Fig. 248.
(i) (ii)

Photomicrographs: (i) 133 screen zinc half-tone formation, x 700 approx. enlargement; (ii) Nyloprint 133 screen half-tone formation, x 700 approx. enlargement. Note the jewel-like precision and symmetry. Dot shape is almost ideal. Compare with that of the zinco.

(iii) *Liquid resin relief process.* These include APR, Sonne KPM, Tevister and Letterflex processes.

All these processes require a photo-sensitive resin to be spread by doctor-blade over the base sheet of polyester, flexible steel or aluminium. The process requires a short exposure time and a second exposure is made through the back of the polyester process to bond the photopolymer to the base sheet. After exposure the unexposed areas are washed away by means of a pressurised solvent spray. In the case of Letterflex the non-image areas are removed with an air-knife. The plate is then re-exposed or heated to harden the image.

The APR relief plate. This process will serve to outline the principles of liquid resin processes (*see fig. 249*).

A negative is placed emulsion side uppermost on a ground glass base plate and covered with a protective film of 0.012 mm (0.0007″). This is held down by vacuum while resin is poured on to the cover film and spread to required thickness by a doctor-blade. A base sheet of polyester (0.1 mm thick) is laminated to the resin surface by a laminating roller. A second ground glass plate is lowered to the base sheet forming a sandwich.

A short back exposure through this top glass provides a thin anchor layer on the base sheet. The main relief exposure is made through the lower glass and negative. After exposure, the sandwich is removed from the exposure unit and the negative and protective film are removed.

The liquid resin in the non-image areas is now removed in a washing unit which sprays the surface with an alkaline solution. After washing the plate with water it is dried with warm air and is then exposed to light to harden off the coating.

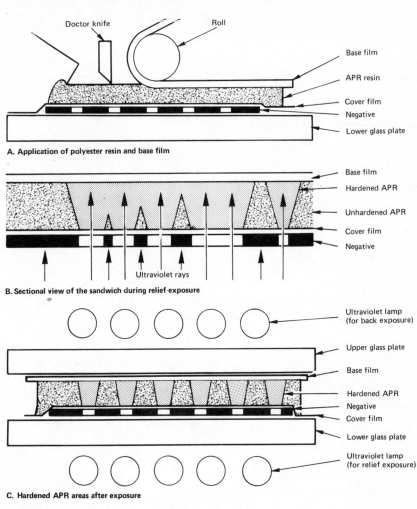

A. Application of polyester resin and base film

Doctor knife
Roll
Base film
APR resin
Cover film
Negative
Lower glass plate

B. Sectional view of the sandwich during relief exposure

Base film
Hardened APR
Unhardened APR
Cover film
Negative
Ultraviolet rays

C. Hardened APR areas after exposure

Ultraviolet lamp (for back exposure)
Upper glass plate
Base film
Hardened APR
Negative
Cover film
Lower glass plate
Ultraviolet lamp (for relief exposure)

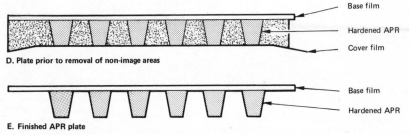

D. Plate prior to removal of non-image areas

Base film
Hardened APR
Cover film

E. Finished APR plate

Base film
Hardened APR

Fig. 249. The processing stages of the APR platemaking system.

Section VI

QUALITY CONTROL

(a) *The Star Target.*
(b) *Dot Gain Scale.*
(c) *Continuous Tone Sensitivity Guide.*
(d) *Signal Strip.*
(e) *Graduated Half-tone Percentage Scale.*
(f) *The Reflection Densitometer.*
(g) *The PIRA Electronic Planimeter.*
(h) *The GATF Standard Offset Colour Control Bar.*
(i) *Screen Angles.*
(j) *Trouble-shooting.*

SECTION SIX

QUALITY CONTROL

QUALITY CONTROL

Quality standards in printing begin with the original artwork and must be maintained through all stages of printing production. It is generally accepted that in the process of printing reproduction there is a degree of loss of quality from the original artwork. In many instances this is due to the method of reproduction itself but in the case of lithography a serious decline in quality may occur if control of quality is ignored.

Two major factors are of importance to the platemaker:

- To reproduce faithfully the photographic image on the litho plate without loss of quality.
- To produce a plate which will give maximum press life without trouble.

Standards of quality therefore include both these factors and are related to the following:

 (i) *Image resolution.* This will be dependent upon hard-dot second generation film elements of high density. Camera negatives generally produce a vignette half-tone dot which may not resolve a sharp image when exposed to the plate.

 (ii) *Vacuum frame contact.* A firm contact between plate coating and film emulsion is necessary to good image resolution. Poor contact during plate exposure will allow light to undercut the dense boundaries of the film emulsion producing a low quality image.

(iii) *Exposure control.* Accurate exposure of presensitised plate coatings has a direct relationship with the press life of the plate. This applies to both diazo and photopolymer coatings. Exposure control involves the quality of light falling on the plate and the condition of the plate coating in terms of manufacturing quality and age of the coating.

(iv) *Half-tone dot gain or loss.* This is linked with resolution and exposure. Over exposure may cause dot gain on negative working plates, and dot loss on positive working plates. Camera half-tone negatives ("soft dot") may produce dot gain images on the plate. Process of Deep Etch and multi-metal plates using stencil-type coatings may produce dot gain if development is extended. Image resolution may be impaired if development of the stencil is not sufficient.

 (v) *Press dot gain and slur.* Lithographic printing commonly produces a gain on plate image resolution by upwards of 5 per cent. This is partly due to the spread of ink on press blanket and paper during

impression. Dot gain also occurs with wet-on-wet printing on multi-colour presses. When dot gain occurs in one principle direction (usually circumferentially) it is called "slur". This can have a serious effect on print quality especially if elliptical half-tone screen dots join together by slurring.

Most of the quality control aids have been developed by American lithographers, the Graphic Arts Technical Foundation (G.A.T.F.) playing a major role in the last 20 years. Aids used are based on geometric designs which are reproduced on photographic film (positive and negative) for inclusion within the planning flat. Designs vary but are generally produced to enable the platemaker and printer to assess changes in image quality without the use of a magnifying glass. We will now examine the most common quality control devices used in the trade.

(6a) THE STAR TARGET

The star target was developed by G.A.T.F. (*see fig. 250*). It consists of a wheel-shaped design 10 mm in diameter containing 36 wedge-shaped spokes which radiate from the centre of the target. Because of its design it quickly indicates:

- *Dot gain.* Slight thickening of the image causes the tips of the spokes to join together to produce a solid hub in the target centre. Thickening may be caused by poor vacuum frame contact, over-exposure of negative working plates, or over-development of Deep Etch and multi-metal plates. On the press, thickening may be due to too much ink, badly tensioned blanket, over-pressure or running inks with too much reducer.
- *Dot loss.* Slight sharpening of the image causes the tips of the spokes in the target centre to break down, giving a visual impression of a white spot. Image sharpening may be caused by poor vacuum frame contact or over-exposure of positive working plates. On the press it is an indication of image wear of presensitised plates.

Visual magnification is about 23 times which means that a change in half-tone dot size of 0.025 mm (0.001″) shows in the target centre as a 0.6 mm (0.023″) change.

The target can be placed at random in any trim area of the layout. For further information see G.A.T.F. Research Progress No. 52.

(6b) DOT GAIN SCALE

This is a cleverly devised guide supplied on photographic film. The scale contains the numbers 0 to 9 (*see fig. 251*), each digit of increased density from its neighbour, made up of 200 line screen at 90° angle. The background is a course 65 line screen at 45° angle. On the film scale the figure "2" blends with the background when viewed at the normal distance with the naked eye. When printed down dot gain is indicated on the plate if a

Fig. 250. The 'GATF' star target.

Fig. 251. Dot gain scale.

Fig. 252. Continuous tone sensitivity guide.

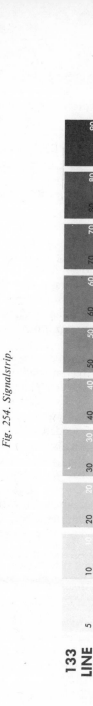

Fig. 254. Signalstrip.

Fig. 255. Graduated half-tone percentage scale.

higher number than "2" blends with the background. The same is true on the press printed sheet. Gain is calculated at 3.5 per cent per increment.

The pressman may also use this guide to monitor slur which forms either laterally or circumferentially on the press. In both cases the word "slur" stands out clearly on the printed scale. A careful inspection of the guide will explain how this occurs. The word "slur" is produced with fine lines at an angle of 90° to lines forming the background. If slur occurs in either direction the lines thicken and the word "slur" becomes prominent.

For further information see G.A.T.F. Research Progress No. 69.

(6c) CONTINUOUS TONE SENSITIVITY GUIDE

This particular guide is very valuable to the platemaker; the example shown in *fig. 252* shows a Stouffer 21 Step Guide. Shorter range guides are also available which contain identical "critical step" densities but the scale is compressed through fewer steps. The same guide may be used with both positive and negative working plates.

The graduated densities of the scale proportionately reduce the amount of light transmitted through the guide during plate exposure. This serves to indicate:

(i) *Correct exposure of presensitised plates.* Most manufacturers recommend the correct density step on the scale for correct exposure of their plates. When setting up standard exposure times for a new type of plate a series of exposures are made through the continuous tone wedge. The exposure time which correlates with the recommended step is then taken as the standard. If the wedge is used at regular intervals during plate production it will quickly indicate the quality of the plate coating and any variation in lamp output (*see fig. 253* for exposure table).

(ii) *Correct development of Deep Etch and stencil-type coatings.* A number of variables may affect the quality of Deep Etch plates: whirler speed, coating density, lamp output and prevailing relative humidity. Development of the stencil is a critical factor in correct

Exposure correction table
for use with the continuous-tone sensitivity guide (21 step).

If a test exposure produces an image that is

Low by 1 step	Multiply exposure time by 1.4
Low by 2 steps	Multiply exposure time by 2.0
Low by 3 steps	Multiply exposure time by 2.8
Low by 4 steps	Multiply exposure time by 4.0
High by 1 step	Multiply exposure time by 0.7
High by 2 steps	Multiply exposure time by 0.5
High by 3 steps	Multiply exposure time by 0.36
High by 4 steps	Multiply exposure time by 0.25

Fig. 253. Exposure correction table.

half-tone dot formation. This may be controlled by the continuous tone step wedge. A test plate will establish the correct step on the wedge (usually step 6 or 7) compatible with good resolution of half-tone dots. The step wedge is used continually for development control of Deep Etch plates.

The continuous tone sensitivity guide is of little value to the pressman and is normally printed down in the clamp allowance area where it will not print.

For further information see G.A.T.F. Bulletin No. 215.

(6d) SIGNALSTRIP (Lithos Inc., 833, N. Orleans St., Chicago, Illinois, 60610)

This is a strip photographic film element containing three special guides and may be purchased in a range of sensitivities to indicate high, medium, or low dot gain. The guide is easy to use and the detailed instructions should be studied by both platemaker and printer to make maximum use of the aid.

Reference to the illustration (*see fig. 254*) will show how Signalstrip is designed.

The print slur section. This section is of use to the platemaker for checking adequate vacuum contact in the printing down frame. If viewed under vacuum with a pencil torch at a low angle the slur section will show a pattern of alternate light and dark bars if the contact is poor. No pattern will appear if vacuum contact is satisfactory.

The plate guide section. This section is viewed with the naked eye after the plate has been made. If the narrow bars are lighter in tone than the background, dot loss has occurred and the overall image is sharper than the original. If the narrow bars are darker than the background, dot gain has occurred and the overall image is thicker than the original. Accurate reproduction of the plate image is indicated by no change in this section of the guide.

The print gain section. This section is examined when printed on the regular stock. We have already mentioned that nominal dot gain takes place on the lithographic press. Signalstrip is produced in a range of sensitivities and the most suitable type is selected to show no pattern when permissible press gain is present. Dot gain in excess of the norm is indicated in this section when the vertical bars appear darker than the background. Dot loss is indicated when the vertical bars are lighter in tone than the background.

The print slur section. This contains a series of horizontal and vertical lines at 133 per inch. Circumferential or lateral slur is indicated when the lines in one direction thicken, giving a visual pattern.

The Signalstrip should be positioned in any waste area of the sheet parallel to the gripper edge.

(6e) GRADUATED HALF-TONE PERCENTAGE SCALE

An example of this aid is shown in *fig. 255*. Both negative and positive forms are available with a variety of screen rulings. Its main usefulness is in checking the resolution of half-tone screen rulings from platemaking to press sheet. The appropriate scale is selected to print with film elements of the same screen ruling. A magnifying lens will help in viewing this guide on either the plate or printed sheet. The scale runs from a fine highlight dot of 5 per cent to a shadow dot of 90 per cent with a graduated tonal range between which is common to most work. Broken highlight dots will indicate failure to resolve fine highlights on the plate or on the printed sheet. Many high speed presses will not print such a fine highlight even if it is produced on the plate. At the other end of the scale the shadow areas may fill-in on the printed sheet with the resulting tonal shift in half-tones. If the scale is compared for quality reproduction like this it may assist the production of half-tones to fall within a range which can be printed with good resolution.

(6f) THE REFLECTION DENSITOMETER

This instrument contains a photocell for measuring the density of the ink film thickness on the printed sheet. It is used primarily for control of multi-colour printing where a reading is taken from a solid patch of colour on the sheet. It is necessary therefore for the planner to incorporate within his planning flat either a solid bar of colour running parallel to the gripper edge across the entire width of the sheet, or a series of solid squares (10 mm wide) placed at random in waste areas of the sheet.

SCREEN ANGLES

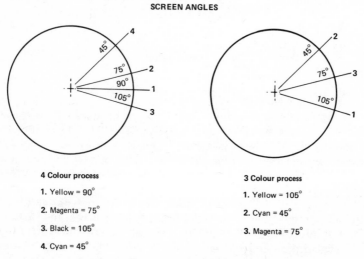

4 Colour process

1. Yellow = 90°
2. Magenta = 75°
3. Black = 105°
4. Cyan = 45°

3 Colour process

1. Yellow = 105°
2. Cyan = 45°
3. Magenta = 75°

Fig. 256. Screen angles.

SCREEN DIRECTION

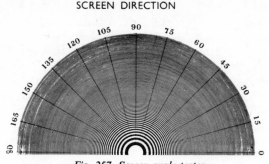

Fig. 257. Screen angle tester.

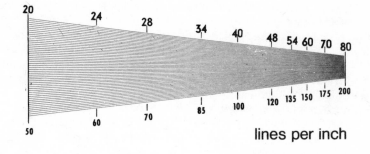

Fig. 258. Screen ruling tester.

Note: Reproducing these two aids is not a practical exercise for the printer. However an attempt to reproduce them has given the result shown in figs. 257 and 258.

(6g) THE PIRA ELECTRONIC PLANIMETER

One drawback to the use of the reflection densitometer on the press is the lack of information it yields regarding half-tone reproduction. The assumption that if a solid is printing correctly the half-tones are all right is not true in the eyes of many pressmen. There is no doubt that a solid area may remain constant but wide variations occur in the quality of half-tones.

The Pira Electronic Planimeter is an instrument which measures dot-size change in half-tones by scanning a selected area and making a comparison with the norm required. The use of such an instrument in the pressroom will require half-tone blocks or strips to be positioned in trim areas of the planning layout for each colour plate produced.

(6h) THE G.A.T.F. STANDARD OFFSET COLOUR CONTROL BAR

This printing aid has been developed for the control of lithographic presswork involving process colours in solid or half-tone. It provides a convenient means for comparing progressive proofs with the press sheet and maintaining the press run with the pass sheet.

The colour control bar contains a number of elements; half-tones in 150, 133 and 120 screen rulings, solid bars for densitometer readings, slur bars, grey balance patches, dot gain scale and star targets. The control bar is supplied as film negative or positive 30 mm × 259 mm ($1\frac{3}{16}'' \times 10\frac{3}{16}''$) which can be cut down to fit narrow areas or sections used where trim space on the press sheet is limited.

The planner may position the bar or sections of the bar in multi-colour work to overlap when printed. In addition to providing visual and densitometric assessment of colour values, the overprinted sections permit a visual judgement of trapping and transparency of inks, grey balance of tints, dot gain and slur.

The aid should be assembled with the film elements in trim areas of the layout or placed on inside flaps of cartons, etc. Due to the resolution quality of the colour control bar, original negative or positives supplied by the Graphic Arts Technical Foundation, Inc., and not contact prints from originals must be used.

For further information see G.A.T.F. Research Progress Report No. 76.

(6i) SCREEN ANGLES

In many cases film for jobs such as advertising are supplied by the customer or an outside source. Camera departments do not adopt a universal standard for screen angles in multi-colour process work.

Monochrome work is usually screened at 45° because the half-tone elements are the least visible to the eye at this angle. In process colour work it is not possible to screen all four separations at the same angle and problems of objectionable moiré pattern arise if the angle between each separation colour is not calculated correctly.

The most predominant colours, magenta, cyan and black, must be produced with a screen angle of 30° between them to prevent moiré occurring. The camera operator may judge the cyan to be the most predominant colour in a set and fix that at an angle of 45°. Magenta will then be screened at 75° and black at 105°. The yellow printer is normally screened at 90° and the moiré pattern produced by this colour is not easily detected when printed because of its light hue. In cases where the yellow does produce an objectionable pattern it is common to change the screen size for the yellow alone (e.g. cyan, magenta and black at 133 screen, yellow at 120 screen).

When flat screen tints are planned into a job for duatones, etc., the screen angles must be considered if moiré pattern is to be avoided.

Screen angle testing. Mistakes which may occur if the screen angle is unknown, may be eliminated with a screen angle tester (*see fig. 257*) which may be obtained from lithographic suppliers. The tester is produced in positive film and is placed over the half-tone film element with the base of the tester parallel to the foot of the film element. A circular pattern forms on the tester and the angle which disects this pattern is the angle of the film element screen.

Screen ruling testing. It may be necessary to check the screen ruling of half-tone film elements to correlate with the quality of paper or board on which the job is to be printed. Most lithographic printing on good quality paper is performed with 133 line screen, high quality paper may allow the use of 150 line screen and rough surface papers like newsprint requiring a coarse screen of 120 lines per inch.

The screen ruling tester (*see fig. 258*) is supplied in positive film. This is placed over the half-tone film element and rotated slowly until interference patterns are produced. The point where the pattern lines form at 90° to the lines on the tester indicate the screen ruling size.

Fig. 259. Comparing dot resolution between film element and finished plate.

(6j) **TROUBLE-SHOOTING** (*see fig. 259*)

Fault diagnosis. Plate failure on the press should be analysed carefully to ascertain the cause and possible remedy. Many of these failures will be caused by incorrect handling by the pressman or poor press settings. Plate failure caused by incorrect processing must be remedied quickly by the platemaker. The following fault diagnosis relates specifically to planning and platemaking:

Planning Faults

(i) *Poor Fit in Multi-colour Work*
- Parallax error when visually sighting multi-colour sets on the planning flat. Use of a collimating magnifying glass will remedy this.
- Shrinkage of tape used to fix film elements to the planning flat causes slight movement of register positions. Use polyester-based tape for this type of work.
- Dimensional instability of planning flat substrate. Use high quality polyester sheet of at least 0.18 mm (0.007") thickness.
- Worn punches in punch register system allows slight movement between assembled film elements.
- Worn guides on step and repeat machine.

(ii) *Poor Back-up Alignment of Bookwork Pages*
- Inaccurate rules and set squares or misaligned ruling-up table.
- Dimensional instability of planning flat substrate. Goldenrod flats larger than A2 should be supported on polyester sheet.
- Dimensional instability of layout material.

Platemaking Faults

Presensitised Plate, Negative Working
(i) *Image dot gain*
- Over exposure.
- Use of soft-dot half-tone negatives.
- Film emulsion out of contact with plate coating during exposure.
- Poor vacuum frame contact.
- Changing the position of the lamp during exposure.

(ii) *Image dot loss*
- Under exposure.
- Heavy hand pressure applied during development stage.

(iii) *Scum in non-image areas*
- Negative not dense enough in non-image areas.
- Masking material not opaque to actinic light.
- Over exposure.
- Incomplete plate development.
- Non-image areas not properly desensitised before inking-up the image.

(iv) *Broken areas in line or half-tone*
- Opaque paint spots on image areas of the negative.
- Piece of opaque masking or tape sandwiched between film element and flat.
- Foreign matter on vacuum frame glass or planning flat.

(v) *Heavy tone border around half-tone illustration*
- Poor contact between edge of half-tone and plate coating caused by: taping too close to the half-tone on emulsion side; film edge cut with dull knife producing a raised burr on emulsion side; stripping-in half-tones with thick film.

(vi) *Heavy tone areas in half-tone illustrations*
- Poor contact in isolated areas allowing undercutting during exposure. This may be due to small particles between film emulsion and plate coating during exposure; use of a diffusion sheet, bright reflector or multiple lamps for exposing the plate—a point source light may overcome this problem.
- Exposing the plate before sufficient overall vacuum has been obtained in the vacuum frame. The vacuum gauge on the printing down frame only shows the level of vacuum at the hose connection in the blanket. Good contact all over must be checked visually before exposure.

Presensitised Plates, Positive Working

(i) *Image dot gain*
- Under exposure.

(ii) *Image dot loss*
- Over exposure.
- Use of soft-dot positives.
- Heavy pressure applied during hand development of the plate.

(iii) *Scum in non-image areas*
- Under exposed.
- Under developed.
- Dust and dirt on planning flat or vacuum frame glass.
- Dust on tape used for fixing film elements to planning flat.

(iv) *Solid pieces in half-tones*
- Pieces of opaque material (slips of masking paper or red tape) sandwiched between film element and flat.
- Opaque paint on planning flat or vacuum frame glass.

(v) *Light tone border around half-tone illustrations*
- Poor contact between edge of half-tone and plate coating caused by taping too close to the half-tone on the emulsion side; film edges cut with a dull knife which produces a raised burr on emulsion side; stripping-in half-tones with thick film.

Deep Etch Plates

(i) *Image dot gain*
- Over developed.
- Over etched.
- Plate coating too thick.
- Under exposed.

(ii) *Image dot loss*
- Poor contact between planning flat and plate coating.
- Over exposure.
- Insufficient development.
- Plate cleaning at spirit wash stage not satisfactory.

(iii) *Scum in non-image areas*
- Over developed.
- Plate coating too thin.
- Dust on planning flat, vacuum frame glass or tape.
- Plate coating splashed with water before processing is complete.
- Handling the plate surface with moist hands.

(iv) *Film edges*
- Film cut with dull knife leaving ragged edge which picks up dirt.
- Clear tape on the roll picks up dirt at the edges if left unprotected.
- Remedy: Film edges may be reduced by the use of a diffusion sheet such as "Polyvac" (Polychrome Ltd.), or by moving the lamp during exposure. This may have a bad effect on half-tone reproduction, however.

(v) *Rings in half-tones*
- Caused by allowing the alcohol used for spirit washing to evaporate during the cleaning stage.
- Alcohol used for spirit washing not water-free (anhydrous).
- Splashing the plate with alcohol during the washing stage encourages rapid evaporation of the alcohol.

(vi) *Broken image*
- Unsatisfactory cleaning of the plate at spirit wash stage.
- Under developed.
- Inking-in solution applied to lacquer before the lacquer has been dried thoroughly.

(vii) *Image blinding* (image will not take ink on the press)
- Lacquer base incompatible with ink solvent.
- Plate gummed up over lacquer with no inking-in solution to protect image.
- Plate gummed up badly, leaving streaks which desensitise half-tone areas.

(viii) *Dirty non-image areas*
- Areas deleted not properly desensitised.
- Insufficient desensitisation of the plate after processing.
- Incomplete removal of stencils based on photopolymers.
- Plate oxidation due to damaged anodic layer (deletion areas or areas developed and etched but not required as an image).

Multi-metal Plates. Surface Image (Negative Working—Whirler Coated)

(i) *Image dot gain*
- Over exposure.
- Use of soft-dot negatives.
- Poor contact between planning flat and plate during exposure.

(ii) *Image dot loss*
- Under exposure.
- Over development.
- Over etching.

(iii) *Scum in non-image areas*
- Under developed.
- Under etched.
- Negative not dense enough in non-image areas.
- Masking not sufficiently opaque to actinic light.

Multi-metal Plates. Sub-surface Image (Positive Working—Whirler Coated)

(i) *Image dot gain*
- Over developed.
- Over etched.

(ii) *Image dot loss*
- Over exposed.
- Under developed.
- Under etched.

(iii) *Scum in non-image areas*
- Over developed
- Coating too thin.
- Under exposed.
- Dust on clear tape used for fixing film elements to planning flat.

(iv) *Film edges*
- Film and tape edges may be eliminated by using a diffusion sheet (*see* Deep Etch (iv)).

Note: Trouble shooting the wide variety of pre-sensitised multi-metal plates requires an "individual approach". We suggest that the technical services department of the supplier are involved in these instances.

APPENDIX I

TERMS USED IN LITHOGRAPHIC PLANNING AND PLATEMAKING (B.S. 4277)

Job layout. An outline drawing showing the relative positions of elements required in the complete assembly of the job, including dimensions, folds and any other necessary data.

Sheet layout. A diagram showing the disposition of individual jobs on the printed sheet.

Patch up or assembly. Positioning of negatives or positives to form a composite image.

Register marks. A set of fine line CROSSES or other suitable devices added to the original artwork to provide reference points for subsequent registration, i.e. in the accurate super-imposition of the colours of a set.

Punch register. System of registration using punched holes and pins.

Three point register. System of registration using two adjacent sides.

Integrating light meter. An instrument which measures a controlled quantity of light.

Spotting out. The application of opaque high opacity paint to pinholes in a photographic image or the repair of small blemishes.

Imposition. The laying of pages in the correct position, so that when the work is printed and folded the page folios will run consecutively.

Blind image. An image on a lithographic plate which does not accept ink.

Sharpening image (dot loss). An image which is deteriorating by losing printing area.

Hydrophillic. Water attracting. A necessary property of the non-image areas of a lithographic plate.

Lateral reversal. To change an image from left to right, as seen in a mirror.

Light table. A rigid table with translucent surface illuminated from beneath.

Double cut. Space left in the sheet for two trims by guillotine to meet the requirements of bleed and size.

Step and repeat machine. A machine for producing by contact multiple images from a negative or positive in accurately pre-determined positions.

Surface plate. A lithographic plate where the image is neither recessed nor in relief in relation to the nonprinting areas.

Presensitised plate. A lithographic plate with a light-sensitive coating purchased in a condition ready for exposure.

Anodized aluminium plate. A finely grained aluminium lithographic plate which has been treated as an anode to produce a hard, porous surface of aluminium oxide.

Bi-metal plate. A lithographic plate consisting of a metal on which a second metal has been electrolytically deposited. One metal, e.g. stainless steel, is selected for its water retaining properties and the other, e.g. copper, for its ink attracting properties.

Counter etch. A weak acid solution, e.g. acetic acid, used to clean a plate chemically before coating.

Developer. A chemical agent which removes unhardened or soluble areas of the coating after exposure.

Grain. A roughened state of a lithographic plate surface which assists the retention of moisture and adhesion of the image.

Brush grain. A fine plate grain produced by the action of abrasive brushes.

Chemical grain. A fine plate grain produced by the chemical etching of a metal plate.

Electrolytic grain. A plate grain produced by electrolysis.

Sand blasting. A means of producing a plate grain by impelling abrasive particles against the metal plate.

Printing down. The stage in the making of a photo-lithographic plate where the light sensitive surface is exposed through a negative or positive.

Sensitivity guide. A strip of film consisting of a number of separate steps of continuous tone of graded density used for controlling exposure and development.

Vacuum frame. A printing down frame, the upper surface of which is plate glass, with facility for extracting air to ensure close contact between the printing plate and the negative or positive during exposure.

Gripper edge. The edge of the plate which is fitted to the leading clamp of the press cylinder.

Clamp allowance. The distance outside the available printing areas allowed for clamping at the front and back edges of the plate.

Gripper allowance. The margin of paper along the leading edge of the sheet, held by the grippers and which therefore cannot be printed upon.

Masking out. The covering of areas of a coated plate during printing down to prevent their exposure to light.

Print out mask (or burn out mask). A mask of solid areas to protect portions of a previously exposed plate when exposing a second time to eliminate unwanted work.

Double exposure. Printing down from two or more positives or negatives to obtain a single image.

Lacquer. A solution which is applied to image areas of a plate to form the printing image.

Developing ink. A solution applied to a printed down plate in order to establish the ink acceptance of the image and to render it visible during development.

Dark reaction. The hardening effect which takes place in a dichromated coating of a plate independently of its exposure to light.

Continuing reaction. The hardening effect in a light sensitive coating which continues after completion of the exposure.

Desensitise. To increase the water retaining properties of the non-image areas of a lithographic plate with a chemical solution.

Monochrome print. A print in single colour.

Bleed. The part of a printed image beyond the area to which the finished print will be cut.

Gum arabic. A vegetable substance applied in solution to the lithographic plate and dried to produce a hydrophillic film on the non-image area, to prevent image areas from spreading and reduce oxidation.

Cellulose gum. Water soluble cellulose derivative used as a substitute for gum arabic.

Sheet work. Printing both sides of the sheet using different plates for each side.

Work and turn (half sheet work). Printing one side of the sheet, then turning the sheet over, retaining the same front- and side-lay edges of the sheet and the same printing plate.

Work and tumble. Printing one side of the sheet, then turning the sheet over, retaining the same side-lay edges but reversing the front and back edges, and using the same printing plate.

Work and twist. Printing one side of the sheet, then reversing the side-lay edges and front and back edges of the sheet, and printing the same side again with same plate.

Ruling out. Preparing a layout to indicate the position of duplicated images and the necessary spacing in the preparation of a machine plate.

Ruling up. The *checking* of a printed sheet for the accuracy of the image position.

Leading edge (of a cylinder, plate or sheet). Front edge. The edge nearest the point of which printing begins.

Adsorption. A physical attraction or adhesion of a substance to a surface.

Washout solution (Asphaltum solution). Solution used for washing out the plate. The solution contains substances to increase the ink receptivity of the image.

Photolithography. A process for producing lithographic printing plates by photographic means.

Substrate. Base or support layer.

Flat. Term used to describe SUBSTRATE on which photographic elements have been assembled upon for exposure to lithographic plate.

Diffusion sheet. Translucent sheet of plastic material which scatters the rays of transmitted light.

Blue key. A form of key in which the image is produced photographically and is non-printing.

Hygroinstability. Behaviour of film or paper in respect of dimensions and "flatness" with variations in moisture and temperature conditions.

Translucent. Allowing light to pass through but not transparent.

Opacity. Not permitting light to pass through. Opposite to being transparent.

Stepping. The "hand" or "mechanical" *moving* of a film element in the printing down of a multiple-image plate.

Assembly (PATCH UP). Positioning of film negatives or positives to form a composite image.

Cutting marks. Marks usually added at copy stage and carried through to printed work, to indicate positions for cutting, slitting, punching, etc.

Negative. A photographic image with tonal values the reverse of the original.

Positive. A photographic image with tonal values the same as the original.

Right reading. An image which is correctly disposed when viewed from the emulsion side.

Wrong reading. An image which is laterally reversed when viewed from the emulsion side.

Actinic light. Light of the wavelength or spectral band which will produce a photochemical reaction in a light sensitive layer.

APPENDIX II

INTERNATIONAL PAPER SIZES

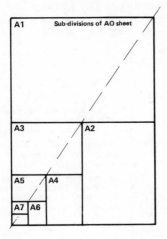

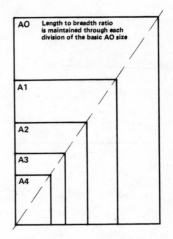

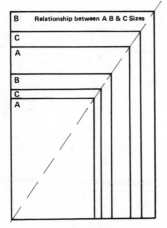

Stock sizes for normal trims:

RA0 860 x 1220
RA1 610 x 860
RA2 430 x 610

Stock sizes for bled work or extra trims:

SRA0 900 x 1280
SRA1 640 x 900
SRA2 450 x 640

Allowance for trim is 3 millimetres

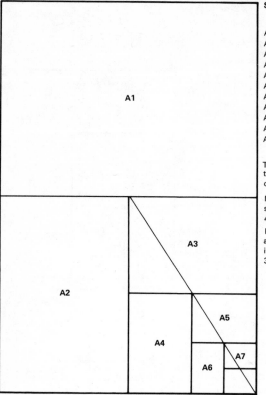

Standard 'A' sizes

	mm			in
A0	841 x 1189	≡		$33\frac{1}{8}$ x $46\frac{3}{4}$
A1	594 x 841	≡		$23\frac{3}{8}$ x $33\frac{1}{8}$
A2	420 x 594	≡		$16\frac{1}{2}$ x $23\frac{3}{8}$
A3	297 x 420	≡		$11\frac{3}{4}$ x $16\frac{1}{2}$
A4	210 x 297	≡		$8\frac{1}{4}$ x $11\frac{3}{4}$
A5	148 x 210	≡		$5\frac{7}{8}$ x $8\frac{1}{4}$
A6	105 x 148	≡		$4\frac{1}{8}$ x $5\frac{7}{8}$
A7	74 x 105	≡		$2\frac{7}{8}$ x $4\frac{1}{8}$
A8	52 x 74	≡		2 x $2\frac{7}{8}$
A9	37 x 52	≡		$1\frac{1}{2}$ x 2
A10	26 x 37	≡		1 x $1\frac{1}{2}$

The table and diagram on this page together illustrate the sizes and divisions of the international 'A' paper sizes range.

In this range the full stock trimmed sheet size is 'A0' and is equivalent to $33\frac{1}{8}$" x $46\frac{3}{4}$" or 841mm x 1189mm.

Progressive divisions of the 'A0 sheet' are obtained by halving the sheet across its longest edge. A1 is thus $23\frac{3}{8}$" x $33\frac{1}{8}$"; A2 $16\frac{1}{2}$" x $23\frac{3}{8}$" etc.

Appendix II. International 'A' sizes.

APPENDIX III

METRIC CONVERSIONS

To convert	into	Multiply by
Length		
inches	millimetres (mm)	25·4
feet	metres (m)	0·304 8
yards	metres (m)	0·914 4
miles	kilometres (km)	1·64
Area		
square inches	square millimetres (mm²)	645·16
square feet	square metres (m²)	0·092 9
square yards	square metres (m²)	0·836
Volume		
cubic inches	cubic millimetres (mm³)	16 400·0
cubic feet	cubic metres (m³)	0·028 3
cubic yards	cubic metres (m³)	0·765
Capacity		
pints	litres (l) or dm³	0·568
gallons	litres (l) or dm³	4·546
fluid ounces	cubic centimetres (cm³)	28·413
Mass		
pounds	kilogrammes (kg)	0·454
hundredweights	kilogrammes (kg)	50·8
tons	kilogrammes (kg)	1016
tons	tonnes (metric tons) (t)	1·016
Illumination		
lumens per square foot	lux (lx)	10·763 9
foot-candles	lux (lx)	10·763 9
Luminance		
candela per square foot	candela per square metre (cd/m²)	10·763 9
candela per square inch	candela per square metre (cd/m²)	1550·00
foot-lamberts	candela per square metre (cd/m²)	3·426 26

Conversion of Fahrenheit to Centigrade
The conversion of Fahrenheit to Centigrade: subtract 32 from the F value, multiply by 5 and divide by 9. The equation looks like this:
$$°C = 5/9(°F—32)$$

Conversion of Centigrade to Fahrenheit
The conversion of Centigrade to Fahrenheit: multiply by 9, divide by 5 and add 32 to the result. The equation looks like this:
$$°C = 5/9(°F—32)$$

CONVERSION TABLE—
INCHES TO MILLIMETRES

(Basis : 1 in = 25·4 mm)

in	mm	in	mm		
1/1000	0·001 000	0·025 400	29/64	0·453 125	11·509 375
2/1000	0·002 000	0·050 800	15/32	0·468 750	11·906 250
3/1000	0·003 000	0·076 200	31/64	0·484 375	12·303 125
4/1000	0·004 000	0·101 600			
5/1000	0·005 000	0·127 000	1/2	0·500 000	12·700 000
6/1000	0·006 000	0·152 400			
7/1000	0·007 000	0·177 800	33/64	0·515 625	13·096 875
8/1000	0·008 000	0·203 200	17/32	0·531 250	13·493 750
10/1000	0·010 000	0·254 000	35/64	0·546 875	13·890 625
12/1000	0·012 000	0·304 800			
15/1000	0·015 000	0·381 000	9/16	0·562 500	14·287 500
20/1000	0·020 000	0·508 000			
25/1000	0·025 000	0·635 000	37/64	0·578 125	14·684 375
30/1000	0·030 000	0·762 000	19/32	0·593 750	15·081 250
35/1000	0·035 000	0·889 000	39/64	0·609 375	15·478 125
40/1000	0·040 000	1·016 000			
45/1000	0·045 000	1·143 000	5/8	0·625 000	15·875 000
50/1000	0·050 000	1·270 000			
1/16	0·062 500	1·587 500	41/64	0·640 625	16·271 875
			21/32	0·656 250	16·668 750
5/64	0·078 125	1·984 375	43/64	0·671 875	17·065 625
3/32	0·093 750	2·381 250			
7/64	0·109 375	2·778 125	11/16	0·687 500	17·462 500
1/8	0·125 000	3·175 000	45/64	0·703 125	17·859 375
			23/32	0·718 750	18·256 250
9/64	0·140 625	3·571 875	47/64	0·734 375	18·653 125
5/32	0·156 250	3·968 750			
11/64	0·171 875	4·365 625	3/4	0·750 000	19·050 000
3/16	0·187 500	4·762 500	49/64	0·765 625	19·446 875
			25/32	0·781 250	19·843 750
13/64	0·203 125	5·159 375	51/64	0·796 875	20·240 625
7/32	0·218 750	5·556 250			
15/64	0·234 375	5·953 125	13/16	0·812 500	20·637 500
1/4	0·250 000	6·350 000	53/64	0·828 125	21·034 375
			27/32	0·843 750	21·431 250
17/64	0·265 625	6·746 875	55/64	0·859 375	21·828 125
9/32	0·281 250	7·143 750			
19/64	0·296 875	7·540 625	7/8	0·875 000	22·225 000
5/16	0·312 500	7·937 500	57/64	0·890 625	22·621 875
			29/32	0·906 250	23·018 750
21/64	0·328 125	8·334 375	59/64	0·921 875	23·415 625
11/32	0·343 750	8·731 250			
23/64	0·359 375	9·128 125	15/16	0·937 500	23·812 500
3/8	0·375 000	9·525 000	61/64	0·953 125	24·209 375
			31/32	0·968 750	24·606 250
25/64	0·390 625	9·921 875	63/64	0·984 375	25·003 125
13/32	0·406 250	10·318 750			
27/64	0·421 875	10·715 625	1	1·000 000	25·400 000
7/16	0·437 500	11·112 500			

BIBLIOGRAPHY

THIS Bibliography has been selected and categorised to provide the student with further information on the subjects covered in this book.

B.P.I.F. Imposition Book (B.P.I.F.).
Modern Lithography (Ian Faux) Macdonald & Evans 1973
Printing Science (Pateman and Young) Pitman 1963.
B.S. Glossary of Terms used in Lithoprinting, B.S. 4277.
Practical Offset Stripping (Deckter) Lith. Offset Pub. Co.
Colour Stripping for Offset Lithography, G.A.T.F., 1955.
Photography and Platemaking for Lithography, Litho. Textbooks Co., 1944.
The Lithographers Manual, (Shapiro), G.A.T.F., 1968.
Litho. in 1960, Conference Reports, (P.A.T.R.A.), 1960.
Chemistry of Lithography, (G.A.T.F.—formerly L.T.F.), 1959.
A Manual of Graphic Reproduction for Lithography (E. Chambers), 1976.
A Manual for Lithographic Press Operation, (A. Porter), 1976.

INDEX